W rking
Aesthetics

RADICAL AESTHETICS – RADICAL ART

Series editors: Jane Tormey and Gillian Whiteley
(Loughborough University, UK)

Promoting debate, confronting conventions and formulating alternative ways of thinking, Jane Tormey and Gillian Whiteley explore what radical aesthetics might mean in the twenty-first century. This new books series, *Radical Aesthetics – Radical Art (RaRa)*, reconsiders the relationship between how art is practised and how art is theorized. Striving to liberate theories of aesthetics from visual traditions, this series of single-authored titles expands the parameters of art and aesthetics in a creative and meaningful way. Encompassing the multisensory, collaborative, participatory and transitory practices that have developed over the last twenty years, *Radical Aesthetics – Radical Art* is an innovative and revolutionary take on the intersection between theory and practice.

Published and forthcoming in the series:

Practical Aesthetics: Events, Affects and Art after 9/11, Jill Bennett
Transitional Aesthetics: Contemporary Art at the Edge of Europe, Uros Cvoro
Eco-Aesthetics: Art, Literature and Architecture in a Period of Climate Change, Malcolm Miles
Civic Aesthetics: Militarism in Israeli Art and Visual Culture, Noa Roei
Counter-Memorial Aesthetics: Refugees, Contemporary Art and the Politics of Memory, Veronica Tello

For further information or enquiries please contact *RaRa* series editors:
Jane Tormey: j.tormey@lboro.ac.uk
Gillian Whiteley: g.whiteley@lboro.ac.uk

Working Aesthetics

Labour, Art and Capitalism

DANIELLE CHILD

BLOOMSBURY ACADEMIC
LONDON • NEW YORK • OXFORD • NEW DELHI • SYDNEY

BLOOMSBURY ACADEMIC
Bloomsbury Publishing Plc
50 Bedford Square, London, WC1B 3DP, UK
1385 Broadway, New York, NY 10018, USA
29 Earlsfort Terrace, Dublin 2, Ireland

BLOOMSBURY, BLOOMSBURY ACADEMIC and the Diana logo are trademarks of Bloomsbury Publishing Plc

First published in Great Britain 2019
Reprinted 2020, 2023

Copyright © Danielle Child, 2019

Danielle Child has asserted her right under the Copyright, Designs and Patents Act, 1988, to be identified as Author of this work.

For legal purposes the Acknowledgements on p. ix constitute an extension of this copyright page.

Cover design: Irene Martinez-Costa
Cover image © *Call Cutta in a Box,* Rimini Protokoll

All rights reserved. No part of this publication may be reproduced or transmitted in any form or by any means, electronic or mechanical, including photocopying, recording, or any information storage or retrieval system, without prior permission in writing from the publishers.

Bloomsbury Publishing Plc does not have any control over, or responsibility for, any third-party websites referred to or in this book. All internet addresses given in this book were correct at the time of going to press. The author and publisher regret any inconvenience caused if addresses have changed or sites have ceased to exist, but can accept no responsibility for any such changes.

A catalogue record for this book is available from the British Library.

A catalog record for this book is available from the Library of Congress.

ISBN: HB: 978-1-3500-2238-6
PB: 978-1-3500-2239-3
ePDF: 978-1-3500-2237-9
eBook: 978-1-3500-2240-9

Series: *Radical Aesthetics-Radical Art*

Typeset by Newgen KnowledgeWorks Pvt. Ltd., Chennai, India
Printed and bound in Great Britain

To find out more about our authors and books visit www.bloomsbury.com and sign up for our newsletters.

CONTENTS

List of illustrations vii
Acknowledgements ix
Series Preface xi
Prologue xiii

Introduction: Labour, art and capitalism 1

1 The deskilling of the artist: Lippincott Inc. (1966–94) 17

2 Neo-liberalism and the facilitator: Mike Smith Studio (1989–) 41

3 The artist as project manager? Thomas Hirschhorn's *Bataille Monument* (2002) and *Gramsci Monument* (2013) 63

4 Immaterial labour: Rimini Protokoll's *Call Cutta in a Box* (2008–12) 89

5 Affective action: Liberate Tate (2010–) 113

6 Digital labour and capitalist technologies: etoy's *Toywar* (1999) and *Mission Eternity* (2005–) 139

Conclusion: Making work visible 167

Afterword: Where do we go from here? A note on post-work 177

Notes 179
Select Bibliography 208
Index 215

ILLUSTRATIONS

P.1 Eyre Crowe, *The Dinner Hour,* Wigan, 1874 xiv
1.1 The original Lippincott work space 25
3.1 Thomas Hirschhorn, *Bataille Monument*, 2002 (Fahrdienst) 68
3.2 Thomas Hirschhorn, *Bataille Monument*, 2002 (Bibliothek) 69
3.3 Thomas Hirschhorn, *Bataille Monument*, 2002 (TV Studio) 70
3.4 Thomas Hirschhorn, *Bataille Monument*, 2002 (Imbiss) 70
3.5 Thomas Hirschhorn, *Bataille Monument*, 2002 (Sculpture) 71
3.6 Thomas Hirschhorn, *Gramsci Monument*, 2013. School Supplies Distribution by Forest Resident Association 72
3.7 Thomas Hirschhorn, *Gramsci Monument*, 2013. Gramsci Archive and Library 74
3.8 Thomas Hirschhorn, *Gramsci Monument*, 2013. Radio Studio 74
3.9 Thomas Hirschhorn, *Gramsci Monument*, 2013. Poetry Session: Tonya Foster 75
4.1 Rimini Protokoll, *Call Cutta in a Box*, 2008–12 93
4.2 Rimini Protokoll, *Call Cutta in a Box*, 2008–12 94
4.3 Rimini Protokoll, *Call Cutta in a Box*, 2008–12 95
4.4 Rimini Protokoll, *Call Cutta in a Box*, 2008–12 96
5.1 Liberate Tate, *Time Piece*, 2015 123
5.2 Liberate Tate, *The Gift*, 2012 125
5.3 Liberate Tate, *Hidden Figures*, 2014 126
5.4 Liberate Tate, *Parts Per Million (1840 gallery)*, 2013 130
5.5 Liberate Tate. *Birthmark* Information Booklet 132
5.6 Liberate Tate, *Toni and Bobbi*, June 2010, Tate Britain. Film still. Liberate Tate, *Toni and Bobbi*, 2010 133

6.1 etoy, etoy.SHARE-CERTIFICATE No. 56, representing the etoy.CREW (1996), 1998 144
6.2 etoy, etoy.HISTORY/SHARE CERTIFICATES, 2010 146
6.3 etoy, TOYWAR.battlefield in January 2000 155
6.4 etoy, The legendary TOYWAR.map (2000), 2000 156
6.5 etoy, MISSION ETERNITY SARCOPHAGUS, 2008 159

ACKNOWLEDGEMENTS

This book has been a number of years in the making. It can be traced back to my first realization, while studying my BA in History of Art, that other people made works of art for artists. My interest in labour has not waned. As such, there have been many conversations and quite a few conference papers that have contributed to my thinking through the relationship between art, labour and capitalism. I am grateful to those who gave feedback, asked questions and commented on these and, in particular, to Gail Day, who helped to shape the art historian I am today.

The anonymous peer-reviewers' early comments on the structure and content of the book proposal were extremely helpful in forming *Working Aesthetics*. I am also very grateful to Jane Tormey and Gillian Whiteley – the series editors – whose valuable feedback also helped to structure this book and for their belief in the proposal itself. And to Frankie Mace, assistant editor (philosophy) at Bloomsbury, whose support for this, my first book project, has been invaluable. Thanks also to all those at Bloomsbury whose labour contributed to turning these words into a book.

Parts of the book have been published elsewhere: An earlier version of Chapter One appeared as 'Dematerialization, Contracted Labour and Art Fabrication: The Deskilling of the Artist in Late Capitalism', *Sculpture Journal* 24, no. 3 (2015): 375–390, which Liverpool University Press have kindly given written permission to reproduce a revised version of here. Chapter Two is a revised and extended version of 'The Artist as Project Manager: Thomas Hirschhorn's *Bataille Monument* (2012)', published in the *Journal of Arts and Communities*, 4, no. 3 (2012): 217–230. I am thankful to the editors and reviewers for their helpful feedback.

I am incredibly grateful for the generosity of the Hirschhorn Studio, Rimini Protokoll, Liberate Tate photographers and etoy for their kind permissions to reproduce images without cost. Particular

thanks go to Gavin Grindon and Mel Evans who hastily provided me with Liberate Tate images at short notice. I would also like to thank Jonathan Lippincott who clarified some points regarding Lippincott Inc. for me and for providing images, and Stefan Kaegi who very kindly sent me copies of *Call Cutta in a Box* scripts for my research.

Manchester School of Art has provided financial support for rights and cover while I completed the manuscript. In the interest of acknowledging work, I would like to thank Gemma Meek, who kindly laboured on my behalf marking essays, while I finished this manuscript.

Finally, I would like to thank those people who have contributed their emotional labour: my parents – David and Janet Child – for their tireless support and encouragement and especially for instilling a work ethic in me; my friends, Michael Coates and Rebecca Wade, for their timely messages of support and camaraderie. And finally, my heartfelt thanks go to Logan Helps, who has endured this journey with me and for which I am eternally grateful.

SERIES PREFACE

The *Radical Aesthetics – Radical Art* series explores what aesthetics might mean in the twenty-first century by integrating practice and theory and firmly embedding the discussion of artworks in the social. Danielle Child's *Working Aesthetics* examines the relationship between labour and art by focusing on key moments in which they intersect. Building on extensive scholarship on the social history of art and grounded in materialist conceptions of art history, the book presents new readings of artistic labour alongside the ideological changes accompanying contemporary capitalism. Focusing on the current rise in collectivity in art practices that are counter to capitalism and those forms of 'socially engaged art' that aim to contribute to affecting social, political and environmental change, the book returns the idea of 'labour' and 'work' to conversations about contemporary art within art historical discourse.

Working Aesthetics presents an examination of contemporary social models of practice that engage in artistic labour but do not necessarily produce an object. Adopting the premise that the social causations of art production are often hidden, or have the appearance of nonwork, the book explores the changing nature of art making under capitalism in relation to wider ideological conditions and asks how artistic practice is affected and why social practices have become dominant in the current period. Using a series of case studies, each chapter focuses on art making in relation to a particular model of work and considers the ways in which the material conditions of work are evident in artistic practice, be it on a practical or an ideological level. The examples discussed in this book make visible a range of classed relations in various aspects of the production and presentation of artworks. It brings into focus workers who are involved in technical aspects of making and project management, and those exploited in myriad forms of hidden labour that contribute to the life of the art world.

With capitalism undergoing constant crisis and the scholarship on precarity growing, there is no doubt that the 'problem of work', with acknowledgement to Kathi Weeks landmark study (2011), is an urgent one. In its questioning of the ways that contemporary art is embedded in neoliberal labour relations, *Working Aesthetics* is timely in its contribution and response. As such, the book's concerns lie very much within the territory of the *RaRa* series and it makes a significant addition to the range of current titles that address some of the most pressing issues of our time.

Jane Tormey and Gillian Whiteley
Radical Aesthetics – Radical Art (RaRa),
Commissioning Editors

PROLOGUE

In Manchester Art Gallery hangs Ford Maddox Brown's renowned painting titled *Work* (1852–65). An allegorical painting of Victorian London work or, more precisely, workers takes centre stage as the subject of the piece. But this is not the painting that draws my attention. To the right of *Work* hangs a smaller painting – Eyre Crowe's *The Dinner Hour, Wigan* (1874) (Figure P.1) – that depicts women workers eating, drinking, resting and chatting outside of the cotton mill (identified as Victoria Mills, Wigan) during their dinner hour. Although painted at a similar time and with the subject of work in common, in contrast to Maddox Brown's *Work*, which contemporaneous viewers paid to view in his studio, Crowe's painting was met with criticism due to its subject matter. When exhibited at the Royal Academy, the *Athenaeum* published the following review:

> *The Dinner Hour, Wigan* (676), a vista of a street, the topography of which, however unlovely it may be, is correct, with tall brick mills on either hand, their lofty shafts and bald walls being purplish red in sunlight; the pavement slopes before us to a lower level. On the wall which divides the one road from the other, are gathered many damsels, chattering away an interval of labour; one, leaning against a lamp-post, throws apples to her neighbours; another squats on the pavement, and takes a meal from a service of tin, two gossip as they loiter. The effect of the picture, rendering of light &c., is quite stereoscopic, but a photographer could have contrived as much; notwithstanding the local interest of the subject, we think it was a pity Mr. Crowe wasted his time on such unattractive materials.[1]

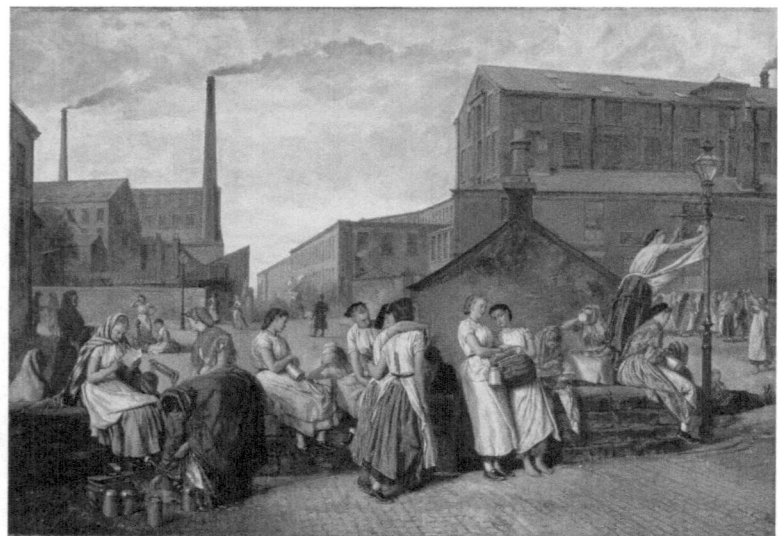

FIGURE P.1 *Eyre Crowe,* The Dinner Hour, *Wigan, 1874. Credit: Manchester Art Gallery, UK/Bridgeman Images.*

In this critique, Crowe's skills are not in question; it is the women whom he painted that are questionable as subjects for art. The response to the subject of Crowe's painting is perhaps symptomatic of a more traditional history of art, with labour and work often becoming 'dirty words' within art history. So few are the moments in which work has gained attention in art history that the artists whose work has garnered attention for its working subjects are often seen as radical or avant-garde (e.g. Gustave Courbet, Jean-François Millet and Vincent Van Gogh). Even in later periods, and particularly since the fetishization of the idea in art around the mid-twentieth century, work has, until recently, been off the art-historical agenda.

Writing in 1874, in the midst of the Industrial Revolution, Crowe's detractors failed to recognize that art and work are inherently connected. Work is not only an appropriate subject for art but, in fact, it also has a dialectical relationship with artistic practice with the effects of one often felt upon the other at any given time. And this relationship is the subject of this book, however unattractive, which

is explored through looking more closely at a series of working and artistic practices within capitalism since the 1960s. *Working Aesthetics* is dedicated to the 'unattractive materials' of Crowe's painting, for those working-class northern women considered to be too ugly a subject for art.

Introduction
Labour, art and capitalism

In *The Problem with Work*, Kathi Weeks states: 'The lack of interest in representing the daily grind of work routines in various forms of popular culture is perhaps understandable', speculating that the 'animation and meaningfulness of commodities' is, perhaps, more enticing for cultural critics.[1] In making this brief statement, Weeks scratches the surface of, what I believe to be, a wider problem in cultural production and, more specifically, in art history. That is, the lack of attention devoted to artistic practice that engages with the subject of labour and of work. In writing this book I hope to contribute my own labour to that which will be required to bridge the gap between work and art. Thus the aim of *Working Aesthetics* is to provoke conversations about labour in art history, in the first instance, through the examination of examples of artistic practice in relation to the practice and effects of distinct models of labour under capitalism.

But why is it important to think about art in terms of labour? Despite capitalism's various transmutations, labour remains central to the capitalist system. Without labour, there would be no surplus value created, without surplus value there would be no profit and without profit there would be no capitalist system. Capital only has one goal and that is profit. Labour is that magical element that turns materials into commodities once exchanged for money. And, as this analysis will reveal, despite its various guises, labour also remains reliant on human intervention. So, why is there so

little attention paid to it in the production and analysis of art? We might return to the development of a modernist art history as a likely source of labour's disappearance from discussions of art. Premodern artistic practices were collectively structured (in workshops and in the guild system for example); it is not really until the modern period that we begin to see a narrowing of focus onto the individual maker, with the collective labour of the studio largely hidden. In the eighteenth century, connoisseurship – which originated as a method of classification and authentication – further distanced those labouring for artists through establishing a canon in art. In attributing authorship and its associated valuation, connoisseurship was closely associated with the art market. In the twentieth century, formalist approaches to the study of art history were originally concerned with classification through employing, for example, a comparative method (Heinrich Wölfflin). Other formalist approaches placed emphasis on the individual viewer who engaged in aesthetic judgements of beauty – for example, Clive Bell's 'aesthetic experience' – or taste (apparent in Clement Greenberg's criticism).[2]

The nineteenth and twentieth centuries fostered and hegemonized the Romantic mythology evident in art, philosophy and literature, a mutated version of which still prevails in the dominant understanding of artist. Coupled with an aesthetic philosophy that embraced individualism, art history did little to dissuade the understanding of the artist as a freethinking individual, set apart from the crowd. This continued understanding of artists as lone, mad, eccentrics persists today. The 2007 Work Foundation report on the creative industries, based on government-funded research, provides an example. It states: 'A culture that tolerates and embraces its deviants, heretics, eccentrics, crackpots, weirdos and good, old-fashioned original thinkers may enjoy payoffs in terms of economic performance.'[3] The mad, lone genius of the nineteenth and twentieth centuries becomes the (economically valuable) heretic or the crackpot in the twenty-first century.

The importance of a revised contemporary art history that takes labour (in both its productive and unproductive forms) as its central tenet thus hinges on the fact that labour is central to capitalism, the economic system under which artists currently work. And this understanding constitutes what I term here 'working aesthetics', proposing an alternative reading of art to the Western tradition

of aesthetics that concentrated on ideas surrounding the beautiful, medium-specificity and, ultimately, taste in art. These philosophical ideas contributed to the narrowing and mystification of what constitutes an artist and, by association, artistic labour. *Working Aesthetics* returns the conditions of making to the conversation about art. Extending beyond appearances, art is seen as an active process in tandem with the economic and ideological conditions of capitalism. Here, the conception of the artist and associated working practices are considered heterogeneous, expanded and, adopting John Berger's understanding of the term, demystified.[4]

Throughout this book five distinct models of labour under capitalism are presented: manual labour, mental labour, contracted labour, immaterial labour and digital labour. While these terms are explained in their respective chapters, it is important here to briefly consider the categories 'work' and 'labour'. As Raymond Williams explains in *Keywords*, work is our most general word for 'doing something'; however, it tends to now refer to regular paid employment, that is, I'm going to work.[5] Labour was more historically associated with hard physical toil and pain, referring to manual and productive work (and, of course, childbirth). As Williams explains, by the seventeenth century it had begun to be used as a term for a supply of work.[6] Labour's understanding as a commodity (i.e. labour power) appeared in writings on the political economy. Furthermore, labour developed as a general social category. It began to refer to the activity (and its associated economic abstraction, i.e. its role in producing value) and also to refer to a class of people who undertook labour.[7] The nineteenth century saw the term 'working class' emerge.

Class is implicit within my approach to labour; my interest in labour in relation to art comes from my own working-class upbringing. The impetus for this analysis is to begin to make visible work that has been historically mystified and obscured. This is most apparent, perhaps, in the Chapters One and Two that look at the manual labourers working for artists, but it also appears in relation to the employed locals in Hirschhorn's monuments and the call centre workers (and their own domestic employees) in *Call Cutta in a Box* (2008–10) discussed in Chapters Three and Four. In this analysis I often use the term labour to refer to paid work, while adopting the more broad usage of the term work; artistic practice is generally referred to as 'art work'. I use the term art

work subconsciously perhaps, due to its economic understanding as 'unproductive' labour, as opposed to the value-producing productive labour. This can be understood in relation to art's relative autonomy from the economic production.

Art's relative autonomy and the categorization of productive and unproductive labour

The acknowledgement of art's relative autonomy to the economic sphere gives permission for art historians and theorists to brush over the perceived marginally related economic conditions of art's own making in relation to the wider economic conditions of capitalism. In his discussion of the relative autonomy of art, Leon Trotsky acknowledges the connection between the artist and the wider social context when he states that the 'psychology [of the artist] is the result of social conditions'.[8] Theodor Adorno too acknowledges art's connection to these conditions when he writes: 'What may be called aesthetic relations of production ... are sedimentations or imprintings of social relations of production.'[9] While the artist is inherently tied to her social conditions, it is only the art object that remains autonomous; hence this is why art's autonomy is only relative and not absolute. As such, art retains its position at a distance from the economic sphere.

In a more recent contribution to the discussion of art's relative autonomy, Dave Beech proposes an alternative to the somewhat obfuscating notion of the relative autonomy of art by understanding art's position in relation to capitalist commodity production as being economically exceptional which, Beech notes, is not an economic argument for art's autonomy.[10] This alternative offers an opportunity to redress the question of autonomy in relation to art's economic understanding as unproductive labour. The relative autonomy of art is predicated on the idea that the artist is not a productive labourer. Artistic labour makes an appearance in a number of Karl Marx's texts. It particularly appears when thinking about pre- and post-capitalist (i.e. communist) modes of production. However, it never takes centre stage, as artistic work is often cited as an example of unproductive labour. As

Marx recounts, the economist Ricardo considered the existence of unproductive labourers a 'nuisance'.[11] Perhaps the inconvenience lay in the inability to fully comprehend how unproductive labour contributes to the capitalist system, at least, in economic terms. This problem extends beyond artistic labour to other modes of work considered unproductive in economic terms, including that of socially reproductive labour.[12]

The term unproductive labour is deceptive; simply thinking that it refers to labour that literally does not produce anything is to miss the point. The key to understanding why certain modes of labour are unproductive is thinking about what it is not producing and that missing element is surplus value. This surplus is realized by employed labour put to work for capital. So, waged labour put to work in the factory produces surplus in the sense that the worker is paid for four hours of his/her capacity to work (labour power) but, in reality, undertakes labour that produces more value than the work for which she is paid. In his writings on unproductive labour, Marx often draws on the examples of creative labour: singers, writers, handicraftsmen and, interestingly, teachers. In his 'Theories of Surplus Value', Marx cites the example of the independent handicraftsman who, he argues, falls outside of the capitalist mode of production.[13] For Marx, the handicraftsman is a seller of commodities and not of labour, thus the buyer purchases a good that has not been alienated from its maker, that is, labour has not confronted the handicraftsman as a separate power.

Artistic labour can therefore be understood as both unproductive – when the artist freely creates and then sells on work – or productive. Under a capitalist system, surplus can be extracted from the artist by a dealer commissioning, for example, the artist to produce a series of editions that are then sold on. The dealer purchases the labour power of the artist who produces commodities (luxury goods) that are then sold, making a profit. Similarly, a cleaner can be employed by a cleaning company that takes on cleaning contracts for businesses. In this equation, the cleaner becomes a wage-labourer whose labour is then resold as a commodity, producing surplus for the company. Central to understanding productive and unproductive labour is that it is dependent on the conditions under which the labour takes place. The unproductive aspect does not relate to a quality inherent in the type of work being undertaken; it lies in how the labour is purchased and what it produces.

Marx remarks in *Capital* that the status of (what we would now understand as) service work as productive or unproductive labour is in a 'transitional phase' at the time of writing.[14] This idea of the transitional phase (which Beech also picks up on in his discussion of unproductive labour) somehow holds the key for thinking about art and contemporary capitalism. This book asks what happens when labour has made the transition, when service work becomes the dominant mode of production in the Western world? How does a type of labour labelled a nuisance become exemplary for developed countries under neo-liberalism? *Working Aesthetics* begins with the transitional phase from industrial production and service work to consider what effect this has on art making and our understanding of it, when historically considered unproductive labour (like artistic labour) becomes productive for capital. This is not to reject the notion of the relative autonomy of art – the labour of the artist does not produce surplus in the same way as mainstream production, thus art is not productive labour in the Marxian sense – however, this analysis intends to return art to the conversation about labour and work to understand the ideological effect of neo-liberal work models on art making. An important point to stress from the outset is to acknowledge that not all labour that goes into the production of art belongs to the artist; this analysis considers those workers making art who are not artists, and who are employed as, arguably, productive labourers. And this is not to expose the existence – or exploitation – of assistants and fabricators, as is often the case for discourse on these practices but, rather, to present a new understanding of the relationship between contracted labour in art and capitalism.

The concept of relative autonomy centres around the notion that the object produced is separated from the artist. When art begins to move away from object production – and the artist's body and actions constitute the work of art – its relative autonomy becomes less clear. If the artist is considered as a social being affected by the economic, then how do we now understand an artwork (performance, action, etc.) that is not distinct from its producer in relation to this concept? We might rightly concur that, after Beech, the artwork is economically exceptional in that it is not produced in the same way as capitalist commodity production. However, we might also consider how this relationship is affected by a shift to working practices that adopt qualities akin to performance in the neo-liberal period.

The practices discussed in this book, with the exception of the work produced by the fabricators/studio discussed in Chapters One and Two, belong to the aforementioned; that is, they engage in artistic labour that does not necessarily produce an object. Moreover, the material conditions of the art world itself, which is often viewed at a distance from the economic base, have more recently been made visible when, for example, groups like Gulf Labor highlight the daily working conditions for migrant workers employed to build the Guggenheim's Abu Dhabi Gallery on Saadijat Island. While art itself may remain relatively autonomous or distinct from the mainstream economic market, the sites of its display are inherently tied to the economic base through the employment of wage labourers. In Chapters Five and Six, the relationship of art-activist practices to the new working practices under contemporary capitalism is explored through the examples of creative interventionists Liberate Tate and the hacktivist practices of etoy.

Methodology

As it may now be clear, the approach that I adopt in this book is unapologetically historical materialist; it is impossible to discuss the work of art without also considering the conditions of labour more broadly. Art historian Arnold Hauser claims: 'In no phase of art history ... do we find the development of art completely independent of the current economic and social conditions.'[15] And this notion is fundamental to understanding the premise of this book. Hauser further acknowledges that art and philosophy may at times veil the social causations of their production and this is, perhaps, the driving motive for this analysis. Art history could be added to art and philosophy as another discipline that obfuscates the social causations of art's production. Since the advent of modernism, art history has largely veiled the labour of art and particularly that of the non-artist.

My historical materialist approach is indebted to Karl Marx and Frederick Engels' section on 'Artistic Talent' from *The German Ideology* (1845–46) in which they write:[16]

> Raphael as much as any other artist was determined by the technical advances in art made before him, by the organisation

of society and the division of labour in his locality, and, finally, by the division of labour in all the countries with which his locality had intercourse. Whether an individual like Raphael succeeds in developing his talent depends wholly on demand, which in turn depends on the division of labour and the conditions of human culture resulting from it.[17]

In this section, Marx and Engels show how the artist is subjected to the division of labour within society while also being influenced by the geographical and historical contexts in which he is making. To view the production of works of art in isolation from these conditions would be to make false assumptions about the nature of art, enhancing the bourgeois myth that art is created in isolation from the outside world. As such, this analysis is based on an understanding that there is a dialectical relationship between the labour of art and the economic, social, historical and geographical conditions surrounding art's production. However, it is not the intention here to present a vulgar Marxist mapping of art making onto contemporaneous labour models; rather, it aims to understand the changing nature of art making under capitalism in relation to the wider ideological conditions produced by the conterminous economic base. Hauser writes:

> The essence of the materialistic philosophy of history, with its doctrine of the ideological character of thought, consists in the thesis that spiritual attitudes are from the outset anchored in conditions of production, and move within the range of interests, aims and prospects characteristic of these; not that they are subsequently, externally, and deliberately adjusted to economic and social conditions.[18]

A brief discussion of Marx and Engel's concept of base and superstructure here may help to clarify this point.

Although a much-debated concept, the base/superstructure dyad is central to thinking about art in relation to the economy: namely, that the dominant modes of production affect the way that art is produced. The notion of base/superstructure appears in various guises in a number of writings by Marx and Engels, with Engels elaborating upon it (and adapting it to his own ideas) in his letters of

the 1890s. Marx sketches an outline of this concept in his 'Preface' to *A Contribution to the Critique of Political Economy* (1859):

> The sum total of these relations of production constitutes the economic structure of society, the real foundation, on which rises a legal and political superstructure and to which corresponds definite forms of social consciousness. The mode of production of material life conditions the social, political, and intellectual life process in general. It is not the consciousness of men that determines their being, but, on the contrary, their social being that determines their consciousness ... With the change of the economic foundations the entire immense superstructure is more or less rapidly transformed.[19]

Thus, Marx proposes that the relations of production are what condition the 'superstructure' and thus the (ideologically constituted) consciousness of men.[20] A common misconception of the base/superstructure relation is that it is only a one-way determinate relationship. In 'Theories of Surplus Value', Marx acknowledges a 'reciprocal influence' between the base and superstructure, identifying that spiritual production can also have an effect on material production.[21] Therefore, the relationship between the base and superstructure can be viewed as dialectical: the economic base informs the realms of art, religion, politics, ideology, and so forth. Moreover, these realms can also inform the base; in Chapter Two this dialectical relationship becomes evident through examining neo-liberal management models that adopt the artist as a model worker.[22]

Literature review

In the opening section of this introduction, I noted that art history had paid little attention to labour until recently. The co-optation of (presumed) artistic modes of working, discussed in Chapters Two and Three has, perhaps, facilitated the renewed academic interest in the relationship of art and labour in the twenty-first century. As work increasingly adopts the appearance of non-work, the perceived gap between the two narrows and thus warrants attention to both.

This narrowing might also provide motive for the renewed interest in the idea of the avant-garde, whose mantra became 'art into life'.

As such, there have appeared a number of recent edited collections that bring together different voices on the topic of art and work. The most recent of these are the Documents of Contemporary Art series' *Work* (2017) anthology and *I Can't Work Like This: A Reader on Recent Boycotts and Contemporary Art* (2017). The latter presents contributions that are framed around four recent cases of art world boycotts: 13th Istanbul Biennial, Manifesta 10, 19th Bienniale of Sydney and 31st Bienal de São Paulo.[23] I return to the refusal of work in the afterword. Other contributions include the (currently out of print) *Work, Work, Work: A Reader on Art and Labour* (2012), which provides contributions from divergent perspectives (artists, architects, theorists, political thinkers and curators) and the result of a series of seminars in 2010 at Iapsis in Stockholm.[24] The earlier US 'newspaper' (distributed in all fifty US states and Puerto Rico) – *Art Work: A National Conversation about Art, Labour and Economics* (2009) – appeared in 2009. The latter was collated and distributed in response to a failing global economy to address the 'topic of working within depressed economies and how that impacts artistic process, compensation and artistic property'.[25] The publication works on the premise that the artist is considered a worker. What is apparent in the collected essays and shorter texts within these volumes is the interconnectedness of the subject of art and work with politics. The two are seemingly inseparable. As I understand capitalism in relation to Marx's critique of the political economy, in *Working Aesthetics* the entanglement of art, labour and politics is also evident.

Some of the key analyses for my own thinking through art's relationship to labour are addressed in the main body of this book; however, I would like to here present an overview of recent contributions to the conversations around art and labour (with a focus on the contemporary).[26] These present critical positions on the non-artist worker, collective political practice and gender, all of which are important to this analysis. *Intangibilities of Form: Skill and Deskilling in Art After the Readymade* (2007) is perhaps the first of these recent accounts to consider the relationship between productive and (what is termed) non-productive labour in the development of avant-garde art. John Roberts presents his own labour theory of culture, with the primary concern noted as the

process of deskilling and reskilling 'as it bears on the exchange and collaboration between artistic labour and non-artistic labour, artistic hands and non-artistic hands'.[27] However, the discussion of this convergence with non-artistic labour largely remains focussed on how this affects the understanding of the artists' work (Duchamp, Moholy-Nagy, Warhol, the Constructivist and Productivists and later collaborative practices, such as Critical Art Ensemble and Superflex) rather than the conditions of those labouring for artists, referred to as the 'detached hand'. In fact, Roberts avoids a discussion of the cooperative production by employed assistants (what I term contracted labour) in Jeff Koons' studio in recognizing that this type of labour is often hidden and 'diffused into technical support', preferring instead to discuss the more performative collaborative studio practices of Art & Language and Andy Warhol.[28] As he moves towards the contemporary in his analysis, Roberts proposes that, through the conflation of artistic technique and 'general social technique' (the technical reproduction of cultural and social forms), art becomes invisible. Roberts warns that, if art does not retain its freedom from the value-form – its autonomy – it might end up completely invisible and, like any other commodity, subject to the general law of value.

Gregory Sholette's *Dark Matter: Art and Politics in the Age of Enterprise Culture* (2011) makes visible the overlooked existent 'invisible' collective political artistic practices formed since the advent of neo-liberalism. 'Dark matter' is the term that Sholette uses to describe that which is 'is invisible primarily to those who lay claim to the management and interpretation of culture – the critics, art historians, collectors, dealers, museums, curators, and arts administrators. It includes makeshift, amateur, informal, unofficial, autonomous, activist, non-institutional, self-organized practices – all work made and circulated in the shadows of the formal art world'.[29] Some of these practices openly reject art world demands, while others have no choice but to be invisible. In making these practices visible, Sholette draws on his own experience as a 'cultural worker'; an artist who was a member of two (in his words) marginal art collectives (Political Art/ Documentation/Distribution and REPO history) within the neo-liberal context of 1980s/90s America. He draws on this experience while, in other chapters, considers examples of other political art collectives whose practice is also considered as the dark matter of the art world. We might

thus extend the notion of dark matter to include those labouring for the artists presented in this volume, adding employed labour to Sholette's understanding.

In *The Composition of Movements to Come: Aesthetics and Cultural Labour after the Avant-Garde* (2016), Stevphen Shukaitis returns to the political potential of the avant-garde within the framework of autonomist–compositionist thinking.[30] He does this through a consideration of cultural labour (including an interesting discussion around art and value) for the purpose of thinking about new practices of resistance and organization in the future (i.e. the movements to come). Like Roberts, he returns to the historical avant-garde to consider what might be learned from these collectives. In presenting an understanding of the avant-garde practice as 'labouring otherwise' Shukaitis looks at the examples of Constructivism, the Situationists and Neue Slowenische Kunst (or NSK) and its associated fine art collective IRWIN. He concludes by considering the undercommons, which reads as something akin to Sholette's dark matter; that is, the self-organization of the incommensurate. Again invisibility is returned to, but this time as a tactic to avoid the process of recuperation-decomposition that Shukaitis identifies in the autonomous cultural and artistic production (i.e. the co-option of this model of production by capitalism).

In the twenty-first century the subject of unproductive labour (another form of 'invisible work') is returned to by materialist feminist art historians reengaging with theories of socially reproductive labour in relation to artistic practice and the economy. Moving beyond postmodernism's 'cultural subject', in *Gender, artWork and the Global Imperative* (2013), Angela Dimitrakaki invites us to instead understand women as an economic subject under globalization.[31] In doing so, she proposes four entry points for feminism into art history: The first is to engage with meanings of feminization, drawing on both quantitative and qualitative data; the second is through identity, agency and representation, through asking do 'women' share an identity under globalization? The third entry point is labour, and the final is transnationalism, or the return to feminist politics in capitalism's Empire. Thus Dimitrakaki asks that we return the labouring bodies of women (in both historically productive and unproductive forms) to the analysis of art in the

twenty-first century through a re-engagement with global politics, labour and identity.

My own engagement with unproductive labour (both artistic and socially reproductive labour) was encouraged by Dimitrakaki and Kirsten Lloyd's invitation to deliver a paper on their co-convened panel 'Labours of Love: Works of Passion: The Social (Re)production of Art Workers from Industrialization to Globalization' at the Association of Art Historians Annual Conference in 2016. While this book does not contain a case study of a specifically feminist practice, an understanding of gendered forms of labour is implicit. It is more visible in, for example, the discussion of the 'feminization of work', in Chapter Four. Dimitrakaki and Lloyd's *Economy* (both the exhibition and the accompanying edited volume), brings together a number of contributors writing about artistic practice in relation to the economy (including Roberts and Sholette). Implicit within this subject is work or, as Dimitrakaki and Lloyd term it, production. Dimitrakaki and Lloyd conclude their introductory essay with an understanding of 'contemporary art as a terrain of production where Marx's "forces of production" tend to be incorporated into "relations of production"'. Furthermore, they claim that, 'when "immaterial" labour becomes hegemonic, the relations of production multiply to the extent that all social relations can potentially count as relations of production'.[32] In response to Roberts' proposition that the distance between art and productive labour must be retained in the contemporary, they propose a shift in attention from the output of art (i.e. the artwork) to the *outcomes* of art. In turn, this shift leads to the understanding of art (as a mode of production) partaking in the naturalizing of society as a system of class relations. Through acknowledging that artists also employ labour within the studio (acknowledging Sholette's dark matter) in order to produce art, Dimitrakaki and Lloyd further highlight the paradox of being a successful contemporary artist. This paradox is found in the reaffirmation of certain ideologies aligned with contemporary capitalism while simultaneously attempting to engage in a practice that is critical and avant-garde. In presenting this discussion, the authors hope 'to encourage further research into *how* whatever we understand by "art" transforms when production does'.[33] *Working Aesthetics* contributes to this research.

Structure of the book

This book comprises six chapters, each of which reads an artistic case study in relation to a concurrent type of labour. The case studies are structured around three types of art work: contracted labour (art labourers); collaborative artistic practices that temporarily employ non-artists; and art-activist practices. As such, *Working Aesthetics* does not present a comprehensive list of all types of labour, nor does it constitute all contemporary art practices. It does, however, intend to provoke critical thought about the relationship between capitalism, work and art through closely examining six examples in which these relationships are apparent.

While *Working Aesthetics*' main period of study is the contemporary, Chapter One returns us to the 1960s context to explore the emergence of the art fabrication firm in the context of Fordist America. The establishment of firms such as Lippincott Inc. provides a starting point for considering the art making as a business model, which is continued and adapted in the contemporary period. The chapter examines the working practices of Lippincott Inc. in relation to Harry Braverman's 1974 deskilling thesis. The employed artistic labour at Lippincott is thus explored in terms of its working practice, and understood within the ideological context of Fordism. In 1994 the firm reconfigured as a Limited Liability Company (LLC), closed its factory premises and made the decision to contract labour to other firms as part of its working practice. The firm's longevity in fabricating art allows us to see how the company adapts to the changing conditions of capitalism during the aforementioned 'transition' from industrial production to an increase in the provision of services.

Chapter Two picks up at the moment of Lippincott's reconfiguration to discuss the inherent changes to art making at this time. Within this context emerged a new, younger model of fabricator – the facilitator – in the form of the Mike Smith Studio, a British art fabrication studio (or facilitator), which established itself in the 1990s while producing works for the Young British Artists (YBAs). When the studio's US predecessors (such as Carlson and Co.) struggled to survive during the economic downturn of the 2000s, the Mike Smith Studio continued to thrive. This chapter questions why the Mike Smith Studio survived, while its

counterparts were adjusting to the changes in capitalism. It draws on the economic and ideological context of neo-liberalism, turning to analyses from Eve Chiapello and Luc Boltanski's *The New Spirit of Capitalism* (2007) and what David Harvey terms 'flexible accumulation' (1990). While distinct in its production of art, the Mike Smith Studio provides a business model commensurate with other working practices under neo-liberalism.

The focus of Chapter Three shifts from the subject of contracted labour to the labour of the artist, in the form of project management. Building on ideas presented in the preceding chapter, in particular, Boltanski and Chiapello's idea of the 'artist critique', the working practice of Thomas Hirschhorn is examined in relation to his *Bataille Monument* (2002) and *Gramsci Monument* (2013). These are complex projects that take place physically outside of the art institution, engaging with and employing a predominantly non-art audience. The monuments provide examples of artistic practice within which we can identify specific tropes akin to project management (that accompanies neo-liberalism). The chapter understands Hirschhorn himself adopting the role of project manager, while retaining his anti-capitalist practice.

As contemporary art becomes more interactive and performative, the case study for Chapter Four is borrowed from performance: Rimini Protokoll's *Call Cutta in a Box* (2008–12). This performance takes the canonical example of immaterial labour – the call centre – as its set. Like Hirschhorn's monuments, *Call Cutta in a Box* also relies on the employment of non-art/actor workers in its making. The chapter thus introduces the key ideas and theorists of immaterial labour (Michael Hardt, Antonio Negri and Maurizio Lazzarato) to understand how artists have adopted the working aesthetics of immaterial labour as a form of critique. It further problematizes this analysis in considering the role of the actor–worker employed to perform in *Call Cutta in a Box* in relation to their immaterial co-workers.

While some artistic practices could be viewed as adapting to the changes accompanying neo-liberalism – and galleries such as Tate adapt to accommodate these more performative, immaterial practices – Chapter Five focuses on a collective who openly critique capitalism's relationship with the art institution: Liberate Tate. The chapter takes an aspect of immaterial labour – 'affective labour' – as a theoretical basis for understanding how capitalist tropes can be

used against it. The chapter concludes with the proposition that the gallery space could be understood as a microcosm of the multitude made up of virtuosos; Liberate Tate provide an example of the assimilation of intellect with action (from Paolo Virno) for the purpose of disrupting the co-optation of performance, collectivity and creativity in capitalist work.

Chapter Six examines two examples from the art collective etoy [sic] in relation to digital labour. After presenting an understanding of digital labour, the chapter returns to Marx's 'Fragment on Machines' from the *Grundrisse* (1857–58) in which he identified the informationalization of human labour (the 'social brain') that accompanies the introduction of machinery into the workplace. The neutrality of machinery put to work for capitalism is further explored in relation to Raniero Panzieri's 1964 essay and updated in relation to the contemporary period in which information is manifested in knowledge work and immaterial labour. In adopting hacktivist means, the *Toywar* (1999) provides an example through which to explore a practice that arguably used capitalist technology against itself; however in the second example, the fundamental nature of peer-to-peer (P2P) platforms raises questions about if, within these digital frameworks, were ever operating as 'capitalist' to begin with. In the conclusion, I reflect on the key tenets of the book including the social labour in art, the impact of the narrowing of the work/life boundary and the visibility of work in contemporary art practices.

CHAPTER ONE

The deskilling of the artist: Lippincott Inc. (1966–94)

The 1960s is a key decade for considering labour in artistic production. This was a decade in which artists began to identify as 'art workers', formed unions (in the United States and UK) and demanded workers' rights. The process of making art also changed during this period with the birth of conceptual and establishment of performance art among other 'dematerialized' or non-object-producing practices. Lesser known, is the birth of the art fabrication firm. The years 1966 through 1971 saw the emergence of at least three fabrication firms *solely* fabricating for artists in the United States: Gemini G.E.L., Lippincott Inc. and Carlson & Co. Of course, this was not the first time that artists had employed others to make their work; artists have long contracted foundries to cast their sculptures and employed assistants in their studios. However, this chapter will contend that the origin of art fabrication firms, such as Lippincott Inc., can be understood in relation to the particular historical moment in which they emerged, both within the field of art history and in relation to the contemporaneous phase of capitalism.

In the first decade of the twenty-first century the existence of artists' fabricators gained attention in art discourse, arguably for the first time since the exhibitions acknowledging fabrication in

the late 1960s and 1970s.[1] This visibility accompanied what Claire Bishop has called the 'social turn' in art, doubtlessly stemming from conversations around the English-language publication of Nicolas Bourriaud's *Relational Aesthetics* in 2002.[2] Journal issues and books considering 'collaboration' often give a nod to contracted labour in art, while unproblematically co-opting and collapsing art fabrication into one of many collective practices. Most notable is *Artforum*'s issue devoted to 'The Art of Production', published in 2007 amidst the contemporaneous debates on collective practice, while Julia-Bryan Wilson's *Art Workers: Radical Practice in the Vietnam War Era* (2009) makes visible Robert Morris's 'collaborative' process of working with contracted workers, including those employed by Lippincott Inc., on his 1970 Whitney show.[3] Bryan-Wilson's most recent contribution – *Art in the Making* (2016) – co-authored with Glenn Adamson, devotes a chapter to 'Fabricating', which introduces fabrication as a mode of art making alongside alternative 'materials'.[4] Others seek to establish a legacy for the art fabricators, as in Jonathan Lippincott's book – *Large Scale: Fabricating Sculpture in the 1960s and 1970s* (2010) – devoted to images of his father's fabrication company.

Rather than appropriate the aforementioned art fabricators for a larger collaborative agenda, this chapter intends to understand the fabricators within the context in which they emerged, not only as companies making for artists but, rather, as businesses within the economic sphere. In this chapter, it is argued that the emergence of the art-specific fabrication businesses within this period is a response to the wider ideological conditions of a gradual 'deskilling' of work within America throughout the twentieth century, as identified by Harry Braverman in *Labour and Monopoly Capital: The Degradation of Work in the Twentieth Century* (1974).[5] The contracting of industrial manufacture and the deskilling of the artist from his/her manual skills is considered in terms of the wider labour conditions within the period. Beginning with the art historical context of deskilling (i.e. the rejection of the artist's hand in making art), this chapter will look closely at the deskilling thesis as proposed by Braverman through to the Fordist ideology that dominated American life in the 1960s, before returning to consider the working practice of one of the contemporaneous fabricators – Lippincott Inc. – and its relation to the 'dematerialization of art' identified within this moment.

'The Dematerialization of Art'

In 1968, Lucy Lippard and John Chandler opened their essay 'The Dematerialization of Art' with the following statement: 'As more and more work is designed in the studio but executed elsewhere by professional craftsmen, as the object becomes merely the end product, a number of artists are losing interest in the physical evolution of the work of art. The studio is again becoming a study.'[6] This statement testifies to an emergent phenomenon in art making in this period, that is, the separation of the idea from the physical form of the artwork. The works of art discussed in 'The Dematerialization of Art' are those of a conceptual nature. Writing in the early moments of conceptual art and taking their lead from Joseph Schillinger's schema, Lippard and Chandler envisaged a move to a 'post-aesthetic' art to come in the near future. Although conceptual art is the article's concern, its opening statement is, furthermore, a reference to minimal works, on which Lippard had previously written.[7] It was the artists associated with minimal art who began to use the early artists' 'fabricators' in America in the 1960s; Donald Judd, Sol LeWitt and Robert Morris were among them. For 1960s conceptual art, the onus was on the idea. A conceptual artist did not necessarily produce an empirical object; if they did, it was often surplus to the idea. With minimal art, objects were produced, but not always by the artist, thus pioneering the utilization of industrial production methods. Thus artists working within both movements could be said to be adopting a form of deskilling – in the sense that artists do not physically make their works – within their respective processes. The subsequent industrial aesthetic in minimal art provoked formalist commentators such as Michael Fried to detect a shift to 'objecthood' in sculpture, while Clement Greenberg discussed minimal works in terms of a 'non-art' aesthetic.[8]

The denigrating terms attributed to these works in the criticism of Fried and Greenberg signal a period of disrupture within art history. In the 1960s modernism reached its peak in America; the publication of Clement Greenberg's 'Modernist Painting' (1961) neatly reduced almost a century's worth of painting into a teleology, beginning with Manet through to the implicit contemporaneous modernist painters (presumably, colourfield

painters).[9] With the help of Kantian aesthetics (purporting self-criticism), modernist painting was reduced to a number of 'cardinal norms' (the boundaries of which, Greenberg argued, were tested by the modernist painters) based on its medium-specificity including flatness, two dimensionality and opticality, which ultimately led to a notion of aesthetic autonomy. After adopting and continuing the (Greenbergian) formalist approach to painting, evident in his *Three American Painters: Kenneth Noland, Jules Olitski, Frank Stella* (1965) catalogue essay, Fried attacked the newly emergent 'literal' (now minimal) art in his essay 'Art and Objecthood' (1967).[10] The work was denounced as inherently 'theatrical', due to its relationship to the viewer and the temporality of this relationship. Fried's contention thus lay with the presence of others to 'complete the work' and the reference to the outside world (objects).

Although minimal objects could be read as a sculptural response to medium-specificity (reducing sculpture to its 'essential norms' of three dimensionality, mass and scale, for example) they marked a departure from the 'flat', self-contained, abstract paintings heralded in art schools across the United States. The three-dimensional works returned to art, reference to the outside world (something denounced in Greenberg's 'Modernist Painting') and also exposed the labour (through the choice of industrial materials and production methods) of industry that obfuscated the hand of the artist. The eradication of the hand of the artist dismantled the autonomy that Greenberg had attributed to the work of the American modernist painters from Pollock through to Jules Olitski.

It was not only minimal artists who, in the 1960s, sought to escape the confinement of aesthetic autonomy. Conceptual artists also sought to escape the reified art object (painting) prevalent in art criticism. In his 1988 essay 'Hans Haacke: Memory and Instrumental Reason', Benjamin Buchloh states: 'It is important to recognize that artists who continue to reject the idea of aesthetic autonomy have also had to abandon traditional procedures of artistic production (and, by implication, of course, the cognitive concepts embedded in them).'[11] Buchloh suggests that artists working in mid-1960s America responded to aesthetic autonomy through a form of deskilling as a mode of negation. Thus, in recognizing the 'historical failure of the modernist concepts of autonomy', a dialectic emerged between deskilling as negation or resistance and expressionism as instinctive (arguably creating an 'unalienated subject').[12] The idea

of expressionism as an 'unalienated' form of (artistic) production is born from the Romantic philosophy to which much of Greenberg's criticism of this period in indebted; thus deskilling marks a break with and a negation of his approach. Buchloh cites Ian Burn: 'deskilling means a rupture with an historical body of knowledge – in other words, a dehistoricisation of the practice of art'.[13] This idea of a rupture is particularly important for understanding the negation of a Greenbergian modernism that established a teleological view of modernist painting going back to the nineteenth century. In *Intangibilities of Form* (2007), John Roberts also acknowledges the artist's move away from craft-based skills. However, he proposes that post-Duchampian art, in fact, entails a reskilling because of the artist's rejection of craft-based skills in favour of developing new immaterial skills.[14] He terms this phenomenon the 'deskilling-reskilling' dialectic.[15]

An art history heavily reliant on the influence of critics and patrons (perhaps for the last time) had produced a definitive criteria for modernist painting; artists wishing to break with this did so in an unprecedented manner. Other art historians of this period also recognize the distance, in the new sculptural forms, from the art practices that had come before. In her canonical essay, 'Sculpture in the Expanded Field' (1986), Rosalind Krauss shows how sculpture adopted new forms that may be more aligned with architecture, landscape and site construction, for example with the earthworks.[16] Again, these are works that require many hands and are indexically tied to the outside world through their materials or the site-specificity.[17] These new works, for Krauss, are a logical rupture with modernism in which the artist is now free from an ascribed medium-specificity to new possibilities within the newly 'expanded field'.[18]

The emergence of the art-specific fabricators occurred at the time when artists were reacting to the aesthetic autonomy of painting, taught in art schools and penetrating the museum space. Given the origins of minimalism as a reaction to Greenbergian aestheticism, it is hard to believe that the emergence of the fabrication companies was solely a response to artists' quests simply for an industrial aesthetic. Moreover, these were artists interested in processes, as evidenced in both Morris's and Haacke's work. Buchloh writes: 'Indeed an object only takes an aesthetic meaning when its referentiality has been abolished, when it no longer reminds us of

the labour invested in its production.'[19] Both the artists associated with minimalism and those, like Haacke – working on the edges of conceptual and process-based, social art – purposefully broke with the aesthetic convention, exposing the labour of others in differing ways. For Robert Morris, it was the labour of industry, for Haacke, the participation of the public. Furthermore, the establishment of these firms extended beyond appearances to working practice. Lippincott Inc. co-founder, Roxanne Everett, often approached artists to work at the firm further complicating the idea of a desired aesthetic.

In this chapter, I propose that the dematerialization of art can be thought differently, beyond the art historical discourse and into the social and economic sphere. Through the sculptor's employment of contracted labour, dematerialization could be understood as a reaction, conscious or not, to the implementation of a Fordist ideology in mid-twentieth-century America. As Max Weber acknowledged, 'The technical and economic conditions of machine production ... today determine the lives of all the individuals who are born into this mechanism ... with irresistible force.'[20] The artists discussed here were neither sheltered from nor unaware of the wider political and economic conditions under which they made work. In fact, as Bryan-Wilson's important book testifies, the artists who employed firms like Lippincott Inc. were very much invested in the political issues facing artists in the 1960s and 70s. In 1976, Carl Andre proclaimed, 'the position of the artist in our society is exactly that of an assembly-line worker in Detroit'.[21] Given the emergent climate in which artists began to consider themselves (and ask to be recognized) as art workers, it is not unwarranted to read the shift to contracted labour and the emergent art fabrication firms in relation to the deskilling of work that affected the wider ideology in this period.

The fabricators

In the mid-twentieth century, artists sought to employ industrial production companies, for example, with the New York-based metalworks – Gratz Industries – (founded as Treitel-Gratz in 1929) that successfully maintained longstanding working relationships with artists (including Judd, Walter de Maria and

Sol LeWitt) while manufacturing industrial items. Later, the industrial metalworkers Milgo Industrial (now Milgo/Bufkin) developed working relationships with artists; in June 1971 Milgo proclaimed itself to be the 'largest fabricator of contemporary sculpture in the world'.[22] However, the relationship between artist and worker in the industrial manufacturing plants was not always straightforward; the difficulties that artists experienced through working with industrial manufacturers allowed for businesses solely devoted to art fabrication to materialize. In a 1975 interview, Robert Murray recalled how he, as an artist working in industrial plants, had to keep his hands off the machinery in some of the union shops.[23] Instead he had to provide the shops with detailed diagrams for the making of his works, a model more in keeping with a Taylorist division of labour. For the most part, art and industry were too far removed to comprehend one another's language: hence the initiation of the art fabrication plants. Lippincott makes clear that this difficult relationship was one of the main reasons for establishing a company devoted to making works for artists: 'I think that recognizing the problems artists had working in other industrial situations is what led us to start with the first pieces.'[24]

Gemini G.E.L, Lippincott Inc. and Carlson and Co. emerged alongside existing industrial fabricators, like Gratz Industries, who manufactured artworks for artists while they continued to produce everyday commodities. Beginning as a print workshop in 1966, with an artist's studio, Gemini G.E.L was primarily a print-based manufacturer whose intentions were to publish prints by mature masters. Responding to the changing needs of contemporary artists, in 1969 Gemini expanded its premises to incorporate sculpture and screen-printing. The fabrication of Claes Oldenburg's *Profile Airflow* (1968) is said to have sparked the company's interest in three-dimensional works.[25] Subsequently, they worked on Oldenburg's ambitious contribution to the 1970 World Fair in Osaka, Japan, *Ice Bag – Scale A,* with the assistance of Krofft Enterprises who designed the hydraulic system in *Scale B*. The piece was not only of a monumental scale, measuring 18 by 16 feet, but also kinetic. Gemini further worked on a number of sculptural editions for artists such as Judd, Ellsworth Kelly and Willem de Kooning before they closed their sculpture facilities in 1972 after Jeff Sanders left the workshop. Despite the closure of its sculpture shop, a number

of employees branched off from Gemini and established their own businesses manufacturing for artists, or became freelance contractors (reminiscent of the 'journeymen' model). In 1974, Ron McPherson founded La Paloma Fine Arts in California, which was initially print-focused and later incorporated three-dimensional art production.

In 1971, Peter Carlson branched out from Gemini G.E.L. to set up his own art fabrication unit in Los Angeles. After a brief period as an independent contractor making works in his garage, he founded Peter Carlson Enterprises (later Carlson & Co.).[26] Distinct from Gemini G.E.L., in the fact that Carlson did not wish to employ artists, Carlson focused on the manufacture of three-dimensional works rather than printmaking. Carlson himself comes from an art background; he initially studied electrical engineering before changing to study fine arts. The firm prided itself on its capacity to undertake any engineering possibilities, and Carlson himself, speaking in 2003, denied the collaborative aspect of working with artists in favour of working *for* them.[27] Until recently, Carlson & Co. continued to manufacture works of art for contemporary artists like Jeff Koons alongside working on architectural projects. Sadly, the firm was hit by the recession and closed its doors in April 2010 only to reopen in October 2010 in its new manifestation as Carlson Arts LLC.

Lippincott Inc.

Founded in 1966, Lippincott Inc. of Connecticut, devoted its business to the production of large-scale sculptural works (Figure 1.1). The company was founded by Donald Lippincott – then a part-time industrial real-estate developer and property manager – and Roxanne Everett – a contemporary art lover who had previously worked in fundraising and public relations. Industrial production was not completely alien to Lippincott; his father was the founder of an industrial design firm in New York – Lippincott and Margulies – that counted the iconic Campell's soup can among its designs. Writing about Lippincott for the *New York Times* in 1976, Leslie Maitland stated: 'The sculpture factory grew out of his [Lippincott's] realisation that a need existed for a place that dealt solely with artists, to execute their large-scale

THE DESKILLING OF THE ARTIST

FIGURE 1.1 *The original Lippincott work space. Photograph by Roxanne Everett. © Roxanne Everett / Lippincott's LLC.*

ideas – freeing them from the sideline status of working at a general metalworks factory.'[28] This allusion to scale confirms the minimal artists' influence in the establishment of the art fabricators alongside the industrial materials (e.g. Cor-ten steel). We have only to recall Michael Fried's 'Art and Objecthood' (1967) or Robert Morris's 'Notes on Sculpture' (1966) to see the importance of scale to this group of artists. The monumental scale, of which artists working with Lippincott were encouraged to undertake, was a result of the public nature of the works. Unsurprisingly, over one quarter of the artists shown in the 1974 *Monumenta* exhibition of outdoor sculpture in Newport, Rhode Island, exhibited pieces fabricated at Lippincott Inc.

In a 1975 interview, Donald Lippincott throws light on the working practices of the firm in their early days.[29] Lippincott reveals that Everett would often approach the artist to initiate the fabrication of a work, rather than have the artist approach them (notably, Barnett Newman, an abstract expressionist – a first-generation colourfield painter –, venturing into sculpture approached the firm to work with them).[30] As such, Lippincott Inc. often selected the artists with whom it worked, fostering a certain aesthetic, whether consciously or not. Everett explains, 'Some of the artists originally chosen [to work with Lippincott Inc.] were dealing with minimal forms in one way or another.'[31] Lippincott Inc. was unusual in the fact that it financially assisted the projects. Alongside this patronage of artists working at the facility, the company acquired fourteen acres of land in which it displayed the finished artworks. The on-site installation of finished artworks acted as a kind of outdoor showroom for potential buyers. Hugh Davis claims: 'The original concept of Lippincott Inc. was to provide both a fully equipped factory and financial support for the realization of large sculpture.'[32] Over the next three decades, the art fabrication firm established relationships with artists with whom it would continue to work.

Harry Braverman and 'the degradation of work'

The art fabrication firms emerged at the height of a specific phase of capitalism in which production and consumption were both speeded up and heightened, the effects of which were becoming manifest in American society. To understand this period, we need to look closely at the changing economic conditions leading up to the late 1960s moment. In 1974, Braverman published *Labour and Monopoly Capital: The Degradation of Work in the Twentieth Century*, a seminal book that examined the changing nature and the deskilling of work in the American labour process under monopoly capitalism. The move towards deskilling was not unique to the United States. Similarly, in Britain and Europe workers in manufacturing plants and elsewhere were becoming increasingly dissatisfied with the degradation of work occurring in the workplace. In the wake of scientific management and Fordist production methods, workers

were no longer able to apply a wide range of skills but were often subjected to repetitive tasks and stripped of their skills in the name of capital. This was not a phenomenon isolated to the sphere of work but extended far beyond the scope of Braverman's analysis and countless others' theses into the world of art.

Braverman proposes that the degradation of work primarily occurs within the division of labour. He claims: 'The separation of hand and brain is the most decisive single step in the division of labour taken by the capitalist mode of production.'[33] The division of labour is not new to capitalism; as Braverman acknowledges, Adam Smith's oft-cited detailing of the manufacture of pins from *The Wealth of Nations* (1776) evidences this fact.

> One man draws out the wire, another straights it, a third cuts it, a fourth points it, a fifth grinds it at the top for receiving, the head; to make the head requires two or three distinct operations; to put it on is a peculiar business, to whiten the pins is another; it is even a trade by itself to put them into the paper; and the important business of making a pin is, in this manner, divided into about eighteen distinct operations, which, in some manufactories, are all performed by distinct hands, though in others the same man will sometimes perform two or three of them.[34]

In his analysis, Braverman returns to the late nineteenth century to locate the origins of deskilling in the workplace. He attends to scientific management and, more specifically, the methods implemented by Frederick Winslow Taylor who cumulated a variety of scientific methods into one, the effects of which become known as Taylorism. I devote some space here to looking at scientific management and its effects from Braverman's analysis, to view the wider economic situation under which the production of art evolves (although this is in no way a simple mapping of scientific management onto art production).

Scientific management was a method of controlling production introduced in the late nineteenth century to achieve optimum production and increase the extraction of surplus. One of the distinctions between competitive capitalism and monopoly capitalism is that, in the latter, the capitalist makes money from surplus value, which becomes profit. The extraction of surplus is attributed to a form of exploitation of the worker. The surplus value

is, essentially, the difference between the wages of the worker and the price of the commodity sold. Therefore, the more productive worker (i.e. the one who assembles the fastest) produced more surplus than those who worked more slowly. It is in the best interest for the capitalist to employ more efficient workers in order to extract more surplus value and this is where scientific management assists. Scientific management involved controlling every aspect of production and took the form of the division of labour into piecework or the implementation of an incentive system where workers are given bonuses for achieving high targets. Braverman argues that Taylorism was a response to the problem of how to best control alienated labour.[35]

Alienated labour, in this sense, refers to the Marxian conception, in which a worker becomes alienated from the labour power (the expenditure of their own labour) that they put into making an object. Marx writes that throughout the process, the worker's labour 'constantly objectifies itself so that it becomes an object alien to him'.[36] Once the object is completed, the worker is further alienated from their labour at the point of exchange as their labour no longer belongs to them and confronts them as the produced commodity (this is the basis of commodity fetishism in which social relations are mediated by things). It is worthwhile noting this point as, to return to the art criticism already discussed, Greenberg's heralding of abstract expressionism, for example, is predicated on an unalienated form of artistic production.[37] The artist is not alienated from the painting that they produce because the visible labour of the artist is inherently connected to the artist through the fetishization of the artist's (hand) labour. The work confronts the patron as an object created by the artist rather than as a good produced by anonymous workers.

Taylorist methods attempted to gain optimum output from the workers by dividing up the work into smaller and smaller tasks. Taylorism was highly concerned with control, Braverman argues that the methods asserted 'the dictation to the worker of the precise manner in which work is to be performed'.[38] The worker no longer employed their own methods of labour but was asked to follow strict guides as to how a particular task was to be undertaken. Hence the scientific element: the optimum results were scientifically calculated to ascertain how long it would take to do certain tasks and then the 'correct' method for undertaking a job is delineated

from this data. Taylor dictated that the control must move into the hands of the management, who would determine each step of the process.[39]

Braverman's analysis splits Taylorist methods into three principles: The first principle stated that the managers should gather all the traditional knowledge that was possessed by the workmen in the past. They then classified the knowledge reducing it to rules, laws and formulae. Braverman argues that this stage was concerned with the 'dissociation of the labour process from the skills of the workers'.[40] The second principle proposed that 'brainwork' be moved from the shop floor to the planning department. This is a key point from Braverman's thesis. He argues that, within this principle, *conception* was separated from *execution*, not *mental* from *manual* labour as it is often interpreted (Braverman claims that mental labour was itself subjected to the separation of conception and execution.) He argues that the dehumanization of the labour process became crucial for the 'management of purchased labour' within the operation of the separation of conception and execution. Finally, the third principle consisted of providing the worker with fully specified instructions for each task in the form of information cards. The instructions were planned ahead by management. Braverman argues that the 'use of this monopoly over knowledge [was] to control each step of the labour process and its mode of execution'.[41] Braverman's thesis acknowledges an increasing deskilling of the craftworker in particular, which led to a separation of execution and conception in work. This deskilling then has a degrading effect upon the workers. Braverman proposes that the entire working class was lowered and deskilled through the implementation of scientific management.

Fordism as ideology

Discussions of Taylorist control often go hand in hand with those of the Fordist assembly line, which is usually considered as a historical extension of the piecework so meticulously delineated by Taylor. In 1913, Henry Ford, owner of the Ford Motor Company, put to work an assembly line that was capable of mass producing the Model T motor car, at the Highland Park site in Detroit. The following year he implemented the five-dollar (eight hour) working day, which

was crucial to his success. In *The Condition of Postmodernity* (1990), David Harvey writes that 1914 is the 'symbolic initiation date' of Fordism.[42] It is important to stress that Ford himself did not invent the assembly line. His engineers developed an assembly line to mass manufacture the Model T, through experimenting with and adapting the existing technology (reportedly found in slaughterhouses). However, Ford was the man who changed the face of history with the particular implementation of this technology in automobile production. The assembly line affected the mode of worker employment and the nature of labour in the plant. The new machinery became a worker substitute in many ways. As Terry Smith writes in *Making the Modern: Industry, Art and Design in America* (1993): 'The multiple-purpose machines embodied the skills that had, for centuries, been the province of the craftsmen … Rather, they concentrated on quite particular partial skills, certain moments in what used to be a sequence of creative labour, the frozen sections susceptible to separation, reduced to a simple motion, untiringly, infinitely repeatable.'[43]

The machinery did not make the worker completely redundant. The upkeep and monitoring of the machines remained a human job and the labourer became another cog in the machinery, completing repetitive tasks on endless production lines on a much larger scale. Note that the terms 'separation' and 'repetition', associated with the Taylorist division of labour, appear in the quotation from Smith. Although there are similarities in how the labour was being divided, Smith argues that Fordist production methods were distinct from Taylorist systems because Taylor viewed the parts in terms of the *whole* process (including the work force); whereas Ford placed emphasis on the function of the *machine* with 'minimal human intervention'.[44] Distinct from the approach of Taylor, Fordist production methods intensified the intervention of the machine within the labour process, leaving the worker with minimum skills.

In his *Prison Notebooks* (1929–35/1971), Antonio Gramsci writes that Americanism and Fordism were 'the biggest collective effort to date to create, with unprecedented speed, and with a consciousness of purpose unmatched in history, a new type of worker and of man'.[45] It is Gramsci's identification of a certain type of worker and man that contributed to the new social and economic model that became known as Fordism (Smith calls the subject of this society 'Fordized man').[46] Ford and Fordism are

separate from one another. Certainly, Ford applied new production methods and implemented the five dollar, eight hour day but it is the *effect* of Ford's changes on the workers that ultimately transformed the wider socio-economic and ideological conditions within society. Gramsci's writings on 'Americanism and Fordism' in his *Prison Notebooks* addressed the question of whether the new production methods put to work in America constituted a new historical epoch. Harvey states that it was not until after 1945 that Fordism matured as a 'fully-fledged and distinctive regime of accumulation', which became a 'total way of life'.[47] By the 1960s, Fordist ideology was embedded in the consciousness of American life. It is against this backdrop that the art fabricators discussed here emerge.

Art fabrication and the labour process

Contemporary accounts of art fabricators often overlook the wider context in which these firms operate. However, before turning to focus her analysis on the political climate, Bryan-Wilson notes the beginning of a decline in industrial production in 1960s' United States, perhaps stressing the need to retain some of these skilled labourers for art production.[48] As noted at the beginning of the chapter, these accounts prefer to read the fabricators in light of the new discourse on collaboration or in terms of art historical narratives, such as the quest for an industrial aesthetic, or the somewhat tiresome attribution of deskilling of art to a singular point of origin in 1917; that is, Marcel Duchamp entering his *Fountain* into the Society of Independent Artists exhibition. Roberts' *Intangibilities of Form* – the subtitle of which is 'skill and deskilling in art after the readymade' – is a case in point.[49] Although he references Braverman's thesis, Roberts asserts that deskilling in art is not the same as that of wider production due to artistic labour's categorization as unproductive labour (to which I am in agreement). Art, in this case, is not subject to the law of value unlike objects of productive labour (i.e. everyday commodities). He further adds that artists are not 'blocked' from the machinery of production.[50] Of course, some of the artists who worked at Lippincott Inc. were also skilled in welding, for example, but the fabricators allowed them access to industrial machinery and a scale they could not attain in their own studios. The works that Roberts focuses on are

the readymades and conceptual art; his analysis is focused on the labour and skills of the artist (which transition from the traditional craftwork of the artisan to immaterial skills, as in conceptual art) while retaining art's relative autonomy from the economic base. As such, Roberts does not consider the (presumably) productive (waged) labour of the workers employed by art fabricators, such as Lippincott Inc., neither does he fully consider the wider ideological implications of a capitalist mode of production that intends to deskill the worker on artistic practice.

In developing an economic theory of art, Dave Beech further complicates a straightforward response to the question of whether or not contracted labour in art is productive labour.[51] He notes that artists' assistants *may* be understood as productive labourers, however, the nature of art and its 'economic exceptionalism' complicates any simple understanding as a work of art is not the same as a mass-produced commodity whose value is based on the expenditure of labour time. However, in working through this problem, Beech notes that, when a company outsources maintenance to contractors, the labour of the workers is productive because the productive capitalist is the final consumer. Thus, we could understand the labour that is undertaken by a (presumably profitable) fabrication firm that employs wage-labourers as productive. My intention here is to show that, although unique in manufacturing works of arts for artists, Lippincott Inc. also functioned as a profitable business that employed skilled (non-art) workers from industrial production backgrounds. As such, while acknowledging that Lippincott made works of art (and associated problems for its economic analysis), it is possible to read the emergence of the fabricators and the working practices in terms of the wider implications of the deskilling thesis.

The working processes of the art fabrication firms have been largely overlooked in art discourse. The firms employed labour processes that were also subjected to a division of labour. The quest to be aligned with manual work is further visible in the language adopted by artists in this period, for example, Morris's 'repeated use of the word automation' signifying the wider deskilling in production and Andre's likening the artist to a Fordist assembly-line worker.[52] The artists may be engaging with 'high-end design';[53] however, the engineers and labourers in the art 'factory' (Lippincott) still have their work divided. In a 1975

interview, Donald Lippincott spoke about the typical division of labour within Lippincott Inc.[54] There is the initial consultation between himself, Eddie Giza (the workshop manager) and the artist, followed by the manufacturing of the artwork, which Lippincott separates into three stages. First, there is the 'layout' stage, which comprises of two workers whose sole task is the laying out and cutting of the material. The welding group undertakes the second stage. Lippincott explains that there are normally four or five workers in this group, headed by Robert Giza. The third stage is the finishing, which mainly consists of sandblasting and painting. Painting was Bobby Stanford's role from which he rarely deviated.[55] Lippincott claims that sometimes, rather than being divided into the three stages, one man *may* work on an entire piece.[56] In the same way that Taylorist methods intended to combat alienated labour by dividing work, having a craftworker devoted to one piece at Lippincott may have raised questions regarding authorship. Furthermore, these were tasks that required specific skills. Lesley Maitland, writing about Lippincott Inc. in 1976, establishes the division between artist and worker: 'The artist contributed his time and ideas, while Lippincott furnished the materials and the workmen that the artist would need.'[57] In the same article, Robert Giza (a worker at Lippincott) confirms this demarcation: 'At an important stage, if we're bending something, the artist is here to say "more" or "less"... We're like their hands, or like seeing-eye dogs.'[58] Furthermore, Lippincott did not employ artists; these were workers who were trained in specific skills within their own industries prior to coming to art fabrication. Similarly, Gemini G.E.L also divided labour into three areas and assigned a 'chief collaborator' to oversee each project. Stage one of Gemini's production consisted of the artist defining the project; stage two translated the idea into proofs and prototypes; and the final stage was the production of editions.[59]

Oldenburg's 'Mitt'

Each artist worked in different ways with the fabricators they employed. Roxanne Everett stated in 1975: 'I tend to consider our "adjustment" to the artist's individual personality and specific technical requirements an overall challenge. Each artist has his

own singular approach to our ambiance and to the technology itself.'[60] It is worth noting the centrality of technology to this company that dedicated itself to large-scale metal sculpture. In *Large Scale: Fabricating Sculpture in the 1960s and 70s*, we are privy to certain artists' working process through documentary photographs and commentary.[61] In this case, the production of Claes Oldenburg's *Standing Mitt with Ball* (1973) is documented. It is worth recounting the stages for the purpose of understanding the process of making a work at Lippincott. The first stage presented is Oldenburg's original model made from an altered and painted actual child's baseball mitt brought to Lippincott, who then makes a wire frame for the cloth model. Once the cloth model is complete, a half-scale (6 feet) metal version is made. We are told that the half-scale work 'allowed Oldenburg and the Lippincott crew to explore the use of lead for the lining of the mitt'.[62] At full scale, the subsequent stages become more machine-reliant. Once the quarter-inch-thick weathering-steel shell is made, it is put into the brake press for shaping (notably, in the accompanying image in *Large Scale* Oldenburg is onlooking, arms folded). Further shaping then takes place in the roller, which determines the curvature; in both of these stages, due to its scale, mitt is suspended from a crane. The laying out of the 3/16 of an inch thick lead sheet is undertaken separately. It is roughly cut to shape and then laid on a bed of sand to support it during the forming process. Eight men are involved in this process, including Oldenburg who appears to be watching. We see the ball being pressed into the lead to create the interior of the mitt's shape, while 'the crew works to support the lead form by packing sand underneath'.[63] The formed lead lining is then placed into the formed steel shell by crane, which acts as a cradle to return it to the shop for finishing. Once returned, we see the patron (Agnes Gund) and Oldenburg with the unfinished sculpture, ball now in place. During the finishing process, we are told that 'Mitt required many hours of Oldenburg's observation, comment, and direction' alongside an image of Oldenburg sat in a director's chair while watching a worker finishing his piece.[64] The final image that accompanies the discussion of *Standing Mitt with Ball* in *Large Scale* is of the piece installed in Gund's garden. At each stage different workers (and different number of workers) are seen working on the piece. Oldenburg acts as an overseer (especially in the final stage) where, we are told, he observes

for hours and comments on the finishing of the piece, while a Lippincott employee labours.

However, other artists used Lippincott in a different way. Bryan-Wilson discusses Morris's employment of Lippincott to install his *Robert Morris: Recent Works 1970* exhibition at the Whitney Museum of American Art.[65] Morris chose the materials (concrete blocks, timber and steel), had them cut or made to scale (as in the case of the concrete blocks, which were actually plywood core boxes, manufactured at Lippincott, due to the weight restrictions in the gallery) and then invited the installers to leave the installation up to chance. Bryan-Wilson writes: 'The pieces were made partially by chance – the workers rolled, scattered, and dropped concrete blocks and timbers, then left them to lie as they fell.'[66] The images of the installation included in Bryan-Wilson's book sometimes show a cigar-smoking Morris as 'worker' – for example, operating the forklift truck (an African American worker is also seen moving the dolly from underneath the load-bearing forks[67]) – but at other times, akin to Bryan-Wilson's reading, although he is touching the materials (leant against a wooden timber, smoking a cigar), we could also read Morris to be overseeing the installation. Notably, the images that show the 'heavy work' omit Morris. The install took a lot of machinery and manpower, due to the cumbersome nature and scale of the materials installed.

Conclusion

The parallel with the separation of execution and conception from Braverman's seminal analysis of the deskilling of work in the American labour process is explicit in Lippard and Chandler's aforementioned opening statement ('As more and more work is designed in the studio but executed elsewhere by professional craftsmen') and in the above examples of both Oldenburg and Morris. The dematerialization of art could thus be considered as an effect of the ideological changes within mid-twentieth-century American society. If we interpret Lippard and Chandler's proposition in terms of Braverman's thesis, within artistic production the artist takes control of the idea (which is a role akin to the manager rather than the factory worker). The craftsperson who executed the work is, by implication, positioned in the role of the worker. The worker,

in this relationship, is not necessarily subjected to the same kind of deskilling as the worker in a manufacturing plant; production for art is distinct from mass commodity production due to the one-off nature of the pieces being made. However, the workers are still wage labourers employed by Lippincott. Contrary to workers in a mainstream manufacturing plant, the workers within the fabricator models still retain their craft knowledge; it is the fabricator's knowledge and expertise that is often purchased. As we have seen, the labour is still divided into tasks; unlike mass production these are non-repetitive (unless producing editions, of course). The person who is being deskilled in this equation is now the artist, a role traditionally associated with the acquisition of skill and craft knowledge. In essence, one could argue that the artist deskills him/herself through contracting labour. Writing in August 1975, the artist Clement Meadmore stated:

> Every work of art includes elements of art and elements of craft and in many cases the two are inseparable (the artist's touch, etc.). There are also artists including myself in whose work the execution (or craft) is completely separate from the art (or conception), and in such cases the execution is a matter of the highest possible excellence and precision. The advantages of working with craftsmen and technicians such as those at Lippincott are the possibility of a degree of precision beyond the capabilities of the artist, a scale beyond the limitations of the artist's studio and equipment, and the freeing of the artist to work on new projects.[68]

There was a fundamental shift in the way in which American artists began to work in the 1960s, which art historians such as Buchloh and Krauss, acknowledge as a rejection of the dominant aesthetic autonomy being taught and promoted in American art schools and discourse. Within this period artists began to work differently, exposing the processes of making and employing the hands of others in doing so. While more contemporary art historians like Bryan-Wilson have understood the alignment of artist with worker as a political move against the backdrop of the Vietnam War and a demand for equal rights (e.g. for women, black and Hispanic artists), including fair pay. This chapter reintroduces the economic to the ideological context under which these artists worked. In

looking closely at a seminal economic text contemporaneous to the period in which artists are working with fabricators, the dominant working models (in which deskilling methods are employed) can be seen in tandem with the model of American ideology known as Fordism. Not only do artists begin to use the language of this economic context, but they also begin to replicate and employ the labour of industry.

In the mid-1960s fabricators began to manufacture work for artists, creating businesses devoted to art making; for the most part, this practice was unquestioned. Those art historians with more formalist leanings will make the argument for the industrial aesthetic as the motivating factor in the shift to artists working alongside industry.[69] However, we have to question why artists began to extensively utilize fabrication methods in 1960s/70s America. Was it due to the large-scale nature of art production (as Lippincott suggests), an increase in public art in US urban centres (as Suzanne Lacy acknowledges) or something else?[70] This period was a cumulating moment for the deskilling of the worker in the production plant and the new models of manufacture did not belong solely to the workplace but filtered into everyday life through Fordist ideology. Art did not remain untouched by this new way of life. The political atmosphere within the art world, typified in the establishment of the artists' unions and the visibility of the feminist and black rights movements in art, all signify and contribute towards the changing ideology of American capitalism.

Of course, the fabricators worked differently to practices employed in mainstream industry. As opposed to dominant labour models, while the labour is still being divided into tasks as with Oldenburg's *Mitt*, in the case of the fabricators, we have seen that the craftsperson is not being stripped of his/her skills. In some ways, the labour within a fabrication firm is more interesting than in industry at large. The artist deskilled him/herself through dividing and contracting out their labour. It is the artist who employed the skills of those involved with industrial production. Braverman argues that the work of the self-employed (i.e. handicraftsmen, artisans, tradesmen etc.) does not constitute productive labour, as their labour is not exchanged for capital. He puts forward that the self-employed do not sell their labour power and do not directly contribute to the increase in capital arguing that their labour is, therefore, outside of the

capitalist mode of production.[71] The artist could be considered in this category. However, the artist employs productive labour to manufacture his/her work. Due to the nature of the labour within a work of art manufactured by a fabricator, but conceptualized by an artist, the productive and unproductive labour cannot be objectively distinguished within the object made. The labour that the artist undertakes is that of mental labour: the ideas. Rather than learning an industrial trade, some of the artists in question purchased the labour power (and knowledge) of others in order to manufacture their work. Therefore, we can ascertain that, within the manufacturing of these large-scale works of art, the conception and execution stages of both the manual and mental labour were, to some degree, separated.

Looking closer at the working process further problematizes the rejection of the autonomy fostered in modernist medium-specificity. While Morris's intentions were to hand over the installation of his Whitney show to chance, the reality is one of financial exchange in which Lippincott workers are paid to, effectively, 'do their job'. If we strip back the layers, the relationship is not one of equivalents, but one of employer and employee. In separating conception and execution, does the artist replace aesthetic autonomy with a new form of fetishism in which the artist's ideas are now prioritized? The labelling of Oldenburg's 'director's chair' (in which he observed the finishing of his piece) with the word 'Mittseatt', although meant as a joke, is telling as to who was really in charge in the artist–worker relationship. We might be left to question whether the artist truly deskilled within this period or, through trying to align themselves with industrial workers, did the artist, in fact, unintentionally begin to reskill in the white-collar working practices of management? In Chapter Three, the role of the artist as manager will be looked at in relation to the context of neo-liberalism and the contemporary art practice of Thomas Hirschhorn.

Lippincott's legacy

The period discussed above allowed for a unique business model to emerge, as Jonathan Lippincott states: 'That era embraced a unique and potent combination of artistic, cultural, financial and political circumstances that aligned perfectly with Don's desire

and the company's ability to fabricate large-scale and public sculpture.'[72] Just as we understand art as reacting to the economic and ideological conditions of capitalism here, in evoking the dialectical model of the economic base/superstructure, businesses – including art fabrication firms – can also be affected by changes in the artworld and the wider economic shifts. Lippincott Inc. is no exception. While the company continued to manufacture for artists in its 'art factory' into the 1990s, the decision was made in 1994 to reconfigure the way in which the business worked. The firm closed its shop floor in North Haven and set up as Lippincott LLC, working with other workshops. Artists wishing to work with an increasing variety of new technologies precipitated the change.[73] The shift in the nature and the aesthetic of public art in the 1990s also meant that there was no longer the same demand for large-scale metal sculptures. The fabricators expanded their repertoire, which forced them to reassess their own working practices. The following chapter introduces a newer model of fabricator emerging in the 1990s: the facilitator.

CHAPTER TWO

Neo-liberalism and the facilitator: Mike Smith Studio (1989–)

Dedicated art fabrication firms emerged within the United States at a particular moment in capitalism, in what we might now understand as the twilight of Fordism. The accompanying ideology took its lead from the deskilling of manual work under the watchful eye of scientific management implemented earlier in the century, and which resonated in artistic practice. However, while the model of art fabrication firm discussed in the previous chapter was becoming established, capitalism had already started to take notice of the criticisms aimed at it. The turning point began as early as 1968, which often functions (sometimes inaccurately) as a symbolic date for social and political unrest, particularly in the West. By the 1990s, the effects of a changing capitalism (responding, in part, to its critique) could be seen in working models, management discourse and, subsequently, as this chapter will discuss, in artistic practice. Before turning to the emergent model of art fabrication business in this later period, let us first remain with Lippincott Inc. for a little longer.

In 1994, Lippincott Inc. reconfigured their working model to create Lippincott LLC. The change is described on the company's website:

> In late 1994 they [Alfred and Donald Lippincott] closed the factory in North Haven and began collaborating with other

companies in the New England area, bringing in Lippincott projects and working closely with key people at these firms to complete them just as they had at their own factory. It worked, and from 1994 to the present, Lippincott's, LLC has been consistently busy directing and participating in the construction and conservation of large-scale metal sculpture. This team approach had the added benefit of bringing fresh ideas and new methods and capabilities to the table; a serendipitous cross-pollination that has enabled the Lippincotts to realize some of their most exacting work to date.[1]

The company shifted from one of manufacturing (plus sales/exhibition on the grounds), using the traditional, crafts-based and industrial skills described in the previous chapter to a model reliant upon the relationships and project management skills garnered throughout the company's twenty-eight-year existence.

Lippincott Inc. was not the only US fabrication firm to undergo a restructuring. In 2010 Carlson & Co. (a fabricator who worked on Jeff Koons' ambitious *Celebration* series) closed down due to the recession, but later re-emerged as Carlson Arts LLC. Both Lippincott and Carlson and Co. chose to opt for the Limited Liability Company status, which is understood as a hybrid enterprise (bringing together characteristics from different business models) and which protects the members (owners) from personal liability for any company debts. The companies would have always been susceptible to a certain amount of flux due to the nature of the art market, but this change to LLC is, perhaps, demonstrative of the unstable nature of art fabrication within the contemporary period. Presumably, the (financial) risk associated with this industry precipitated such a change.

Prior to the 2010 closure, in a roundtable discussion for *Artforum*'s 2007 'Art of Production' issue, Ed Suman (principle, Carlson and Co.) acknowledged the shifting landscape of art manufacturing. He claimed that the site of production was becoming 'increasingly dispersed' and claimed that the role of the fabricator was 'being broadened to include fairly complex types of contracting, subcontracting, and sourcing, sometimes on an international basis'.[2] Within art fabrication he also noted the increasing importance of project management.[3] Similarly, Lippincott's LLC states that post-1994, it began to work 'in an altogether different way'.[4] It could

be conceived that time was always against the older fabricators, whose businesses emerged in a transitional period of capitalism and also a transitional moment of art. While there are, of course, still material, sculptural artistic practices in contemporary art, as the last chapter testified, the 1970s onwards witnessed a broadening of what constituted 'art', as it began to 'dematerialize' into more performative, temporary projects. The difference between Morris's performative install and Oldenburg's *Standing Mitt with Ball* (1973) is a case in point. In the gap between Lippincott's establishment and the decision to change its working practice there also arose a change within working practices more widely under capitalism.

The fundamental changes in the working practices of established art fabrication firms since the 1990s evidences a shift in the landscape of art making more widely. This chapter charts these shifts in relation to the changing context of work within the neo-liberal period, while looking to a younger studio that established itself in the 1990s: the Mike Smith Studio in London. While the older fabricators were forced to either close or adapt to the new conditions of neo-liberal capitalism, within this context (and prior to Lippincott and Carlson's restructuring) Smith's studio model emerged. The studio embedded the types of practices to which the old fabricators had to adapt into its business model from the outset (i.e. outsourcing, project management) providing an updated framework for art production to survive under neo-liberalism. The Mike Smith Studio in London could be regarded as the younger kin of the fabricator with its, or more aptly Mike Smith's, new title of 'the facilitator'. Akin to its US predecessors, the studio emerged under particular economic and social conditions in Britain, a time in which British industries and manufacturing were being made redundant or relocated overseas in search of cheaper labour. Although contentious, this chapter argues that the neo-liberal context fostered and allowed for small businesses like the Mike Smith Studio to emerge within 1990s Britain.

The Mike Smith Studio

In 1989, Mike Smith graduated from Camberwell College of Art in London with a degree in fine art, specializing in painting. While studying, he worked as an assistant to the painters Christopher

Le Brun and Ian McKeever. He later assisted the sculptor Edward Allington, which is from where Smith claims he developed his knowledge of different materials.[5] Around this time, Smith inhabited an artist's studio on Jacob Street alongside his peers Anya Gallaccio, Damien Hirst and Angus Fairhurst. According to Gallaccio, Smith was known for his practical knowledge, even at Jacob Street, and was often enlisted to help his neighbouring artists with the practical side of realizing their works.[6]

In these formative years, Smith's role could cautiously be analogized with that of the journeyman, bringing his skills from studio to studio. Once established, the Mike Smith Studio would then list Allington, Hirst and Gallaccio among the artists with whom it works. On graduating, identifying a gap in the market for a studio devoted to assisting artists, Smith started his own business. His first recorded projects in 1988 were with artists such as Hirst, Gary Hume and Gillian Wearing. In 1990, Smith established the Mike Smith Studio in London, housed in an old gasworks premises on Old Kent Road. The artists associated with the Young British Artists (YBAs) movement made up a large part of the studio's initial clientele and, throughout the years, have continued to work with the studio. Like Lippincott's 'large scale' public sculpture (some would say monumental) aesthetic there is an aesthetic that accompanies the Mike Smith Studio.[7] David Batcherlor claims that, 'if someone dropped a bomb on Mike Smith's studio, it would change the face of London's contemporary art world'.[8] This is a polished, manufactured, minimalist aesthetic that appears in Hirst's vitrines and Darren Almond's clocks to Mona Hatoum's *Divan Bed* (1996) or Rachel Whiteread's ambitious Fourth Plinth Commission, *Monument* (2001).

The subject matter of the YBAs has been theorized in terms of the 'philistine', associating it with non-specialist, sometimes vulgar, working-class everyday culture.[9] However, the aesthetic of those artists working with the studio presents something different. The desire for a polished, clean-lined, manufactured aesthetic might further be traced back to the some of the group's influences, among which are listed the readymade, minimal artists and Jeff Koons.[10] The artists whom the YBAs cited as influences had established relationships with fabricators (including Lippincott Inc. and Carlson and Co.) In fact, Carlson and Co. was mid-project on an extremely large-scale Koons work when the company folded. Despite the

generational difference, the influence of Koons' work – coupled with the new model interdisciplinary fine art teaching from Jon Thompson (whose interest was the humanist European tradition) and Michael Craig-Martin (conceptual, everyday object American art) at Goldsmiths – formed the basis of a desirable aesthetic for this group of artists.[11] Mike Smith provided the skills (both immaterial and material) to realize this aesthetic.

Smith's business grew alongside the rising profile of the YBAs. From 1995 the studio employed two to three staff members, growing to over eleven in 1998 and steadily increased over the years.[12] The studio was created solely to assist artists with everything from the conception to the realization and exhibition of a work of art including consultation and installation services. Not unlike Donald Lippincott, Smith himself is at the heart of the process and is the first point of contact for an artist wishing to discuss the fabrication of a work of art. He employs a team of technicians that increased nine-fold from two in 1995 to eighteen in 2003.[13] The technicians come from a range of different backgrounds including fine art, industrial design, graphic design and engineering. When talking about the studio, it becomes clear that both Smith and Patsy Craig (a studio employee and author of *Making Art Work*)[14] think of the studio's work in terms of both design and engineering.[15]

Since the studio's incarnation, it has been involved in the making of a number of key British artworks; however, it maintains a low profile. The nature of artistic production (by the non-artist) has been historically guarded. The notion of authenticity in sculpture that requires many hands in its production has been questioned in the past, for example, in the notorious example of the (unauthorized) posthumous casting of Rodin's work. Similarly, the role of artists' assistants has been obscured and guarded (particularly for painters) in order to preserve an image for the market. There is also a further distinction made between fabricators and artist's assistants, the latter of which are often vetoed from the list of acknowledgements.[16]

The Mike Smith Studio is sometimes mentioned in accompanying exhibition notes or on information panels alongside the works it has fabricated, but largely the studio's involvement is behind closed doors. As such, embedded into the studio's practice is its ability to be discrete in order to maintain its clientele. Despite this discretion, the studio appeared more frequently in the art press in the early 2000s, with Smith himself agreeing to interviews and taking part in

roundtables on art fabrication. In 2003, the studio was the subject of a book, edited by an employee of the studio – Patsy Craig – titled *Making Art Work*.[17] This visibility accompanied the artworld's endorsement of collective artistic practice in art. The presence of Smith in these art publications, makes apparent the studio's role in the history of British art, particularly that of the 1990s.

The context

The 1990s was set against a tumultuous political and economic climate in Britain. The YBAs rose to fame (or notoriety) within the context of Thatcherite Britain and became established during the transitional phase to New Labour. While Julian Stallabrass has already presented a thorough account of this context in relation to the YBAs emergence, it is worth recounting some of the key aspects here.[18] Ten years after her initial election – after privatizing and selling off state-run industries (i.e. coal, gas, telecommunications and housing) and Britain's involvement in the Falklands War – in 1989, Britain officially went into economic recession. The privatization of industry was part of a neo-liberal agenda that encouraged competition between private interests to create a thriving market.

In 1990, Thatcher's prime ministry was challenged, with John Major eventually taking the post and retaining it until 1997. In 1993, the economic recession was announced, after which Britain bore witness to mass unemployment. The changes in the economy, such as privatization, mass unemployment and the weakening of trade unions (an ideological attack on collectivity) initiated by Thatcher in the early 1980s, had a profound effect on British society. Continuing the post-war legacy discussed in the previous chapter, in this period industrial labour – the home of the British working classes – was devalued and dismantled. As Smith's studio began to employ staff in 1995, we can deduce that Smith was getting enough work to need the extra help and, by 1998, he had over ten employees working for the studio. So why did a firm like the Mike Smith Studio succeed in this climate, when other fabricators elsewhere were beginning to struggle?

The economic downturn forced patrons like Charles Saatchi to look at the lesser-known artists. The year 1991 proved a bad

financial year for his advertising firm Saatchi and Saatchi, during which it lost £64 million.[19] Saatchi was forced to take a fifty per cent pay cut and sold off ten million pounds worth of his art collection that he had built with his then-wife Doris. He then turned to buying contemporary British art by young, not-yet-established artists due to this financial set back. Thus beginning his relationship with the YBAs. This patronage subsequently provided capital for the manufacture of certain works. Artists were no longer afforded individual grants from the state while private businesses were offering sponsorship or, in the example of Saatchi, buying and exhibiting their work.

Furthermore, Smith's success coincided with the transition to the New Labour government in 1997 during what has been referred to as the 'golden age' of the arts in Britain. Within New Labour's time in government, there was increased funding for the arts, which accompanied an agenda to make the arts more socially inclusive. Although some of the changes made to the arts were problematic, free entry to museums and the opening of Tate Modern in London may be counted as some of the more successful changes to come out of the adopted neo-liberal policies in the course of Tony Blair's prime ministerial terms. Throughout this time the (presumed old-fashioned, isolating) term 'heritage' transitioned through 'culture' (still perceived as elitist) to the younger, hip term 'creative' that is still redolent of a certain 'type' today (more later). Of course, capitalism was lurking in the shadows of this seemingly benevolent turn in which the social benefit of the arts, presumably for the working class, was being promoted. The incoming New Labour government was aware of the shift from manufacturing industries to the knowledge economy; in *Cultural Capital The Rise and Fall of Creative Britain* (2014), Robert Hewison suggests that the change in direction to an arts-focussed agenda was a way for Labour to remain relevant when its historical supporters – the industrial working classes – were rapidly disappearing.[20] The government had to find a way to make the knowledge economy work for Britain; in 1997 the 'creative industries' were conceived, with a 'mapping document' released the following year, cementing a direct relationship between the arts and industry.[21] As Hewison points out, with the implementation of the creative industries, culture became viewed in economic terms, with the citizen becoming a consumer, and experiencing social relations through the market.[22]

The changes in Britain under neo-liberal New Labour afforded new opportunities for the arts. Housed in the symbolically charged, historical site of manual labour – a converted power station, in 2000 the new Tate Modern opened. The grand entrance to the gallery – the Turbine Hall – which scales the entire height of the building, presented a home for revolving large-scale art commissions, beginning with Louise Bourgeoise's three monumental towers – *I Do, I Undo, I Redo* – in 2000. London now had a dedicated space in which large-scale ambitious projects could be sited (and a fabricator up to the challenge). The first question for any artist commissioned to produce a work for the Turbine Hall is how to make sure their work is not lost in such a vast space.

Tate Modern was not the only gallery to reuse a site of industrial labour in this period. The YBAs 1988 inaugural exhibition – *Freeze* – led by Hirst was situated in the Port of London Authority Building in Surrey Docks, southeast London. The young artists took advantage of the developing sites and secured sponsorship from London Docklands Development Corporation and the property development firm Olympia & York, in addition to being given space in which to put on the show. Three years prior to *Freeze*, Saatchi had similarly chosen a disused paint factory as the site of his first gallery on Boundary Road, London. It was here that he had shown the work of the American minimalists – such as Judd – alongside abstract painters such as Cy Twombly and Andy Warhol. The Mike Smith Studio's premises are also situated in an old industrial building, an old gasworks. This repurposing of old sites of industry for the arts is significant in the transition from industrial to knowledge production in the UK.

Tate Modern's Turbine Hall was not the only space to begin rolling temporary commissions for contemporary artists. In 1998, the Royal Society of Arts began the Fourth Plinth Project. Commissioned by the Cass Sculpture Foundation, the project produced three contemporary art works to consecutively occupy the empty fourth plinth in Trafalgar Square (due to insufficient funds the originally proposed William IV statue by Charles Barry was never realized). These works were Mark Wallinger's *Eco Homme* (1999), Bill Woodrow's *Regardless of History* (2000) and Rachel Whiteread's *Monument* (2001). The plinth stood empty again after Whiteread until the Greater London Authority took control of the square and began the Fourth Plinth Commission

competition from 2005 onwards. Similar to the Turbine Hall, the Fourth Plinth occupies a significant location and demands a designated scale with which to work. The spectacular nature of these sites means that it would be difficult for an artist to produce work alone. Commissions that successfully utilized the entire space, Olafur Eliasson's *The Weather Project* (2003–4), Doris Salcedo's *Shibboleth* (2007–8) and Ai Weiwei's *Sunflower Seeds* (2010–11), for example, were produced using contracted labour. And the Fourth Plinth Commissions are no different; it was the site of Mike Smith's most talked-about project: Whiteread's *Monument*.

The 'new spirit' of capitalism

While Britain was struggling to conceive of a way in which the arts would produce economic value, a wider look at the ideological changes in capitalism provided by Luc Boltanski and Eve Chiapello's *The New Spirit of Capitalism* (2005) provides another view against which to understand the shifting conception of creativity under capitalism.[23] Although focussed on France, Boltanski and Chiapello's analysis is valuable in mapping the direct relationship between larger ideological shifts and the material and economic conditions of work. Their thesis relies upon an analysis of management discourse from the late 1960s to the 1990s for the task of illustrating the inherent changes within capitalism.[24] The authors actively work against a particular conception of ideology in the French theory of the 1970s, which they argue reduced it to a set of 'false ideas'.[25] Despite their insistence that the new spirit is not a superstructural phenomenon, Boltanski and Chiapello's analysis becomes useful for looking at the ideologies emerging through the implementation of new management models (as in the previous chapter) due to the focus on management textbooks.

As discussed in the introduction to this book, the understanding of ideology used here is based on the Marxian conceptualization. The economic base (i.e. working models, such as those cited in this article) is understood to have a dialectical relationship with the 'superstructure' (law, art, politics) to which Marx argues that there 'corresponds definite forms of social consciousness'.[26] These forms of consciousness – ideas and beliefs – that stem from the dominant economic models in society are here referred to as

'ideology'. In Boltanski and Chiapello's analysis 'spirit' appears to be interchangeable with a more dialectical conception of 'ideology' as they state: 'The spirit of capitalism not only legitimates the accumulation process; it also constrains it.'[27]

Boltanski and Chiapello's thesis has not remained within the sphere of sociology or management studies. Its reception within contemporary art circles, particularly those concerned with art and social change, is noteworthy.[28] The appeal of the book to contemporary art theorists lies in the inherent connection that Boltanski and Chiapello identify between an ideological phenomenon within management models and the demands of the artist in the 1970s. This identification paves the way for a new model of capitalism that co-opts these demands as its own, evident in management discourse since the 1990s. It is within this period of change that 'Creative Britain' is coined and Mike Smith Studio is established (and during which time fabricators, such as Lippincott Inc., adapt and adopt new working practices).

Capitalist co-optation: The two models of critique

In *The New Spirit of Capitalism*, Boltanski and Chiapello present two models of critique identified within society and aimed at challenging capitalism found in management texts. These models of critique appear around moments of social and artistic change – namely, the 1930s and the late 1960s. Extending this interest in specific periods, their examination focuses on the ideological effects of capitalism on management discourse. For their research, Boltanski and Chiapello looked at two corpora of management literature (from the 1960s and the 1990s) focusing on the subject of 'cadres' (in its various guises from engineer to middle-management), comprising of sixty texts each. In addition to the above two periods (the 1930s and post-1968), they infer that a third 'spirit of capitalism' has come into being since the 1990s. The 'spirit of capitalism' is defined as 'the ideology that justifies engagement in capitalism'.[29] Each 'spirit' of capitalism identified within the management literature is demonstrative of how the subsequent model of management responds to each mode of critique. For example, the 1960s model

legitimizes the manager while denouncing a more familial model of the firm; subsequently, the 1990s model works against a rigid management model to adopt a more flexible approach.[30]

The first moment of critique – 'social critique' – is identified with post-1930s and the implementation of Fordism, while the second – 'artist critique' – occurs in the 1960s and is foregrounded in 1968.[31] The social critique challenges capitalism as a source of poverty among workers and for unprecedented inequalities (especially between the rich and the poor). It further criticizes capitalism for being a source of opportunism and egoism, which destroys collective bonds and solidarity by exclusively encouraging private interests.[32] The earlier US fabricators were founded at the end of this period of social critique, when the social critique was being absorbed and another critical model was beginning to emerge.

It is the second mode of critique that is of most interest for thinking about artistic practice within the neo-liberal period and the 1990s more specifically. Boltanski and Chiapello propose that the model of artist critique began to be co-opted by capitalism after 1968.[33] Within the artist critique, capitalism is criticized, first, for being a source of oppression. Second, it questions the freedom and autonomy of humanity; man is now subjected to the market and capital more widely. Finally, capitalism is criticized for being a source of disenchanted goods leading to disenchanted lifestyles.[34]

In *The Resources of Critique* (2006), Alex Callinicos suggests that Boltanski and Chiapello prefer the corrective over the radical mode of critique.[35] The corrective mode of critique comes from within the city (to which we will return) and is viewed by Boltanski and Chiapello as reformist. In its corrective form, the criticism aimed at capitalism is thus adopted by capitalism.[36] The corrective critique becomes the motivating factor for the changes in the spirits of capitalism. Capitalism utilizes the features of the modes of critique (in this discussion, the artist critique) in order to correct itself and appeal to those critical of it. Thus, it becomes evident how an economic model that fosters 'thinking like an artist' can exist within a capitalist framework. Clearer still, perhaps, is why the British government decided to embark on a journey to economize the arts, forming a new set of industries around the notion of creativity in the 1990s.

The type of worker emergent in this period can be assimilated with what Brian Holmes identifies as the 'flexible personality'

which, he argues, 'represents a modern form of governmentality, an internalized and culturalized pattern of "soft" coercion'.[37] The capitalist adoption of this personality is a new form of alienation from 'political society' in the sense that the flexible personality is a 'new form of social control, in which culture has an important role to play'.[38] Ultimately, Holmes views the co-optation of the artistic critique as an obscured form of control. The workers *appear* to be unalienated through the dissolution of the divide between production and consumption but they, in fact, remain under the control of capital. This returns us to the notion of unproductive labour, discussed in the introduction to this book.

The artist, historically, is associated with freedom, especially if we think about the mythological artist struggling to survive but doing what 'he' loves. In Marx's writings, the artist (alongside the housewife!) is exemplary of the unproductive labourer, as the artist does not produce profit for the capitalist system. Thus, in this formulation it is assumed that the artist's work is free from capital. Taking the artist as a model of worker for capitalist production (i.e. within the absorption of the artist critique) thus presents newer modes of work aligned with unproductive labour, which gives the *appearance* of freedom (from capital). The work no longer *looks* like productive labour, but that aligned with the freedom of artistic labour.

Furthermore, capitalism's co-optation of the artist critique adapts the capitalist model to embrace the freedom questioned by the critique itself. The shift to immaterial labour (the knowledge work that takes place at the Mike Smith Studio and other models to be discussed in subsequent chapters) further assists the illusion of non-work. Freedom, in a material, work sense, then transmutes into practices such as 'flexi-time', where the worker is afforded leeway in their working hours beyond a fixed pattern (i.e. 9 am to 5 pm). Working from home becomes another mode of work that allows the worker an apparent degree of freedom. The adoption of project-based work further blurs the rigidities of set working hours, as projects are temporary and deadline-focussed. The ultimate form of this freedom fostered under neo-liberalism is the blurring of the distinction between work and non-work as workers, for example, take their work home or work during their commutes. Through capitalism's adoption of the artist critique, cultural producers are not an exception from the division of labour (as the appearance

of unproductive or free labour might have us believe) but also implicitly tied to their work through offering their 'inner selves for sale'.[39] Over ten years later, it appears that the jig is up; this hidden control of work disguised as leisure is now widely acknowledged.

These new, flexible modes of work are in contrast to the strict monitoring of the Fordist or Taylorist principles in the early twentieth century (although monitoring is not really abandoned, but digitized). In *Fair Play: Art, Performance and Neoliberalism* (2013), Jen Harvie proposes craftsmanship as a way in which artists can resist neo-liberalism's encouragement of artists becoming what she terms 'artrepeneurs' (a legacy of Thatcherism in Britain).[40] In her analysis, neo-liberalism is understood as encouraging individual self-interest over social value. She draws on Richard Sennett's (problematic) notion of craftsmanship, with its romanticized association of craft with freedom and skilled expertise, for her definition of the term.[41] In Harvie's argument, artists should become more like craftspeople in order to resist the fast-paced nature of 'artrepeneurialism' (a term which she uses to refer to contemporary art making, which rewards entrepreneurialism, individualism, creative destruction and self-interested profit-making). In this understanding, craft-based production combines the skills of the hand with those of the mind, is associated with quality over quantity, and the skill of making things well. It is also aligned, for Sennett, with problem-solving.[42]

In an earlier chapter, Harvie concedes that only an 'extremely small number of expert collaborators enjoy the privileges and pleasures of highly skilled work'.[43] With the shift to flexible, immaterial labour, skilled work becomes the exception and not the norm. The Mike Smith Studio business model might thus be more aligned with the qualities of craftwork that Harvie proposes. She identifies three ways in which artists are resisting neo-liberalism: a network of affiliation and mutual support that challenges individualism and hierarchies; testing the beneficial effects of creative destruction by pushing them to their limits; and challenging the emphasis on profit and self-interest by connecting art practices to craftsmanship.[44] The notion of a network of support can be found in the relationship between artist and contracted studio; Smith's own network beyond the studio adds to this structure. Similarly, the final criterion, which aligns craft skills with contemporary artistic practice, can be seen in Mike Smith Studio's business model. Testing creative destruction is less clearly identifiable in the studio example; it is understood as

an effect of neo-liberalism with the shift to the knowledge economy cited as an example (i.e. the tearing down of old industries to create new ones). However, we might look to artists with whom Smith works to see how the boundaries of capitalism's destruction are pushed, such as Michael Landy whose infamous work *Breakdown* (2001) is cited by Harvie.[45]

To the final way (the alignment of artists with craftsmanship) Harvie adds 'socially collaborative' and 'egalitarian' to the qualities of artists whose practice is resistant to neo-liberal capitalism.[46] She cites Jeremy Deller as an artist who engages these qualities in his work, and whose 'craft' she sees as collaboration especially when it takes time, as in the *Battle of Orgreave*'s (2001) two years of planning.[47] However, in referring to the re-enactment, Harvie overlooks the paid employment of participants, which is understood in her argument as contributing to the work's egalitarian designation. The exchange of money for labour (the re-enacters were paid for their time in the *Battle of Orgreave*) does not seem to affect the understanding of the work as collaborative and all participants are, presumably, seen as equivalents perpetuating the social value of the work.[48] The hierarchical relationship between the named artist and around one thousand unnamed historical re-enactors and ex-miners is unquestioned. Furthermore, Artangel commissioned *The Battle of Orgreave* following an open call for proposals (it also facilitated Landy's *Breakdown*).[49] The addition of a commissioning agency contributes a further node to the network that made up this particular event.[50] Although Harvie evokes Deller's project as an example resistant to the individualism of the artrepeneur, a closer look at elements that made up the work perhaps moves us away from the traditional idea of craftsperson as collaborator and towards something more akin to the neo-liberal networker.[51]

Rather than resisting neo-liberalism, we can see how a model that embodies craft skills (and multiple pairs of hands) – problem-solving through making and quality, skilled work – could survive in the ideological context in which the creative industries were born, especially when Sennett states that 'all his or her [the craftsperson's] efforts to do good quality work depend on curiosity about the material at hand'.[52] Of course, this returns us to Smith's focus on materials (which is coupled with his knowledge of these) and problem-solving or, as he terms it 'designing solutions'.[53] The qualities of craft might employ a slower, thinking through of solutions in opposition to the

fast-paced, profit-focussed artrepeneur; however, it is the artist who employs Smith's studio in order to accommodate demand. Smith explains, in a 2012 talk given at the Architecture Association, that the 'dilemmas of the late twentieth and early twenty-first centuries is that the works are only made because there is an exhibition where the piece is going to go and curators think that making sculpture is like going to the supermarket'.[54] The craftsperson is implicated in the artpreneurial turn as much as the artist, but as a contracted worker.

The 'new spirit' of neo-liberalism

Boltanski and Chiapello's analysis is not without omissions. The key omission for this analysis is the inherent connection between the move to flexible, networked, creative management models and neo-liberalism. Arguably, the features within business models that Boltanski and Chiapello identify as originating from the artist critique are indebted to the implementation of a neo-liberal economy. In *New Capitalism? The Transformation of Work* (2009), Kevin Doogan views the omission of the concept of neo-liberalism from Boltanski and Chiapello's account as a critical weakness, despite their analysis being specific to France (the two main 'neo-liberal' countries being America and Britain).[55] Because of this caveat, the shift to flexible working models – evident in the 1990s management literature and associated with the 'third spirit' – appears out of nowhere, unrelated to the state or the wider economy.[56] The gap between the two, however, can be bridged by looking to analyses of neo-liberal capitalism alongside the period in which Boltanski and Chiapello claim that the third spirit manifests. In her *Third Text* article, Eve Chiapello refers to the period following the late 1970s, when the artist critique was subsumed into everyday business practice, as 'neo-flexible capitalism'.[57] Elements of Boltanski and Chiapello's artist critique can also be found within the economic model that David Harvey terms 'flexible accumulation'.[58] Harvey's concept of flexible accumulation is analogous to Chiapello's neo-flexible capitalism. The two economic models share features such as worker flexibility, the encouragement of an ethos of individuality and the employment of subcontracted labour or project-based work.

In *The Condition of Postmodernity*, Harvey delineates the features of the economy initiated by the neo-liberal governments

in both Britain and the United States, under Thatcher and Ronald Reagan, respectively.[59] Flexible accumulation is the economic 'regime' within the post-Fordist period; as such, Fordist production methods are in decline and the move to the service industry is increasing. Harvey states that flexible accumulation directly confronts the problems that a waning Fordism posed. In particular, the rigidity enforced on the markets and the mass production systems that lead to inflexibility in design.[60] Subsequently, flexible accumulation replaces the rigidities of Fordism with flexibility; whereas Fordist production methods dictated the market in many ways, the consumer directs production under flexible accumulation. This adoption of flexibility results in the implementation of new production processes.

The idea that a product can be quickly adapted to the market pertains to another feature of flexible accumulation. Harvey argues that flexible accumulation pays attention to changing trends and 'cultural transformations', while also reducing the half-life of a product (the time it takes the product to 'wear out'). On a visual level, Harvey suggests that flexible accumulation adopts the 'fleeting qualities of a postmodernist aesthetic'.[61] This adoption, he argues, includes the commodification of cultural forms, to which we could further add the creative industries, which directly ties the arts to the economy. The idea of the commodification of cultural forms is insightful and helps to explain how flexible accumulation fosters an economy in which artists or creative individuals become valuable. Within this model, artists are no longer the critical outsiders but rather, if we accept Boltanski and Chiapello's thesis, the criticality of the artist is adopted by the new capitalist economy. Harvey writes: 'All this has put a premium on "smart" and innovative entrepreneurialism, aided and abetted by all of the accoutrements of swift, decisive and well-informed decision-making.'[62] And this returns us to Mike Smith.

The 'great man': Mike Smith Studio and the 'new spirit'

The Mike Smith Studio's business model fits comfortably within the framework of Harvey's description of flexible accumulation. Harvey

identifies a change in business models that moves from a solid core of workers through to an increase in part-time or temporary workers and subcontractors in the 1980s. Moreover, the creative industries that are made up of 'small, flexible, indeed ephemeral micro-businesses that celebrated their creative independence' can be considered among these.[63] The Mike Smith Studio in its simplest form is a contractor; it takes on work commissions from artists but do not take any credit for it (the studio is not named as the 'maker'). It is in the mid-1990s that the newly restructured Lippincott LLC also changes its model to one that project manages. Harvey writes: 'Organised sub-contracting ... opens up opportunities for small business formation, and, in some instances permits older systems of domestic, artisanal, familial (patriarchal) and paternalistic ("god-father", "guv'nor" or even mafia-like) labour systems to revive and flourish as centrepieces rather than as appendages of the production system.'[64]

The Mike Smith Studio is one of the artisanal small businesses that has emerged and flourished from this move to flexible accumulation. It was founded during a time when the British government encouraged entrepreneurialism through the establishment of small businesses. An example of which is the Enterprise Allowance Scheme introduced in 1983, which provided an allowance of forty pounds per week to unemployed people who set up their own businesses (with Tracey Emin named among its recipients). Smith deals not only in labour but also in knowledge. He prides himself on his specialist expertise and, based on his knowledge of the art world, offers project management as one of his services. Echoing the rhetoric of New Labour's creative industries, Harvey writes: 'Knowledge itself becomes a key commodity.'[65] It is Smith's knowledge and expertise that makes his business unique in its specificity to art. Depending on the size and nature of the object being made, and again conforming to Harvey's model of flexible accumulation, Smith also employs temporary workers and subcontracts to other businesses with which the studio has links for particular projects. This is also the model to which the older fabricators have adapted. At the beginning of this chapter we saw Lippincott's business model reconfigured from a dedicated 'factory' space, with land to show public sculpture in situ to a business model now reliant on the relationships with other industries and artists built up throughout the firm's – and arguably Donald Lippincott's – career. Suman, from Carlson LLC, also noted

the growing importance of project management to the fabricator's toolbox.[66]

Boltanski and Chiapello argue that the adoption of the artist critique allowed for a new political community to emerge that is based on networks and projects, which they call the projective city.[67] This community is only identified in the 1990 corpus of business literature and thus its emanation coincides with neo-liberalism. They argue that various models of political cities coexist within contemporary society. Drawing heavily upon Boltanski's earlier work with Laurent Thévenot, Boltanski and Chiapello state that each city corresponds to a distinct 'logic of justification'.[68] Boltanski and Chiapello's spirits of capitalism are rooted in the idea of justice within the cities, in so far as models of critique are always backed up by justifications. They delineate 'high status' or a model of 'great man'[69] for each city, believing that disputes over justice always refer back to status. The great man is one who is powerful within the community and adopts an authoritative status; he is the person to whom to turn when a dispute arises. The example that Boltanski and Chiapello cite to illustrate this notion is to imagine the order in which people are served at the dinner table as a *'principle of equivalence'*.[70] Thus we can deduce that the 'great man' is the person to be served first.[71]

The projective city is relevant to this argument. The analysis presented here is not concerned with justification, as such, but with the ideology that stems from Boltanski and Chiapello's analysis of the management literature corpus.[72] Thus, the articulation of the projective city is useful for this discussion because the tropes associated with this city are ascertained within Boltanski and Chiapello's close analysis of management literature from the 1990s. Taking up Doogan's proposition, neo-liberal ideas evolve and disseminate through management discourse in this period; therefore, one should be cautious not to disregard Boltanski and Chiapello's identification of the cities, as the projective city is the site in which neo-liberal management ideology is revealed.[73]

Boltanski and Chiapello state that the projective city is a new 'general representation of the economic world' in the period when the new spirit takes hold.[74] In this model, the organization of society is seen to be in a project form; communication, reflexivity, engagement and working together are all key factors.[75] The 1990s management corpora further demonstrate an increase in the use

of the term 'network'. However, rather than basing their model of justification on a 'network city', Boltanski and Chiapello understand the architecture of the projective city as being more than simply a series of networks. The project is central to this city precisely because it is the moment that brings networked people together, if only for a limited period of time.[76] In this city, the organization of society is in project form. The status of people is measured by activity; the more active the person, the greater their status becomes. Status, in this community, is measured by communication, reflexivity, engagement and working together. The 'great man' is, essentially, the 'network man' or, as I understand it, the project manager.

The type of work undertaken at the Mike Smith Studio reflects that of the projective city: temporary, project-based commissions for different clients. Smith employs a team of workers who are engaged in numerous projects simultaneously. Smith's network is not limited to artists but also extends to outside help, for example, those from whom the studio source materials and galleries with which Smith works. Smith is at the heart of a wide network of British artists. His symbiotic relationship to the YBAs, particularly in the 1990s' 'Cool Britannia' period, further ties the studio's success to the neo-liberal context, albeit under the guise of New Labour's 'Creative Britain'.

While the US fabricators move to the LLC business model that allays personal financial risk, risk appears fundamental to the operational reality of the Mike Smith Studio. The studio is known for its risk-taking, Whiteread's *Monument* being the prime example; Patsy Craig claims that this is why artists are drawn to the studio while Smith refers to what they do as 'managed risk'.[77] Craig more candidly refers to it as 'maverick' claiming that the studio's risk-taking nature means that 'nobody in there [sic] right mind would have a studio like this, they just wouldn't'.[78]

Smith can be seen in the model of the autonomous, flexible individual associated with the projective city – the innovative, problem-solver.[79] To quote Smith on his working practice: 'I spend most of my day organising things and solving problems which is kind of the most interesting stuff, but there is a great satisfaction in letting people within the studio grow as well ... you know ... arranging a team of people and allowing them to have input.'[80] Smith is a problem-solver; to date, his most ambitious project is *Monument*, which he took on with no prior experience of the material from which the sculpture was to be made. Smith

recalls: 'It took us 18 months to realise a successful test model for [it] ... People got close to throwing in the towel. Eventually it worked out.'[81] Despite the manual skills employed in the studio's work, when discussing the role of the studio, Smith places emphasis on the knowledge work undertaken. He suggests that a large part of what the studio does (presumably Smith is referring to the manufacturing aspect) is readily available; 'what the studio does', he adds 'is the application of knowledge to design solutions to fabricating these strange works of art'.[82] It is interesting that knowledge and immaterial skills are valued over the manual, craft skills of making.

To return to Boltanski and Chiapello's definition of the 'great man' in the projective city:

> In the projective city they are not only those who know how to engage, but also those who are *able to engage others*, to offer involvement, to make it desirable to follow them, because they inspire *trust*, they are *charismatic*, their *vision* generates enthusiasm. All these qualities make them leaders of teams they manage not in authoritarian fashion, but by *listening* to others, with *tolerance*, recognizing and respecting *differences*. They are not (hierarchical) bosses, but integrators, facilitators, an *inspiration*, unifiers of energies, *enhancers* of life, meaning and autonomy.[83]

Facilitation is now par for the course in the projective, neo-liberal city. Of course, the proposition that Smith adheres to the great man is not based on terminology alone but what the role entails. Even those who do not entirely condone Smith's making works for other artists still recognize Smith's 'greatness'.[84] His greatness lies in the fact that Smith can solve a problem faster, or make something look more professional, than others: 'this man who can make your dreams come true'.[85]

Chiapello states that neo-management listened to the complaints of the artist critique and thus absorbed these. As such, managers are now encouraged to understand how artists work, as management changed in response to artistic critique.[86] The new manager is indebted to the co-optation of the 'artist critique', which allowed for the replacement of 'cadre' (the 1960s' rigid management

style) with a new conception of manager. The new manager is a 'visionary', a 'team leader' and a 'source of inspiration'; they see the manager as a 'network man'.[87] This manager shares the information gleaned from his networks, rather than retaining it for his own gain.[88] Boltanski and Chiapello state that: 'These "innovators" have scientists, and especially *artists*, as their models.'[89] The Mike Smith Studio comprises elements from both, with Smith employing staff from a range of backgrounds from fine art to engineering. As a problem-solver, Smith is someone who incorporates the scientific while coming from an artistic background.[90] He does not even have to look to the 'model' of the artist as he already embodies the role. Perhaps the Mike Smith Studio is the ideal business model under this specific phase of capitalism.

Conclusion

Like other businesses, art fabrication adapted to the changing conditions of capitalism throughout the twentieth century; not only did it adjust to these conditions but in the neo-liberal period, the way in which artists worked began to influence them. While art transitioned from object to concept, similarly working models began to transition from manual production to immaterial, service and knowledge industries. At the same time, the criticism aimed at capitalism by artists in 1968 was beginning to be absorbed to create a capitalist modus operandi, evidenced in 1990s business literature, based on the commodification of traits historically associated with the artist. We see this shift in the dismantling of British industry under Thatcher's Britain and the encouragement of entrepreneurial spirit. These traits were similarly adopted by artists – Hirst's *Freeze* demonstrated his 'entrepeneurial' spirit – and one-off businesses devoted to art making (i.e. the Mike Smith Studio). The transition to the New Labour government and its interest in the arts further cemented the commodification of creativity, with its coining of 'Creative Britain' and its associated 'creative industries'.

The Mike Smith Studio thus provides an example of a unique business born out of this complex economic and ideological context; one in which manual work was devalued and contracted from other

parts of the world in favour of flexible project-based work. Smith claims that:

> With larger-scale projects, it's very difficult for the artist to become the project manager, as this may not be within the realm of his or her experience. It also doesn't allow the artist to focus on the bigger picture, since he or she will get bogged down in details that other people may be better suited to resolve.[91]

Contrary to Smith's claim, the following chapter looks at an artist whose practice is paradigmatic of project management: Thomas Hirschhorn.

CHAPTER THREE

The artist as project manager? Thomas Hirschhorn's *Bataille Monument* (2002) and *Gramsci Monument* (2013)

The combination of immaterial (knowledge) and material (manual) skills in the new art fabrication firms discussed in the previous chapter can be straightforwardly understood in relation to the economic era in which the creative industries were born. Less cognizant, perhaps, is the alignment of artistic practice undertaken by artists themselves (as opposed to fabrication firms) with current economic conditions. The appearance of a neo-liberal management theory based on the artist as a model worker has proven problematic for theorizing and analysing contemporary socially engaged artistic practices. In the past, these practices were considered to be hostile to capitalism (through avoiding the production of material objects and engaging sociality) but now, with the rise of project-driven work within mainstream business models and the adaption of capitalism to the artist critique, how might we understand the socially engaged artist's relationship to capitalism? The project, the network and communication have become key attributes within

neo-liberal management discourse. This chapter presents a certain type of artistic practice that engages in project management led by the artist.

The discussion returns to Boltanski and Chiapello's exploration of neo-liberal ideological tropes in *The New Spirit of Capitalism* (2005) with a focus on the artist model on which the artist critique is based. What happens to the artist once their mode of critique is co-opted by the system that they intended to criticize? It would be short-sighted to think that artists simply become part of the capitalist system once their presumed working practice is adopted. Considering the ways in which artists respond to the changes is helpful in understanding the development of contemporary artistic practice from the late twentieth and into the twenty-first century. Conversely, there is not a single, definitive way in which the artist responds to her co-optation in this period; since postmodernism, artistic practices have become even more heterogeneous, with artists developing divergent practices in the neo-liberal period.[1] This diversification provides the impetus to undertake an examination of the wider (non-art) conditions.

The post-1968 period saw an increase in collective practices in art utilizing the artist critique as a mode of resistance, while capitalism began to assimilate it into its eventual new 'spirit'.[2] These practices responded to the internal changes within capitalism, such as privatization and inequality. A later return to social and collaborative practice, more prominent in the 1990s (and to be discussed in the following chapter), signalled a rejection of the model of artist critique, which capitalism had by then fully co-opted. These newer practices, for the most part, adopted the terms of the earlier 'social critique' and collective labour in order to criticize the spirit that accompanies the artistic critique. The artist as a free-thinking individual now belonged to capitalism, and the new avant-garde was to be found in collaborative art practices. However, not all social artistic practices rejected entirely the new ways of working.

Contrary to Mike Smith's proposition that 'it is not possible for an artist to project manage', this chapter considers a body of work by an artist engaged in project-based works that he facilitates: Thomas Hirschhorn's monuments.[3] Although he has completed four in total, it is the final two monuments (for which Hirschhorn was continuously present) that are the focus of this discussion. These later monuments involved the coordination of

fairly large 'events' with multiple static and changing elements, not always conventionally understood as art. Unlike public art's predecessors (discussed in the previous chapters), these public works were ephemeral and temporary; similar to the fabricated works though, as large-scale undertakings, the monuments required many hands. Sited in public space, these monuments further complicate an understanding of artistic practice in the twenty-first century; one on which we can further reflect by looking at the changing nature of work within this period.

Hirschhorn's monuments

Thomas Hirschhorn's work has never been concerned with making saleable art objects; he often uses perishable everyday materials like cardboard, parcel tape and tinfoil. His oeuvre comprises of installations and temporary projects that adopt anti-capitalist tendencies. Hirschhorn is critical of the effects of capitalism and has made works about looting – *Chalet Lost History* (2002), victims of war – *Ur Collage* series (2008) – and also ones that address material excess and mass consumption – *Too Too* – *Much Much* (2010). This approach makes his practice an interesting case study for thinking about how contemporary art responds to the changing conditions of work within capitalism.

Hirschhorn began creating what he terms 'monuments' dedicated to philosophers whose work he admired in 1999. The first was his *Spinoza Monument* in 1999 in Amsterdam, The Netherlands; in 2000 he created the *Deleuze Monument* in Avignon, France, followed in 2002 with the *Bataille Monument*, Kassel, Germany and ending in the United States, with his final *Gramsci Monument* in 2013, The Bronx, New York. The monuments grew from resembling a more traditional monument (*Spinoza Monument*) to fairly large-scale undertakings reliant on the local communities (*Bataille Monument* and *Gramsci Monument*). The term 'monument' has connotations of historical or political, commemorative, publicly sited physical structures. What each of Hirschhorn's monuments has in common with this interpretation is the commemorative aspect; each monument is dedicated to a philosopher or political thinker. However, the locations in which each monument is situated are not directly connected with the chosen thinker, as is typical with

a historical monument. Neither is there a static, permanent material monument erected; Hirschhorn's monuments are temporary, project-based, active, local events. Yes, structures are built, but these are made from everyday materials that are dismantled at the end of the event, signifying the ephemeral, quotidian nature of the project, with the exception of what Hirschhorn calls the 'sculpture'. As such, Hirschhorn refers to these works as 'precarious monuments', prioritizing the activity over the material production; he writes: 'What will stay is the activity of reflection.'[4]

Hirschhorn's later monuments were conceived to be built by the communities in which they were located. He stresses the importance of having people from the communities build the works (in the case of the *Bataille* and *Gramsci* monuments, these were built on housing estates). The 'workers' are paid for their time so, for the duration of the projects, we could understand them as contracted workers. Hirschhorn states that the monuments are 'conceived as community commitments'.[5] For him, the local residents employed as workers are not considered as another material that makes up the work, but play an inherent part in making the work.[6] In his letter to the residents of the Friedrich Wöhler housing complex in which the *Bataille Monument* was sited, he states: 'I cannot produce the *Bataille Monument* alone ... I know that realizing the *Bataille Monument* requires the help, support and tolerance of the residents, including the younger ones. So I don't say: Do as I do; but rather: Do it together with me.'[7]

In his 2003 statement defining the monuments, Hirschhorn proposes that each are composed of two parts: the classical and the information parts. The classical refers to the making of a sculpture, which is conceived as a 'form reproducing the thinker with his features, head or body'.[8] The informational part is the rest: the place, the temporary structures and its 24/7 accessibility. Hirschhorn's intention is to make the work of the philosopher accessible to the public. In his work, Hirschhorn operates an 'anti-exclusionary' policy. In a 2014 talk at the Royal College of Art, London – and after the completion of his fourth and final monument – Hirschhorn updated this criteria to include four elements within the monument: Location, dedication, duration and output.[9]

I chose to focus on the later two monuments as these are the ones for which Hirschhorn was permanently present, and which adopt the

process of 'presence/production', that is, people (including himself) have to be there and something has to be made.[10] Through this process, he asks: 'Can a work – through the notion of "Presence," my own presence – create for others the conditions for being present? And can my work – through the notion of "Production" – create the conditions for other production to be established?'[11]

After he experienced difficulties with his *Deleuze Monument* in 2000, including keeping secure the electronic equipment in the video library after a theft due to a lack of funding for the employed workers, Hirschhorn decided to end the project early. He concluded that, for the future monuments he would need to be present for the duration of the project (rather than undertaking weekly visits as with the *Deleuze Monument* in Avignon). He honoured this commitment with both the *Bataille Monument* and the *Gramsci Monument*. Hirschhorn's presence for the duration of the projects allows us to understand his role as project manager and his involvement with these temporary publicly sited projects.

The Bataille Monument (2002)

In 2002, Hirschhorn created his third temporary monument – *Bataille Monument* – for *Documenta 11* in Kassel. Despite Hirschhorn's claim that he never saw the work as a social art project, it exemplified the kind of work that comes under the rubric 'new genre public art' (Suzanne Lacy) or 'socially engaged art'; it incorporated a public audience and also participation from the community where the piece was sited.[12] Hirschhorn's ambitions were not to produce objects but to engage a social dialogue. He states: 'The *Bataille Monument* demanded friendship and sociability and was intended to impart knowledge and information, to make links and create connections.'[13] In his writings on the *Bataille Monument*, Hirschhorn repeatedly stresses the idea of the work being an experience and an opportunity for discussion. From the outset, the work is understood as a temporary project. In Hirschhorn's own words: '*Bataille Monument* is a precarious art project of limited duration in a public space, built and maintained by the young people and other residents of a neighbourhood. Through its location, its materials and the duration of its exhibition, the *Bataille Monument* seeks to raise questions and

FIGURE 3.1 Thomas Hirschhorn, Bataille Monument, 2002 *(Fahrdienst)* Documenta 11, *Kassel, 2002 (photo: Werner Maschmann). Courtesy: Thomas Hirschhorn/Gladstone Gallery, New York.*

to create the space and time for discussion and ideas.'[14] *Bataille Monument* was funded by *Documenta 11*; however, Hirschhorn chose to situate the work away from the main site on the Friedrich Wöhler housing complex, located in a suburb where the majority of the population was Turkish.[15] This choice of location was in keeping with his previous monument that had also been situated in a housing estate – Cité Champfleury – on the outskirts of Avignon. Hirschhorn admits that he did not expect so many *Documenta 11* visitors to turn up to the three-day opening event (which he purposefully held on the estate, hoping for a diverse mix of residents and *Documenta* visitors).[16] On signs located at various sites within the monument, Hirschhorn had written a provocative quotation from artist David Hammond, which included the words: 'The art audience is the worst audience in the world So I refuse to deal with that audience, and I'll play with the street audience.'[17] Notably, the quotation was included at the two (distinct, classed) sites of the shuttle service: at the Friedrich Wöhler housing estate and at the main site of *Documenta* (Figure 3.1). Retrospectively,

FIGURE 3.2 *Thomas Hirschhorn*, Bataille Monument, 2002 *(Bibliothek)* Documenta 11, *Kassel,* 2002 *(photo: Werner Maschmann). Courtesy: Thomas Hirschhorn/Gladstone Gallery, New York.*

Hirschhorn notes the tension that choosing a satellite site caused, not only in that *Platform 5* (the exhibition to which the work belonged) was meant to be a group show but also in distancing himself from aspects such as technical support.[18]

The *Monument* consisted of three shacks situated between two housing projects: one housed a library of books and videos around Bataillean themes with an area to view these (Figure 3.2); the other was a television studio (Figure 3.3) and the final one consisted of an installation based on Bataille's life and work. Ongoing contributions included a series of workshops held throughout the duration of the project and a website containing photographs from the web cameras located at the monument. There was also a snack bar (Figure 3.4) and a shuttle-taxi service run by locals and a sculpture (Figure 3.5). The three latter elements were not just practical offerings. Hirschhorn had considered how to alternatively engage people in conversation through them. For example, Hirschhorn writes: 'The idea of a snack bar was not primarily about offering food and drinks, but about offering visitors the opportunity to meet, converse and spend time together.'[19] The sculpture appears at the end of the list

FIGURE 3.3 Thomas Hirschhorn, Bataille Monument, 2002 *(TV Studio)* Documenta 11, *Kassel*, 2002 *(photo: Werner Maschmann). Courtesy: Thomas Hirschhorn/Gladstone Gallery, New York.*

FIGURE 3.4 Thomas Hirschhorn, Bataille Monument, 2002 *(Imbiss)* Documenta 11, *Kassel*, 2002 *(photo: Werner Maschmann). Courtesy: Thomas Hirschhorn/Gladstone Gallery, New York.*

THE ARTIST AS PROJECT MANAGER?

FIGURE 3.5 *Thomas Hirschhorn*, Bataille Monument, 2002 *(Sculpture)* Documenta 11, *Kassel, 2002 (photo: Werner Maschmann). Courtesy: Thomas Hirschhorn/Gladstone Gallery, New York.*

as this seems to be, interestingly, how it is prioritized in some of the other literature on the monument. Notably, Hirschhorn does not directly refer to the sculpture in his statement reproduced above. However, he does state elsewhere that: 'The sculpture was supposed to be only the sculpture of the monument and not the monument itself.'[20] As already noted, traditionally the term 'monument' refers to a structure or object; the three shacks and snack bar structures could fall under this category. In terms of syntax, the sculpture would be more readily viewed as the actual 'monument': the public object. In Hirschhorn's definition of the monuments, he states that 'I want to make it possible first to be in contact with information, to read about the work, the philosophy, and then afterwards to look at the statue.'[21] He conceives of the two as, respectively, an active and a passive part of the work. In an interview for *October* journal with Benjamin H. D. Buchloh, Hirschhorn states that he perceives of sculpture as an event or meeting place rather than an object just to be looked at; it is something in which someone participates.[22] One could further interpret this definition of the monument as a project.

The Gramsci Monument (2013)

Hirshhorn's final monument was realized eleven years after *Bataille Monument*. Like his previous monuments, it took a number of years of planning. During his hiatus from building monuments, Hirschhorn represented Switzerland at the Venice Biennale in 2011, with his *Crystal of Resistance* installation. While participating in what is arguably the most popular contemporary art fair in the art world the artist continued to cogitate on a key question proposed by the monuments: How can he engage a non-exclusive public in his work?

Hirschhorn's final monument – the *Gramsci Monument* – took place across seventy-seven days during the summer of 2013. The project was funded by DIA Art Foundation, which Hirschhorn approached with his proposal in 2009. As with the Deleuze and Bataille monuments, it was built in a public housing project (Figure 3.6). Hirschhorn visited forty-seven public housing locations in New York before selecting Forest Houses in the South Bronx (or perhaps it is better understood as Forest Houses choosing him). As part of the selection process, Hirschhorn met with local people

FIGURE 3.6 *Thomas Hirschhorn*, Gramsci Monument, 2013. *School Supplies Distribution by Forest Resident Association, Forest Houses, The Bronx, New York. Courtesy: Dia Art Foundation. Photo: Romain Lopez.*

from the housing estates to see if they understood and were open to his ideas. Asserting the monument as an art project, he was put off by questions such as 'what is the benefit to the community?' from people at the other locations, a question that is in conflict with his artistic intentions. When he arrived at Forest Houses, Diane Herbert and Clyde Thompson (the community centre workers with whom Hirschhorn initially spoke) understood that the artist did not want to do social work; they grasped the notion that he was an artist asking *for* help (rather than asking *to* help), something which was also clearly articulated in his initial letter of in February 2002, to the residents of the Friedrich Wöhler housing complex regarding *Bataille Monument*. An introduction was made to the president of the Forest Houses Residents Association – Erik Farmer – who then proposed the project to the community. It was also Farmer who officially invited the project into Forest Houses.[23]

Like *Bataille Monument*, the *Gramsci Monument* included a number of static and changing parts, which Hirschhorn categorized as falling into the category of either presence or production. 'Presence' included an exhibition space comprising of objects loaned by the Gramsci Institute in Rome; a Gramsci archive (which contained five hundred books loaned by City University New York) (Figure 3.7); internet corner; a radio station run by local DJs (Figure 3.8); a bar (organized by five residents); a lounge, a pool/sculpture and banners including Gramsci quotations throughout the site. 'Production' included daily and weekly events that took place at the monument including the presence of an ambassador to explain art and culture to the residents; an art school; a newspaper; a website (updated daily); open mic events; theatre; poetry readings (Figure 3.9); field trips; seminars and a daily lecture.

The project was a large undertaking and involved a lot of people.[24] The residents were involved in the planning, building and implementation of the project. Unlike the *Bataille Monument* (for which Hirschhorn expressed regret for not utilizing more of the technical support provided by *Documenta*), nine members of DIA staff were on the construction team. Around fifty residents from Forest Houses were temporarily employed for the duration; this figure included sixteen residents for construction with others employed to run and dismantle the monument. As with the Kaban family who ran *Bataille Monument*'s snack bar, the locals who ran the bar at the *Gramsci Monument* also kept the profits. At the end

FIGURE 3.7 Thomas Hirschhorn, Gramsci Monument, 2013. *Gramsci Archive and Library, Forest Houses, The Bronx, New York. Courtesy: Dia Art Foundation. Photo: Romain Lopez.*

FIGURE 3.8 Thomas Hirschhorn, Gramsci Monument, 2013. *Radio Studio, Forest Houses, The Bronx, New York. Courtesy: Dia Art Foundation Photo: Romain Lopez.*

FIGURE 3.9 *Thomas Hirschhorn,* Gramsci Monument, *2013. Poetry Session: Tonya Foster, Forest Houses, The Bronx, New York. Courtesy: Dia Art Foundation. Photo: Romain Lopez.*

of the project, Hirschhorn organized a free raffle to distribute what was left of the monument; it lasted four and a half hours.

Through orchestrating these large (in terms of scale and time) events, Hirschhorn had to engage and sustain the interest of his paid worker-participants. To do so, he maintained and asserted his role as artist while also engaging in project management (which began with the planning stage years before the monuments were realized). Rather than see the roles as distinct from one another, it is argued here that the conflation of the two roles (artist and project manager) in the working practices of Hirschhorn is affected by the coterminous changed nature of capitalism after its adoption of the artist critique.

Artist critique and artist model

Boltanski and Chiapello claim that the artistic critique presents itself as a 'radical challenge to the basic values and options of

capitalism'.[25] In their analysis, the model of artist critique is rooted in the nineteenth-century invention of a bohemian lifestyle. This notion is founded upon the divide between the bourgeoisie as landowners, on the one hand, and the artists and intellectuals who are considered to be free from 'production', on the other.[26] Charles Baudelaire's 'The Painter of Modern Life' (1863) provides first-hand insight into the life of the nineteenth-century artist, with his poetic presentation of the flâneur. In Baudelaire's account, the flâneur is a man at home on the streets of the city who 'delights in universal life', observing life with a genius, but drunk-like view of the world: a passionate spectator.[27] The artist referred to in the text, now known to be Constantin Guys, reflects modernity and represents the different classes in his work. Like Baudelaire, Walter Benjamin understands the flâneur (or the artist who Baudelaire discusses) as a new type of man, temporarily aligned with bohemia and accompanying modernity; however, his is a bleaker picture. For Benjamin, the flâneur is understood in relation to the conditions of capitalism; his gaze is that of an alienated man who, rather than being at home in, seeks refuge in the crowd because he belongs nowhere.[28] He is on the threshold of the metropolis and the middle class. Of course, this is the period in which the middle class is newly emergent; Chiapello and Boltanski draw on César Grāna's account of the bohemian as 'self-exiled' for their own understanding of the bohemian with which the artist critique is identified.[29] It is this self-separation that forms the basis of the artist critique as one that calls for freedom and autonomy (as opposed to the collectivity of the earlier social critique).

It is not only Boltanski and Chiapello who recognize a parallel between bohemia and the period in which the 'new spirit' manifests – the term 'neo-bohemia', coined by Richard Lloyd (whose earlier work theorizes the rise of the 'creative class') becomes synonymous with the new economy.[30] We might further add 'hipster' to the growing terminology of people belonging to new 'creative class', whose close alignment with the concept of gentrification has been noted in recent years. The personification of this type of critique thus manifests in the model of the dandy: a free-thinking, creative, individual, based on the ideals of the Romantic artist. Boltanski and Chiapello identify the absorption of the model of artist critique into business models after 1968. Thus, by the 1990s, management discourse began to seek qualities stemming from the critique – such

as flexibility and creativity – in its employees, demonstrated in the publication of titles such as *Artful Making: What Managers Need to Know About How Artists Work* (2003).[31] These qualities are drawn from the model of the artist, albeit a mythical one. The transparency of these qualities is made clear in documents such as The Work Foundation report commissioned by England's Department of Culture, Media and Sport's (DCMS's) 2007 review of the economic performance of the creative industries in which the management of 'creative' people is highlighted.[32] The report notes: 'The creative process necessarily involves marrying and integrating diverse and sometimes very individualistic people in creative teams.'[33] It later states that the 'organisational challenge is to find a way of harnessing it [creativity], rather than obstructing it'.[34] These mythical qualities have a concrete effect on the contemporary artist whose work is project-based, evident in Hirschhorn's practice.

Qualities aligned with the Romantic conception of artist thus manifest in the new model of 'worker' within the third period (c. 1990s) in which capitalism has fully absorbed and neutralized the demands of the artist critique. In 'The Misfortunes of the "Artistic Critique" and of cultural employment' (2007), Maurizio Lazzarato disparages this model of artist.[35] He argues that the idea of the artist, which Boltanski and Chiapello claim capitalism co-opts, is an out-of-date notion. Because of this proposition, the model is, therefore, not a true representation of the artist that is contemporary to the period on which Boltanski and Chiapello focus. Contrary to Lazzarato's criticism, I propose that the model of artist – that is akin to that of the Romantic artist (the creative individual, embodying divine talent, who goes against the grain, etc.) – is precisely the conception, or rather the stereotype, of an artist that the non-art experts surmise is an 'artist' in contemporary culture. The earlier cited DCMS report makes this clear when, with reference to management hiring creative types, it refers to them as deviants, heretics, eccentrics, crackpots, weirdos and original thinkers.[36] As such, the manager or management theorists (who are not concerned with recent artistic practice) choose this mythic artist stereotype as a new ideal worker because they believe that artists are non-conforming, free-thinking individuals tied to countercultural activities. Tolerance for these types of people will pay off in the long run, as long as they can be managed. Management becomes a key issue highlighted in the DMCS report: 'Organising diversity can be problematic … If not

managed wisely, that divergence may give way to disagreement and even conflict that eventually stifles creativity.'[37]

Clearly, this view is historically conditioned, originating from the artist–genius myth in which the artist is considered to be a lone creative individual who suffers from having an innate God-given talent and whose personality borders on madness (Vincent Van Gogh is a prime example of this mythology).[38] While Hirschhorn is not the stereotypical 'starving artist working alone in a garret', he aligns himself the modernist conception of 'artist' through his asserted autonomy.

Thomas Hirschhorn: Artist as project manager?

Hirschhorn's project-based work is not the same as that undertaken at the Mike Smith Studio; however, the nature of a contemporary art world that embraces temporary art fairs and large-scale, often spectacular, public art commissions fosters project-driven work albeit with a material or event-based outcome. Despite his anti-capitalist leanings, we can understand Hirschhorn's monuments as belonging to Boltanski and Chiapello's projective city. This is the emergent city in the period in which the creative industries were born closely aligned with neo-liberal ideology and also one to which short-term temporal projects and networks are central. Both the *Bataille* and *Gramsci Monuments* epitomize the utilization of the temporary project within contemporary art. We can assume that the choice of working model adopted for the *Bataille Monument* was affected by the ideological implications of an economy based around networks and short-term projects, and one that welcomes the creative individual who can make it happen.

Hirschhorn's projects included heterogeneous and large groups of participants. Referring to the networked society, Boltanski and Chiapello write:

> In a reticular world, social life is composed of a proliferation of encounters and temporary, but reactivatable connections with various groups, operated at potentially considerable social, professional, geographical and cultural distance. The *project* is the occasion and reason for the connection. It temporarily

assembles a very disparate group of people, and presents itself as a *highly activated section of network* for a period of time that is relatively short, but allows for the construction of more enduring links that will be put on hold while remaining available.[39]

Both monuments brought together socially diverse groups of people to work on the project.[40] As already noted, in *Bataille Monument* the shacks were built by Hirschhorn and between twenty and thirty residents from the Friedrich Wöhler housing complex, where the monument was situated. The monument took two months to build. Even more locals were employed in the making and running of the *Gramsci Monument*, with an estimate of around fifty people. The residents of the housing estates in which Hirschhorn chose to work were from ethnically diverse communities; the Friedrich Wöhler estate's residents are predominantly Turkish, while Forest Houses is home to large African American and Hispanic communities.[41] With the *Bataille Monument*, Uwe Fleckner — an art historian — assisted in choosing the categories and selecting books for the library. For the Gramsci archive, City University New York loaned five hundred books, while the Gramsci Institute in Rome loaned objects relating to Gramsci. The French writer and art critic, Jean-Charles Massera; French poet, Manuel Joseph and the German philosopher, Marcus Steinweg, were each invited to hold workshops at the *Bataille Monument*. Similarly, at the *Gramsci Monument*, Steinweg delivered daily philosophy lectures and others were also invited to speak. Massera worked with the young people of the Friedrich Wöhler estate to perform his texts; Joseph forged ten letters titled 'Sculpture as a bullfight', which were disseminated to almost 100,000 Kassel households, while Steinweg's workshop focused on the production of texts that contributed to an exhibition panel on *The Ontological Cinema*. The *Gramsci Monument* employed an ambassador from DIA Art Foundation — Yasmil Raymond — to be on site to explain the art and culture to the residents. Also included are the local residents who ran elements of the monuments: those who manned the bar/snack bar and the five drivers who provided the shuttle service to and from the *Bataille Monument*, and the DJs who ran the radio station for the duration of the *Gramsci Monument*. Furthermore, Hirschhorn consulted the poet Christophe Fiat in his research on Bataille's work in preparation for *Documenta 11*. The visitors who made the journey from the main site of *Documenta 11* to Friedrich Wöhler and those who travelled to

Forest Houses should not be excluded from this status. In addition, there were webcams that were set up for worldwide access to the *Bataille Monument,* the website for the *Gramsci Monument* and the people who accessed these. Without extending this count further afield to people such as the 'Artistic Director' of *Documenta 11,* Okwui Enwezor, who was also inextricably linked to the project, and DIA Art Foundation, we can see the disparate worlds that Hirschhorn attempted to bring together through these two projects. Hirschhorn's monuments clearly embrace and encourage heterogeneity, while retaining his own position as artist.

Autonomy and unshared authorship

Key to understanding Hirschhorn's practice in relation to what Boltanski and Chiapello identify as the projective city – or the networked society – lies in how he conceives of being an artist, and through comprehending his position on authorship. While Hirschhorn's 'non-exclusive' policy allows for anyone to work with him, which he openly encourages by siting his monuments outside of galleries and away from a typical (white, middle class) art audience, he simultaneously maintains his authorship of the monuments. In a 2012 text written as part of his fieldwork for the *Gramsci Monument,* Hirschhorn explains his concept of 'unshared authorship': 'me, the artist, am the author of the "Gramsci Monument", I am entirely and completely the author, regarding everything about my work'. Similarly, the 'Other' can also be the author 'completely and entirely, in his/her understanding of the work and regarding everything about the work'.[42]

In using the term Other, Hirschhorn evokes a philosophical conception of the people with whom he chooses to work while also acknowledging difference.[43] As such, Other refers to those people who are not the same as the artist; this could be understood as social, economical, ethnically, gender- or class-based difference.[44] Central to his practice, therefore, is his belief in equality. 'For the "Gramsci-Monument"' he writes, 'I am doing this alone and solitarian, because I am convinced that the only possible contact with the Other can happen "One to One". This is not self-enclosure or a romantic attitude. Only a "One to One" contact can create a dialogue or even a confrontation with the Other.'[45]

This desire to engage with Other has undoubtedly attracted a critical reaction to the projects. In particular, criticism was aimed at Hirschhorn's situation of the *Bataille Monument* within the Turkish community, and also the employment of local people to assist in the build. Carlos Basualdo writes that critics referred to the work as abusive to, and exhibitionistic of, the people of Kassel.[46] Interestingly, Hirschhorn's response to these accusations was that he did not wish to exclude anyone from his audience.[47] Furthermore, Hirschhorn welcomes judgement; he claims that you can only progress when your work is judged and that the artworld evaluates rather than judges, which is why he makes these works outside of the (physical) art institution.[48]

One could question how abusive was the employment of workers to assist on a creative project? We know that Hirschhorn paid his workers eight euros per hour for the *Bataille Monument*, which one assumes would be the equivalent to the minimum wage. The locals in the *Gramsci Monument* were not simply manual labourers but also helped with the logistical decision of how to build and where to place the different shacks. For both projects, Hirschhorn lived on the estate for the duration of the projects as he wished to be a part of the community for the time that he worked there rather than an artist who entered their social space everyday and left again. He also understood that, in order to facilitate an engagement with the local community, he had to put the work in with the local participants. This was not without problems. While living on the Freidrich Wöhler estate during the *Bataille Monument*, Hirschhorn's flat was broken into and expensive equipment was stolen. However, he did not go to the police but publicly asked that the equipment be returned, which it was. Because of this incident, Hirschhorn felt, in some ways, that the local inhabitants of the estate had accepted him.[49]

The friction that working with people from diverse backgrounds attracts is part of the process. Hirschhorn states: 'To address a "non-exclusive" audience means to face reality, failure, the unsuccessful, the cruelty of disinterest, and the incommensurability of a complex situation.'[50] Not all of the residents were interested in the monument. In an online interview, one of the community members describes it as an 'eyesore' that looks like a 'homeless shanty town'.[51] In her oft-cited critique of Bourriaud's *Relational Aesthetics* (1998), Claire Bishop is right to articulate that there are aspects of Hirschhorn's

work that are antagonistic, such as the choice of location, in the sense that Hirschhorn intentionally selected a site where 'friction and engagement might be possible'.[52] Bishop draws on Ernst Laclau and Chantal Mouffe's notion of antagonism, which understands subjectivity as a central aspect of democratic society.[53] For them identification holds the key to antagonism; the presentation of Other prevents a person from being themselves. We can therefore understand Hirschhorn's monuments that are conceived to bring people from diverse economic and cultural backgrounds together in one place (a confrontation with Other) as facilitating Laclau and Mouffe's understanding of antagonism in public space. The choice of location played with the ambiguity that Hirschhorn evokes through his work, which is never quite social work (and does not intend to be); neither is it openly political. However, there is usually a definite political air around his work, and Hirschhorn is not apologetic for this ambiguity. He states: 'I am the artist, and when I work in an open space I decide where to place my work. It interests me that my work has to defend itself in any surroundings, in any sector, and fight for its autonomy.'[54] It is this concept of autonomy that is important for Hirschhorn, and he still considers himself to be the artist at the heart of the project. Speaking about the *Bataille Monument*, he states: 'That is why I said that my presence on the site was not required for communication or discussion with people, but simply in the role of a caretaker, to check that everything was functioning.'[55] Furthermore, this autonomy is rooted in the artist model on which the artist critique is based, one that demands the freedom of man from the constraints of the market. Can we therefore understand Hirschhorn's practice as adopting the traits of the artist critique?

I would argue that Hirschhorn's role is more like a project manager – the instigator and facilitator – rather than mere caretaker, which implies a kind of 'nannying' (if we recall, his *Deleuze Monument* was closed early when he simply acted as a weekly caretaker). Noticeably, Hirschhorn chooses to step back from the participants in order for 'real' experiences and discussions to take place, as opposed to ones directed by the artist. Hirschhorn's decision to avoid directing the relations between participants can be viewed as contrary to the interaction that is encouraged (or directed) by the relational artists whose work engages the audience within the gallery space, such as Rirkrit Tiravanija. Furthermore,

Hirschhorn's concept of presence and production was devised as an alternative to community, educational or relational art or other terms, none of which Hirschhorn felt applicable to his practice.[56]

The working practice employed by Hirschhorn for his monuments is distinct from the collaborative practices that engage the viewer in the gallery space (Hirschhorn considers collaboration as a 'soft' term), which Bojana Kunst has argued creates a (neutral) specific public sphere without a public in which social and political activity is rehearsed without consequence.[57] To cite a canonical example of 'relational' art, with *Pad Thai* (1990) Tiravanija cooked for his audience – which then facilitated the sitting and eating with the artist or strangers – these relations occur between art gallery visitors who arguably have art in common. The cooking of food is a precursor to the sitting and eating and can be seen as 'directing' in a performative sense. The 'event', in this work, is orchestrated between participants with commonalities and, perhaps, similar educational and economic backgrounds. In contrast, while also providing food, Hirschhorn's snack bar at the *Bataille Monument* was run by a local family and was frequented, not only by *Documenta 11* visitors, but also people from the surrounding communities in their own (non-art) space.[58] The resulting conversations and interactions would perhaps be more interesting than those solely between a typical art audience.[59]

Kunst calls the public who contributes to collaborative artistic practices the 'working spectator'.[60] Building on Hito Steyerl's understanding of the contemporary museum as aligned with the 'social factory', Kunst proposes that the audience members at the contemporary art event 'work as autonomous workers, managing their "affective, social and cognitive skills" in the scope of post-Fordist production'.[61] For Kunst, by contributing to the contemporary art event, members of the audience – as autonomous workers – undertake 'invisible work', which produces subjectivity. However, these are unpaid, art-going members of the public. How does this translate to the paid, non-art workers in projects such as Hirschhorn's?

There are clearly parallels between the notion of the spectator as worker, Kunst's proposition that the artist is a 'facilitator' who creates the conditions for communication, and Hirschhorn's practice. However, Kunst sees the artist as handing over his/her autonomy to the audience in order to be exploited.[62] In the monuments,

Hirschhorn maintains his autonomy while, at the same time, claiming that unshared authorship moves towards 'co-existence'. As such, we might understand Hirschhorn's monuments as creating the possibility for a space in which a more realistic public sphere could emerge, one in which antagonism and politics are able to take place. These encounters are possible because of the role that Hirschhorn takes as the autonomous author/artist/project manager (a position that is nurtured within neo-liberalism), and this returns us to thinking about Boltanski and Chiapello's proposition that the artist critique is based on a certain conception of (autonomous) artist.

'great man'

Like Mike Smith, Hirschhorn conforms to aspects of Boltanski and Chiapello's 'great man'. They state: 'the great man proves *adaptable* and *flexible*, able to switch from one situation to a very different one, and adjust to it; and *versatile*, capable of changing activity or tools, depending on the nature of the relationship entered into with others or with objects'.[63] Hirschhorn moves from an international artist exhibiting in the gallery, and representing his country at the Venice Biennale, to one who engages a non-art public in his work through situating his monuments in low-income housing neighbourhoods. He does this all without the intention to 'do good' but simply to engage in, what he terms, co-existence. He brings together in one space disparate worlds – philosophers and community workers, academics and housing estate teenagers – through his monuments. Boltanski and Chiapello state that the great man in the projective city is a risk-taker, who must possess intuition and talent (in the artistic sense of the term). To be excluded from the project is 'death in a reticular universe'.[64]

Alongside embodying aspects of the 'great man', Hirschhorn is also keen to find other inspirational people with whom to work, to build his network. It could be argued that Hirschhorn sought out key community figures ('great men') with whom to engage in his monuments. Central to the *Bataille Monument*, was Hirschhorn's encounter with Lothar Kannenberg, who ran a boxing club for local youths. Hirschhorn knew that if he could get Kannenberg on board with the monument, in turn, he

would inspire the youths to work on the project. Similarly, when he met Erik Farmer (the president of Residents Association at Forest Houses), Hirschhorn knew he had found the location for his *Gramsci Monument*. Farmer had a key role in introducing the project to the residents and welcoming the monument into Forest Houses. Both Kannenberg and Farmer could be considered 'great men' in their community; ones to whom members of their communities come when disagreements arise. Hirschhorn knew to build his network beyond the art world and into the community in order for his projects to work.

The participants in both monuments had more control over the direction of the work because of Hirschhorn's role as project manager (akin to the great man in the project-based community). The result of his work was to engage people and to facilitate discussion, while Hirschhorn stepped back. Again, we can draw correlations between new forms of management and Hirschhorn's approach. The aforementioned DCMS report states: 'Over-centralisation of decision-making, while preventing deadlock, militates against organisational creativity.'[65] The report further stresses the importance of 'more discursive, open-ended inquiry, the lifeblood of more radical and unexpected innovation'.[66] Hirschhorn allowed for the participants to attain the results, whatever forms these may take and, according to the literature, this freedom is precisely the role that the project manager should take in order to achieve truly creative, innovative results.

Boltanski and Chiapello state: 'The great man in a connexionist world is active and *autonomous*.'[67] Hirschhorn sees his monuments as requiring others, but ultimately retains his name as the 'author' of the work. More pertinent, perhaps, is that he wishes art itself to remain autonomous and, therefore, as distinct from the capitalist world and the social relations that it encourages:

> The other possibility is that by letting this autonomy shine through, by holding fast to this affirmation of art, I want people to reflect, to think, okay? That is what I want: reflection about my work, art in general, the passage of time, the world, reality. It is possible, for example, to talk with Turkish kids about art, because I don't talk with them as a social worker but as an artist, as someone who believes in art [...] I am not here to rehabilitate anyone, or not to rehabilitate them. That is not my job [...]

At the same time I find a cynical stance impossible, because it creates no autonomy or activity for me.[68]

Thus, Hirschhorn's method of working, with his monuments at least, is fostered by the conditions of capitalism under which artists work today. The autonomy of the individual artist is not compromised because the project is ultimately subsumed under his name. Further, the mode in which he chooses to work – the collaborative project, which focuses on participation rather than object production – is in keeping with contemporaneous business working models. Thus, the emphasis on the individual under neo-liberal ideology materializes in the 'great man' who is able to work with others but who is, ultimately, autonomous. Hirschhorn defends the autonomy of art, in which he believes anything is possible, while engaging in non-exclusionary collaborations. He states: 'Nothing is impossible with art. Nothing.'[69] Moreover, Hirschhorn is, as Basualdo proposes, a modernist at heart.[70] However, his modernist leanings lie in the type of artist that he embodies rather than how he goes about making art (the modernist artist is historically associated with painting as opposed to social engagement). This type of artist is that of the Romantic conception that Boltanski and Chiapello argue is co-opted by capitalism, evidenced in the corpora of management literature that they examined from the 1990s. In this role, the artist is considered to be a free, creative individual, autonomous and flexible.

Conclusion

The ideological traits, identified by Boltanski and Chiapello as stemming from 1990s management literature and the co-option of the artist critique, are implicitly connected to the establishment of a neo-liberal economy. This economy is based upon creativity, flexibility, short-term projects and the establishment of networks, all of which can be tied to certain conceptions of artistic production. The establishment of the creative industries in 1990s Britain further demonstrates the appeal of the 'creative type' to an economy based upon the aforementioned principles. Through adopting a Marxian understanding of ideology as connected to the economic base, I have argued that these principles are not disassociated from the production of contemporary art through an exploration of the *Bataille* and *Gramsci Monuments*.

Hirschhorn acts as a kind of project manager in order for the creative, informational and social aspect of his art to play out. Hirschhorn may be able to initiate and implement a project, but the aims and objectives are not set in stone beforehand, and the 'result' is not predefined. What is important for Hirschhorn is the inclusionary aspect of his projects: 'I want people to be inside my work, and I want spectators to be a *part* of this world surrounding them in this moment.'[71] Unlike the adaptable 'great man', in public works such as *Bataille Monument*, Hirschhorn always sees his role as that of the artist. His works are, ultimately, concerned with making art and the possibilities that art can achieve. Contrary to his artistic intention, I argue that Hirschhorn still proves adaptable. He was, like the 'great man', happy to move to Kassel and The Bronx for the duration of his projects. He lived onsite and adapted to the conditions in order to truly engage with his location and the locals who lived and worked alongside him. He also overcame the difficulties that accompanied these temporary relocations. His interventions into public space are not easy transitions. He has to develop the skills to work alongside people from diverse backgrounds, the success of which he does not judge.[72] Reflecting on his earlier monument, Hirschhorn states that the *Bataille Monument* was 'the hardest project I have ever created'.[73]

Hirschhorn prioritizes experience over results. While his work may be ideologically affected by working under neo-liberalism, Hirschhorn's practice is demonstrative of the fact that the artist and the neo-liberal model of manager cannot truly be assimilated. Thus, in this analysis, the title of 'project manager' is not a derogatory one. Neither is the association with neo-liberal ideology within which the development of a practice like Hirschhorn's in his more recent monuments can be understood. Hirschhorn is able to work alongside others (and sometimes Others – as in those that are not the same as him; he operates a non-exclusionary audience) on temporary, short-term projects because of the kind of world in which he lives, a world that now welcomes the precarious, the network and the facilitator role. But this is not to label Hirschhorn a neo-liberalist, and certainly not a capitalist; his work (especially that beyond the monuments) is also committed to a form of anti-capitalism. While the 'real' project manager, fosters and develops projects for the creation of profit, Hirschhorn is doing something very different, Romantic even. In his own words, he does it for love, politics, aesthetics and philosophy. These are not always covered

in equal measures within each project – *Gramsci*, for example, straddled the borders of love (of Gramsci) and politics – but, we can be sure that profit does not come into the equation for Hirschhorn.[74]

Despite Hirschhorn's practice being indebted to neo-liberal working tropes – such as the project – he will never become the 'true' manager. Contrary to the DCMSs tolerant approach to 'creatives' in order to receive economic 'payoffs', Hirschhorn's primary concern lies not with profit (the driving force of capitalism) but the experience. Boltanski and Chiapello state: 'Anything can attain the status of a project, including ventures hostile to capitalism.'[75] We see this at play in the work of Hirschhorn.

CHAPTER FOUR

Immaterial labour: Rimini Protokoll's *Call Cutta in a Box* (2008–12)

While the co-optation of the artist critique (and its associated artist model) was transforming work, artistic practice was responding (consciously or not) by presenting a collective front; that is, by presenting social practices within the gallery space. By 'social', here I mean those practices that broadly engage more than one person in some kind of interaction (as opposed to the lone artist creating an object for the viewer) whether it is through interacting with, performing or making the work (as with Hirschhorn's projects discussed in the previous chapter).[1] In common with the new capitalist work models, these practices do not directly produce a material product for sale/consumption; the emphasis of the work is placed on engagement or activity. In his 1996 essay 'Immaterial Labour', Maurizio Lazzarato defines immaterial labour as 'the labour that produces the informational and cultural content of the commodity'.[2] This description conforms to the analyses of neoliberalism addressed in the previous chapter, where the network becomes paradigmatic of new forms of labour. Known for its accommodation of the worker's personality associated with service work, immaterial labour is also concerned with collective forms that are epitomized in 'ad-hoc projects', 'networks and flows'.[3] Lazzarato states that classic forms of immaterial production are

found in the creative industries, that is: advertising, audio-visual production, fashion and other cultural activities, including art.

The collective, social nature of immaterial labour and the emphasis on knowledge production can be found in contemporary socialized art practices. The effect of immaterial labour on these practices is visible: first, in the practices that remain within the institutions of art, and often associated with the book *Relational Aesthetics* (1998) and, secondly, in those openly resistant to capitalism (to be discussed in Chapters Five and Six). The intention here is not to present a homologous account that literally reduces 'immateriality' to a type of art that is not centred around the production of material objects, rather it is to explore how skills associated with this type of work are evident in contemporary art and, by extension, performance.

When I began looking at this phenomenon in the mid-2000s, the shape of social artistic practices was still emerging and largely under-theorized, with a few exceptions. After its translation into English in 2002, Nicolas Bourriaud's now well-dissected *Relational Aesthetics* was piled high in gallery bookshops and presented an early attempt to ring fence and theorize the new practices that took the social as material.[4] Lacy's *Mapping the Terrain: New Genre Public Art* (1996) provided an alternative narrative to the origins of the new social art, considering the development of these practices as stemming from the legacy of community and public art practices in the United States.[5] Subsequently, Claire Bishop's much-cited essay 'Antagonism and Relational Aesthetics' (2004) became a key critique of Bourriaud's book questioning the democratic nature that he proposed was evident in the cited artworks.[6] By the mid-2010s there had appeared a number of larger anthological volumes devoted to social practices in art, often attached to contemporary art exhibitions or from commentators who were also engaged in commissioning these works (i.e Nato Thompson from Creative Time in the United States and Claire Doherty from Situations in the UK).[7] Social practice is now, in 2017, prominent in (and outside of) contemporary art galleries, having been labelled, theorized and exhibited globally throughout the 2000s and 2010s.

In trying to understand the new practices, the distinct labels – relational aesthetics, dialogic aesthetics, socially engaged art, participatory art, new genre public art and so on – have, in one way, hindered the discussion of a new social approach to art

making by trying to fix and narrow its meaning and terminology, more in line with a modernist art historical approach (i.e. that of teleological narratives) than one adapted to contemporary art.[8] In fact, some artists have been stigmatized by reference to their work in Bourriaud's book, as their work has been eternally reduced to and read through the terms of relational aesthetics (and its critiques). It is thus unsurprising that, in these early accounts, a number of writers on social practices, such as Grant Kester and Bourriaud, returned to modernism for the purpose of framing the new practices. Kester's approach in *Conversation Pieces* (2013) draws on the legacy of the avant-gardes; he understands the newer, less confrontational approach of artists that adopt what he terms 'dialogical aesthetics' as providing an alternative to the shock tactics used by the avant-garde artists, but for the shared aim of disrupting and awakening a criticality in a viewer exposed to the alienating effects of mass culture.[9] Bourriaud similarly proposes that the artists that he identifies as engaging a relational aesthetic take up the legacies of twentieth-century avant-gardes, while challenging their dogmas and doctrines.

This persistence of the term 'aesthetics' in accounts of social practice, perhaps for fear that art not concerned with the visual tradition might be shunned from the narratives of art history, highlights an on-going need to readdress the term and its associated approaches. While it is acknowledged here that social practices in art are not a complete separation from past forms of art making, these practices could be better understood by looking to alternative frameworks, such as the wider economic changes. Building on the preceding discussion of neo-liberalism, this chapter thus considers the visibility of social practices in the 1990s (and particularly, its institutions) in relation to the shift from production to service led in working practices within contemporary capitalism. Despite its shortfalls, I devote a portion of this chapter to *Relational Aesthetics* understanding it as a document that reveals the symptoms of immaterial labour (albeit unbeknownst to Bourriaud, at the time) in contemporary art of the 1990s. To explore the relationship between immaterial labour and artistic practices further (and rather than selecting from the pool of well-known social artworks), this chapter takes as its case study an example of postdramatic theatre that draws on (and at times departs from) relational tropes. This particular piece of theatre takes immaterial labour as its subject, its

setting and its modus operandi: Rimini Protokoll's *Call Cutta in a Box* (2008–12).

Call Cutta in a Box (2008–12)

Rimini Protokoll is a Berlin-based collective comprising of three members: Helgard Haug, Stefan Kaegi and Daniel Wetzel. They describe themselves as 'author-directors' and the group's work (which traverses theatre, sound, radio plays, film and installation) is often understood as belonging to the category 'postdramatic theatre', a term coined by Hans-Thies Lehmann in his book of the same name.[10] *Postdramatic Theatre* was first published in German in 1999 and, subsequently, in English, in 2006. In the book, Lehmann identifies tendencies in theatre since the 1960s that move away from the conventions of drama and towards performance. This performative turn involved the dissolution or disruption of a conventional narrative structure, extending beyond the fourth wall and turning towards to the audience. In this vein, Kaegi states that: 'Rimini Protokoll's purpose is to pry apart the sense of reality and present all its facets from unusual perspectives.'[11]

In dealing with the 'prehistories' of postdramatic theatre, Lehmann writes about the neo-avant-garde referencing Black Mountain College's experiments in performance (by John Cage, Merce Cunningham and Allan Kaprow) alongside those of Robert Rauschenberg, Yves Klein's *Anthropometries* (1960), Vienesse Actionism and happenings.[12] The proximity of art and performance in postdramatic theatre is further established when Lehmann notes that postdramatic theatre practitioners often start out in the visual arts. Further connections can be made between Lehmann's 'applied theatre' (which Kaegi, Haug and Wetzel studied) and the contemporary art practices that exit the gallery, such as socially engaged art. Rimini Protokoll's work does not often take place in the traditional theatre setting; the group's work is performed globally in both art and performance contexts, such as festivals and art fairs. *Call Cutta in a Box* is no exception.

Call Cutta in a Box is billed as an 'intercontinental phone play'. The piece was performed twenty-two times in a number of iterations in various international locations (including Cape Town, Amsterdam, New York and Sharjah) between 2008 and

FIGURE 4.1 *Rimini Protokoll*, Call Cutta in a Box, 2008–12. Pictured: Alexandra Lauck in the Willy-Brandt-Haus in Berlin, 2008. © Barbara Braun/drama-berlin.de.

2010, with two further performances in the years 2011 and 2012. The play is performed across two sites: the first location is that of the audience (an office, a hotel room or other location) and the second is a call centre based in Calcutta, India where the performer is situated. Each iteration is slightly different, but the premise is that a single participant (these are appointment-based, one-to-one performances) engages in a fifty-minute phone call initiated by a call centre 'worker' based in India, but rather than the caller trying to sell something, a personal exchange takes place. The first version in 2005, simply titled *Call Cutta*, was a walking tour directed by the call centre 'worker' via mobile phone through the streets of North Calcutta and Berlin. The 2008–12 versions took place in various venues, including offices of art centres, theatres, hotels and as part of art festivals; each performance 'set' in the locations has items in common: a computer, a printer, a comfortable chair/sofa, a kettle, purposefully hung pictures on the wall and various other objects hidden for a later reveal (Figure 4.1).

In contrast to examples discussed in the previous chapters, *Call Cutta in a Box* primarily *performs* labour rather than engaging

FIGURE 4.2 *Rimini Protokoll,* Call Cutta in a Box, *2008–12.* ©*Rimini Protokoll.*

in productive labour. However, the majority of the 'performers' are not actors but people who have answered a job advert, some are actual call centre workers (Figure 4.2). Wetzel describes them as 'students, young middle class urbanites'.[13] In her book *Social Works: Performing Art, Supporting Publics* (2011), Shannon Jackson refers to the performers as 'actor-labourers', which is adapted here to term them 'actor-workers'.[14] In the following, the audience (of one) is referred to as the 'viewer-participant'. The actor-workers are located in a real call centre building owned by Descon Limited on the outskirts of Calcutta. The company provided Rimini Protokoll with fifteen workstations and the use of equipment (including technical support) free of charge in return for mentioning the company's name in the performance (Figure 4.3). The only fictional aspects of Descon Limited are the branded items (pens, mugs, etc.) used in the performance, which Rimini Protokoll developed to give the company a corporate identity in the webcam chat. Furthermore, the actor-workers play themselves and, unlike their call centre colleagues, use their real names and photographs.

FIGURE 4.3 *Rimini Protokoll,* Call Cutta in a Box, *2008–12.* ©*Rimini Protokoll.*

There is actually very little fiction in the 'play'; as described on the script, the official reason for the call is to find out how the actor-worker (on behalf Descon-Outsourcing) and the viewer-participant can work together. The actor-worker is then told (via the script) that they personally don't care much about it and that the real task of the call is to 'use the occasion to talk to this person once in a lifetime and to just get to know each other a little bit'.[15]

The conversation is organized into a number of scenes (the number varies with each location), with the actor-worker noting the points in the conversation when the next scene starts. During the conversation, the actor-worker directs the viewer-participant around the room inviting them to do certain tasks (make a cup of tea, look out of the window, 'draw a picture of me'). Initially, they are invited to take a seat on the sofa/comfortable chair/bed and offered a cup of tea; if they accept, the worker remotely switches on the kettle. The participant is then asked details about themselves, in response to prompt questions, with the actor-worker offering personal responses to their own questions in an

attempt to break down the barrier normally established between caller and call centre operative. Throughout the fifty-minute performance, the viewer-participant is asked to look at things on the walls – a photo of the office building where the actor-worker works in Calcutta – they receive pictures from printers and are asked to identify people in these and eventually, in the final scene, engage in a webcam exchange with the actor-worker, which is revealed by lifting up a potted plant on the desk (or similar action) (Figure 4.4). Throughout the play, information about call centre life and Indian culture is revealed through employing various devices. If they have fully engaged, contrary to a typical call centre exchange, the viewer-participant will have shared a cup of tea, conversed, eaten and danced with, and seen the person on the other end of the call.

FIGURE 4.4 *Rimini Protokoll*, Call Cutta in a Box, 2008–12. ©*Rimini Protokoll*.

Immaterial labour

Call centre work has become paradigmatic of the new service work within the wider phenomenon of globalization. The factory-line of Fordism is now replaced with rows of headset-wearing people sitting in front of screens isolated in their booths. Although appearing earlier (in Lazzarato's writing, for example), the concept of 'immaterial labour' became popular with the publication of Michael Hardt and Antonio Negri's book *Empire* in 2000.[16] In *Empire*, they identified that information and communication now played a central role in production (exemplified in the Toyotist methods of production). For Hardt and Negri, however, it was the service industries that truly presented 'a richer model of productive communication'.[17] And, because the service industries do not produce a 'material and durable good', they defined the labour in this type of work as 'immaterial labour', that is: 'labour that produces an immaterial good, such as a service, a cultural product, knowledge or communication'.[18] In this early account they identified three types of immaterial labour. The first type is informationalized industrial production: production that incorporates communication technologies, which change the production process. The second is analytical and symbolic tasks: computing tasks that involve creative and intelligent manipulation and also routine tasks. And the third was termed 'affective labour' or labour in the bodily mode: the production and manipulation of affect that involves human contact, such as the caring professions.[19]

In Hardt and Negri's later book *Multitude* (2004), which revises and furthers arguments from *Empire*, these types are reduced to two: that of primarily intellectual or linguistic labour, such as problem-solving tasks and the second is affective labour, such as carework.[20] The aspect of immaterial labour that is connected to material production – and its associated communicative technologies – is omitted from their revision. In short, immaterial labour is refocused onto intellectual, knowledge and service-based work. The narrowing of focus onto knowledge and service work incited critics to accuse Hardt and Negri of looking to the '"high" end of the capitalist work hierarchy'.[21] Nick Dyer-Witheford, referring to the writings of George Caffentzis, directs the reader to the counter of immaterial labour – the 'new enclosures' in the global

South – where the poorer people are forced into the sex industry, crime, drugs and low-paid manufacture, for example.[22] Caffentzis also reminds us that the models of labour that Hardt and Negri call 'immaterial' have a very material base in the sweatshop.[23]

Call Cutta... prompts a consideration of the globalized world, the contracting of (cheaper) labour to the global South and the human, material basis of (so-called) immaterial labour. It reminds us that, in addition to manufacturing, service labour is also displaced and relocated to so-called developing (or newly developed) countries for economic purposes and as an effect of globalization. Rimini Protokoll utilize the call centre model to make visible the worker at the other end of the phone. The actor-workers in *Call Cutta in a Box* (and, perhaps, their 'real' call centre counterparts) are not the exploited workers in the 'new enclosures' of the global South to which George Caffentzis alludes; however, these are, much like their 'real' call centre counterparts, Indian workers paid to perform to a predominantly Western audience.[24] More problematic is the idea that the Descon workers in the call centre who work alongside the actor-workers of *Call Cutta* ... are employed because their labour power is cheaper than the Western equivalent (the workers alongside whom the actor-workers perform are providing services for Australian and American among other customers). We are told that the actor-workers are educated, middle class urbanites – is this the same for the Descon co-workers?

It would appear so. Drawing from research on Indian call centres, Christian Fuchs reveals that India is the preferred location for outsourcing work for English-speaking countries.[25] Furthermore, four hundred of the Fortune 500 companies have call centres based in India. Fuchs's analysis reveals that Indian call centre workers are often university educated and overqualified for the tasks they undertake, commonly seeing it as a stopgap, rather than a permanent job; the average salary is 9272 Indian rupees per month, three times the per capita income in India, thus call centre agents consider themselves white-collar professionals. However, call centre work is also 'repetitive, features rigid discipline and large-scale surveillance of employees, has negative health impacts for employees ... and has a hierarchical character with a lack of participation in decision-making.'[26]

In his critique of Hardt and Negri, David Camfield asks how can the qualities of immaterial labour 'informationalize' and 'make

intelligent' such a diverse spread of workers from food-servers to healthcare professionals and teachers?[27] In 'Forward How? Forward Where?: (Post-)Operaismo Beyond the Immaterial Labour Thesis' (2007), Rodrigo Nunes expands on this idea when he compares the work of the waitress and the graphic designer.[28] Although both are engaged in producing affect, once the graphic designer has completed her work, the work can be reproduced without the designer's input. For the waitress, the experience of 'service with a smile' has to be replicated for each customer to ensure a 'genuine' experience. We might consider the call centre worker akin to the waitress, whose 'performance' must be restarted and equally as engaging with each phone call. In this sense, the experience of the actor-worker in *Call Cutta* ... is comparable to that of the call centre worker. At the end of each fifty-minute performance, the 'stage' (in this case, the virtual stage of the computer programme) is reset and the performance begins again. The actor-worker starts to prepare for the next performance. The script contains a checklist for the actor-worker to go through before each performance, which includes things such as deleting and adding photo files, resetting onscreen panels, checking cameras, and so forth. Although working to a script, the actor-workers are afforded more freedom than their call centre counterparts; the script is more open than that of a cold-caller, providing a series of prompt questions to structure the conversation. After hearing from the viewer-participant, the actor-worker is invited to give genuine responses to the questions, revealing their own thoughts and interests. Her real identity is revealed from the outset (in the form of a business card) and details of the actor-worker's life are told.

For the viewer-participant, the experience is unique and, for some, authentic.[29] Writing for *The Globe and Mail*, Simon Houpt expressed that, after Shubu (the actor-worker in his performance) had disappeared from the screen waving goodbye, 'I felt at a loss. I couldn't even say thanks or applaud.'[30] Does this experience provide an antidote to (or the absorption of) the 'artist critique' that criticizes capitalism for its 'inauthentic goods, persons and lifestyles'?[31] In her account, Shannon Jackson recounts the distinct experiences that she and her mother had when they each 'saw' the work in Paris.[32] Jackson recalls that, as a theatre scholar 'in the know', she tried not to get 'caught' by the performance.[33] Her mother's interaction was reportedly less guarded and Jackson

learned that her mother's actor-worker revealed more about her life in India. She suggests that her mother had a more personal conversation with her actor-worker, which continued to resonate beyond the fifty minutes. The following day, Jackson's mother found herself thinking about a question ('do you have any regrets in life?') that the actor-worker had asked her.

Nunes writes: 'As long as each performance of affect has to be repeated for each new customer, the waitress' condition remains different from that of the individual worker who "steps to the side of the production process".'[34] Rimini Protokoll listened to call centre operatives in different industries as research for their play; on the actor-workers' scripts is written 'BE PERSONAL AND INTIMATE.'[35] This is, of course, distinct to a typical interaction with a call centre worker, who is professionally friendly, yet distant and must not deviate from the script. In *Call Cutta ...* , although following a script, that which is usually an impersonal necessary exchange is subverted to become a personal encounter.

Performance, subjectivity and immaterial labour

Hardt and Negri's engagement with immaterial labour comes out of the traditions of the Italian Autonomia and, earlier, Operaismo (Workerism) movements of which Negri was a part. The debates around the concept of immaterial labour were initiated in the *Futur Antérieur* journal that brought together Autonomia and other leftist thinkers. Among those thinkers is Lazzarato, who gives a more thorough analysis of immaterial labour in his earlier essay on the subject.[36] He stresses that immaterial labour is not simply the production of something 'non-material'; in fact, immaterial labour navigates the terrain between mental and manual labour, straddling the division between conception and execution. Through utilizing Fordism's terms, Lazarrato makes clear the transformation of work from the Fordist model to that of a post-industrial type. Further, he proposes that immaterial labour involves the intellectualization of manual labour. This intellectualization is a result of the implementation of new technologies in areas of production that were traditionally manual. Thus, the worker has to learn a new

set of skills in order to be able to adjust to the new technologies and their maintenance. The deskilled worker is reskilled within immaterial labour processes but, arguably, with intellectual or knowledge-based skills rather than manual ones.

Much of Lazzarato's analysis is concerned with the subjectivity of the worker. The subjective nature of immaterial labour requires the worker's personality to be invested in the work that they undertake. Reminiscent of Boltanski and Chiapello's 'new spirit', Lazzarato states: 'What modern management techniques are looking for is for "the worker's soul to become part of the factory." The worker's personality and subjectivity have to be made susceptible to organization and command.'[37] Again, this focus upon subjectivity contrasts the previous Fordist and Taylorist models that encouraged workers to work 'like machines'. However, this change is not necessarily emancipatory; Lazzarato warns that the incorporation of the 'worker's personality and subjectivity within the production of value' could be more 'totalitarian' than the previous labour models.[38] The waitress, in Nunes's example, and the call centre worker are both exemplary. It is clear to see now that the dominance of the computer in workplaces can operate a stricter form of monitoring, rather than act as an emancipatory tool. For example, the logging into a network merely replaces the clocking-in card. This notion follows Marx's warning in his 'Fragment on Machines' (1857–61) (to be further discussed in Chapter Six) in which he predicts that the productive forces of the social brain will become dominant in production and crystallized in machinery.[39] Thus, the creation of wealth will come to depend on the social brain, as opposed to the expenditure of labour time.[40]

As the actor-workers' lives are brought into the performance, Lazzarato's proposition that 'the worker's soul becomes the factory' is equally as applicable to the performed version of call centre work in *Call Cutta ...* . Within the play, Rimini Protokoll cleverly evokes the idea of art imitating life. The actor-workers are working with scripts, under specific conditions, with certain rules ('turn off your personal mobile phone'), undertaking timed phone calls and paid working hours in a place of work – the call centre – while also being asked to bring their personality to each performance. When performative (service) labour becomes paradigmatic of work, how do we distinguish the two?

A note on the feminization of work and unproductive labour

There is another facet of service work referenced in *Call Cutta* ..., which provides insight into the classed nature of call centre work. The term 'immaterial' is more appropriately applied to the 'products' of the labour, that is, services (or, as Marx termed it, general intellect) than the type of work. Carework, for example, is material in the sense that it is a physical form of labour that involves 'material' with regard to human bodies. In her essay 'On Affective Labour' (2011), Silvia Federici points out the lack of reference to the gendered nature of immaterial labour, despite affective labour's leaning towards tasks and traits historically considered as 'women's work'.[41] She suggests that Hardt and Negri overlook the increase of women in the workplace and gender-specific tasks (such as childcare) in favour of proposing that the work itself has become 'feminized' (rather than its workforce). Federici thus invites us to think about the transition from material to immaterial labour otherwise, as one affected by and developed from an increase in women in the workplace during the latter half of the twentieth century.

The blanket 'feminization of work' (also discussed in the work of Guy Standing) thus renders the specificity of women's work (and associated political struggles) invisible.[42] However, as Kathi Weeks notes, under post-Fordism 'both the labour of production and the labour of reproduction are difficult to limit to an identifiable set of workers, let alone to identities as specific as proletarian and housewife.'[43] Taking up Negri's assertion that productive labour no longer produces capital but, rather, produces society, Weeks argues that reproductive labour has morphed into a more productive form of labour (evidenced by its 'many waged forms'). Similarly, she asserts that productive labour has also become increasingly reproductive in the sense that it creates 'social landscapes, communicative contexts and cultural forms' in addition to creating economic goods.[44] Thus the two are no longer separable as was the case in Fordist models of work.

And this returns us to thinking about productive and unproductive labour within post-Fordist, neo-liberal work. Like the term 'immaterial', which describes a type of labour that still has a material base, unproductive labour still produces something (services). As

Weeks intimates, a type of work historically deemed unproductive (broadening Weeks' discussion of 'reproductive labour' in relation to the Wages for Housework debate) has now become one of the dominant forms of labour within the contemporary period. Thus, this work can no longer be 'unproductive' in the Marxian sense, as it is must be profitable to survive the capitalist system (which always has profit as its goal) once implemented en masse. It has become waged labour. As discussed in the introduction, in Marx's writings, unproductive labour is aligned with performance, art and reproductive labour. Within the neo-liberal period, as we have already seen in Boltanki and Chiapello's analysis, productive labour now takes the form of historically 'unproductive' types of work.

Although its main focus is labour in the call centre, *Call Cutta...* also makes reference to waged reproductive labour in the home. At one point in the performance, we are introduced to this other form of labour when some of the actor-workers send photos of people working in the home to their viewer-participant (or in Jackson's case, the actor-worker told her she had a maid at home). When asked by the actor-worker who it is, the viewer-participant assumes it is the person on the other end of the phone. The actor-worker then reveals that this is the maid/cook employed in their home. One actor-worker states: 'India is cheap, we can afford to employ service personnel.'[45] On the informed viewer, the irony is not lost.

This reference to labour in the home is redolent of the devices used by feminist artists working in the 1970s, whose work was focussed on labour. In particular, Margaret Harrison, Kay Hunt and Mary Kelly's *Women and Work: A Document on the Division of Labour in Industry 1973–5* (1973–75), stands out. The three artists undertook a sociological examination of workers in the South London Metal Box Co., Bermondsey, London as part of an artist's fellowship supported by the Greater London Arts Association Thames Television Fund.[46] The work was conceived to observe the effects of the Equal Pay Act, implemented in 1970, in the factory; in the final exhibition, the artists presented documents of labour in the factory, from working hours, tasks undertaken on the different pay scales, interviews with workers, images of the workers and a breakdown of each workers' day, among other information. Within the typed and framed daily schedules presented on the gallery walls as part of the installation, the women workers listed the tasks (which we identify as socially reproductive labour) that they undertook in

the home. For example, getting the children ready in the morning, cooking their husband's dinner, cleaning the home, and so forth. Through exhibiting this information alongside that of productive industrial labour, Harrison, Hunt and Kelly, made visible the unpaid labour that the women worker additionally undertook in sustaining and maintaining the capitalist system. Similarly, *Call Cutta* ... offers a glimpse of the reproductive labour (this time paid) employed in the home of the new service workers through the introduction of the photograph (the image of the worker) into the discussion. It is anticipated that the viewer-participant will assume that the worker depicted in the photograph is the actor-worker, which allows for another reveal: that the call centre worker employs worker/s in the home.

Immateriality and relationality in contemporary artistic practice

Returning to immaterial labour, in *Call Cutta* ... information is exchanged and, for some viewer-participants, new knowledge is produced. Central to the play's functioning is the conversation and thus, communication. The actor-worker is provided with a script and prompt questions; however, the real conversation is dictated by how willing the participant is to engage (as discussed in Jackson's account). Some of the questions are (designed to be) intrusive and also intersect with the types of questions you might be asked by a call centre worker: marital status?; 'are you satisfied with your life?'; 'In your next life, which animal will you be?'; 'What is the biggest mistake you ever committed?'; Drugs/addictions?; 'Any diseases?' A more cautious viewer-participant may choose not to answer some of these.

In *Call Cutta* ... it is clear that the actor-worker is the *worker*. In thinking about the role of non-professionals, Bishop coins the term 'delegated performance', which is used to describe 'the act of hiring non-professional specialists in other fields to undertake the job of being present and performing at a particular time and at a particular place on behalf of the artist.'[47] She references artists such as Santiago Sierra, Phil Collins and Tania Bruguera who hire people to perform their own socio-economic category. Beyond

Call Cutta ... , Rimini Protokoll are known for the use of 'real' people (in place of professional actors); in the past, these have included lawyers, teenagers, old people, lorry drivers and Vietnam War veterans. Unlike their non-art work counterparts, the non-professional specialist is, Bishop argues, hired by artists to increase the unpredictability of a work. This is confirmed when Jackson writes that casting real people threatens to unhinge *Call Cutta* ...'s status as a play.[48] In *Experts of the Everyday. The Theatre of Rimini Protokoll* (2008), Miriam Dreysse and Florian Malzacher state that these people: 'stand at the centre of the production as experts (and very clearly not as amateurs): they create the performances through their stories, their professional or private knowledge and lack of knowledge, through their experiences and personalities'.[49] Here emphasis is placed on knowledge and experience in framing the 'performers' as experts, skills that are commonly attributed to immaterial labour.

Bishop pitches delegated performance as an alternative to the understanding of social practice as a 'micro-model of reification', found in Bourriaud's account.[50] However, there is a tangential link to be made here between Lehmann theorizing in the late 1990s about a new mode of theatre (indebted to post-war experimental art and theatre practices) that activates the spectator and publication of Bourriaud's *Relational Aesthetics* in 1998. The artists whom Bourriaud selects for his discussion of relational aesthetics have one thing in common: the centring of interaction, often of social interaction. For example, Felix Gonzalez-Torres invites viewers to take a sweet from a pile or an arrangement of sweets on the gallery floor and eat it. The emphasis is not on the arrangement of sweets but the taking and eating of one. In this way, the viewer participates in the work, which would otherwise be a static formal arrangement of sweets in shiny wrappers. Similarly, in *Call Cutta* ... interaction is prioritized; without the audience-participant picking up the phone and conversing with the actor-worker, the play is rendered moot. Both postdramatic theatre in the form of *Call Cutta in a Box* and the works discussed in *Relational Aesthetics* use social encounters to prompt questions about our relationship to the world. In her introduction to Lehmann's *Postdramatic Theatre*, Karen Jürs-Munby claims that: 'The spectators [of postdramatic theatre] are ... asked to become active witnesses who reflect on their own meaning-making and who are also willing to tolerate gaps and

suspend the assignment of meaning.'[51] Through utilizing a form of immaterial labour to initiate an international conversation, *Call Cutta in a Box* indirectly invites the viewer-participant to reflect on the complexities of a globalized world.

Contrary to the contemporaneous practices that Lehmann identifies as postdramatic (which 'often focuses on exploring the usually unacknowledged anxieties, pressures, pleasures, paradoxes and perversities that surround the performance situation'), Bourriaud claims that a new kind of artistic practice emerged in the 1990s that encouraged convivial relations.[52] The moments of sociability that are created by these works, Bourriaud argues, are an attempt to escape mass communications and its ideology.[53] Through this proposition, relational aesthetics takes on a political task: these artworks are no longer solely about a social encounter but the presentation of alternative 'life possibilities'.[54] These alternatives are played out in microtopic spaces created by artists commonly within an art gallery.

The relational works differ to the earlier 'dematerialized' conceptual artworks. According to Bourriaud, they do not eradicate or escape form. He criticizes the earlier conceptual artists for fetishizing 'thinking'.[55] Through this criticism, one could argue that Bourriaud is inadvertently suggesting that relational aesthetics fetishizes interaction. However, Bourriaud stresses the role of the material or formal aspect of the work. To distinguish this new practice from conceptual art, he draws attention to the material element of those works that are often considered 'immaterial' because of the prominence given to the interactive aspect of the works. Bourriaud writes: 'What has one bought when one owns a work by Tiravanija or Douglas Gordon, other than a relationship with the world rendered concrete by an object, which, *per se*, defines the relations one has towards this relationship: the relationship to a relationship?'[56] Although it is not, perhaps, intended to reduce the works' understanding to commodified relations, this statement is redolent of Angela Metropoulos' definition of affective labour (immaterial labour in the bodily mode) as the 'valorization of human sociability'.[57] Commodity fetishism is rendered redundant, as the very quality that makes the commodity 'magical' (human labour) is made visible and could be understood as unalienated, in this sense.[58]

In Bourriaud's understanding, the material forms mediate the viewer's relationship to the world. This idea could be considered

a midpoint between the fetishization of thinking (in conceptual art) and the fetishization of form (as with more traditional types of sculpture and painting). Thus relational aesthetics comprises of immaterial and material tropes; the value of which, according to Bourriaud, lies in the relationship that one has with the presented work. Furthermore, he asserts that relational aesthetics represents a theory of form not a theory of art.[59] But it is a social form rather than a material form. This reminds us of Rikrit Tiravanija including 'people' on list of materials for his work or of the room filled with identically dressed women in Vanessa Beecroft's installations. Interestingly, Rimini Protokoll refer to the non-actors they employ in their works as 'theatrical readymades.'[60] *Call Cutta* ... requires objects to function (a mobile phone at the minimum, on the side of the participant) but the conversation is the real 'product'.

In *Call Cutta* ... the actor-worker *is* the immaterial labourer whose (performative) labour time has been bought and with whom an encounter is 'sold' to the spectator-participant. In his 'Foreword', Bourriaud proposes that the relational artworks are indicative of an alternative to the commodification of society, producing 'hands-on utopias'.[61] He rightly identifies that we are living in a world in which the majority of things are commodified and he argues that: 'The social bond has turned into a standardised artefact.'[62] Yet, as in the above citation, Bourriaud alludes to the fact that, despite the omission of a traditional art object, artists still make money through selling and exhibiting the relational artworks: in reality, are these artworks not commodified social relations?[63] With the increasing branding and corporate sponsorship of exhibitions, fairs, galleries and museums – not forgetting the art market – is the artist, in this interpretation, just another (immaterial) labourer?[64] Through various devices (discussing the location of the call centre, the workers on the same shift, and the rules, for example) *Call Cutta* ... makes clear its relationship to capitalism and presents a commodified social relation.

In his 'Critique of Relational Aesthetics' (2007), Stewart Martin points out Bourriaud's fatal error: his belief that art escapes reification through creating social relations rather than objects.[65] Martin explains: 'Capitalist exchange value is not constituted at the level of objects, but of social labour, as a measure of abstract labour. It is the commodification of labour that constitutes the value of "objective" commodities. To think that the source of value is in the

object-commodity is precisely the error that Marx calls fetishism.'[66] Relational works are, therefore, closer to commodification than Bourriaud initially believed.[67] The artists omit the production of the object and replace it with the very act that creates value: labour. *Call Cutta* ... presents a transparent understanding of the labour employed in the work. At no point does the actor-worker pretend to be anyone other than themselves. Once the performance is underway, the viewer-participant understands that they have booked an appointment to converse with a call centre worker based in Calcutta, India.

Technology and immaterial labour

It is, perhaps, easy to make comparisons between what is delineated as immaterial labour and Bourriaud's concept of relational aesthetics. These comparisons are not without validation: the emphasis on human relations rather than object-production; the creation of an immaterial cultural product; communication and the 'manipulation of affect that involves human contact' – found in relational works such as Tiravanija's cooking pieces – makes the two comparable, on the surface at least.[68] However, the two types of labour (immaterial and relational-artistic) depart on a fundamental aspect of the new economic model: communicative technologies. Bourriaud argues that relational artists encourage social relations as a response to the proliferation of telecommunications and its associated technology that detract from the qualitative human relations in society. In this respect, the two concepts could not be more distinct in their intentions: relational aesthetics escapes the new technological advancements through a return to sociality, whereas immaterial labour embraces the new technologies at the level of production and also analytical tasks. These technologies adopt a positive role in Hardt and Negri's initial musings on immaterial labour in *Empire*.

Returning to Marx's 'Fragment on Machines', we read that: 'The accumulation of knowledge and of skill, of the general productive forces of the social brain, is thus absorbed into capital, as opposed to labour, and hence appears as an attribute of capital, and more specifically of fixed capital, in so far as it enters into the production process as a means of production proper.'[69] If we are to

acknowledge the centrality that Dyer-Witheford claims the *Futur Antérieur* thinkers place upon this section from the *Grundrisse*, the inherent connection between technological development and the social brain becomes clear.[70] Hardt and Negri take up Marx's idea and argue that information and communication now take the foundational role in production processes. Further, they claim that: 'we increasingly think like computers, while communication technologies and their model of interaction are becoming more and more central to labouring activities'.[71]

Bourriaud's claim for what he terms relational aesthetics – which escape the physical constraint of communication technologies and replaces these with human interaction – does not address the idea that the social brain is also subjected to capital. This omission may have originated in the idea that knowledge and skill 'appear' as an attribute of capital and are thus normalized as a part of capitalist labour through this appearance. Relational aesthetics cannot be aligned with immaterial labour because of the emancipatory ambition – the emancipation from capital – that Bourriaud believes his selected artists to hold in their work. This incompatibility is specifically because Bourriaud sees the emancipation as occurring through encouraging human interactions in the face of technological advancement in society. He does not acknowledge the role of these technologies in organizing an exhibition of these works – electronic mailing lists and the dialogue between gallery and artist, for example – that forms part of the division of labour in the artworks. Hence, Bourriaud's myopic vision exists predominantly within the gallery space; the microtopic atmosphere is penetrated once the visitor steps out onto the street.

Rather than escaping them, communicative technologies are central to *Call Cutta* Even in its pared back predecessor (*Call Cutta*) the mobile phone was the technical support for the entire work. The play only really begins when the phone is answered. It utilizes the tools of communication to reveal the viewer-participant's relationship with capitalism. The viewer engages in a one to one experience, which is intended to conflict with the usual call centre exchange through introducing intimacy and revealing the real worker. Simultaneously, the work also plays on the personalized experience that neo-liberalism promises (yet never delivers). The play provides the appearance of intimacy while also aligning the performer with the worker, something increasingly common in the

service industries. This is a paradox; the use of a script in everyday call centre work is, of course, a device borrowed from performance.

Conclusion

To return then to *Call Cutta in a Box*, we bear witness to the difficulties in articulating the distinction between real/performance in contemporary working models as work begins to not look like work. Although the work's success is in breaking the usual divide between consumer and service-provider – the personalization of work that Jackson mentions – and thus exposing the artifice of immaterial labour; this, I would argue, is not its only function.[72] Each iteration is slightly different; there are sometimes two script options for each location, dependent on the room of the performance. During the performance, we are given insights into call centre life. For example, when one actor-worker applauds her viewer-participant's singing, the workers in the call centre join in the applause. The actor-worker explains that the other workers could not hear the singing but it is call centre culture to join in applause when someone claps as it marks a sale. In another instance, the actor-worker reveals that it is around 11 p.m. and the viewer-participant states 'you're working late' to which he responds 'it is a call centre'.[73] Again, revealing that late shift patterns are typical.

There are other built in devices – such as the actor-worker coughing – that reveal the rules of the call centre, that is, no eating. The actor-worker is then able to ask if the viewer-participant would like to be let in on one of the rules of which they are invited and select a number from one to six. On the script, there are six rules listed, which the actor-worker is able to reveal. In the final scene, the viewer-participant is able to see the call centre through the webcam chat, revealing the 'reality' of the call. The actor-worker shows the other workers in the call centre and even discusses to where they are selling; in one instance this is Australia and the actor-worker reveals that the workers have to pretend to be in Australia and adopt false names and false accents. The actor-worker also acknowledges other workers on the 'theatre shift' who might be providing the same service to viewer-participants in Dublin or Berlin, for example.

Through returning the personal to the performance, Rimini Protokoll exposes the falsity of the capitalist co-optation of qualities

associated with immaterial labour – social interaction, for example – and artistic labour – that is, freedom – in the service-based, affective labour of the call centre. Jackson writes: 'Rimini Protokoll began to grapple with art's imbrication *within* rather than valiant separation *from* the social formations they critiqued.'[74] With this we can return to earlier chapters in thinking about the co-optation of the artist critique and the adoption of the artist as model worker under neo-liberalism. *Call Cutta in a Box* reveals to us, through artistic media, real-life information about working conditions and the capitalist ideologies stemming from these distinct modes of work. It is not incidental that Rimini Protokoll employed actor-workers and found a base in a call centre in India – these are the labour conditions of global capitalism. The play engages with real working people under real conditions and this entanglement makes it a complex work. Although sharing commonalities with Bourriaud's relational aesthetics, which could be understood as the institutional response to a widespread immaterial labour, *Call Cutta ...* is not as easily exposed as creating 'false' relations. Perhaps this is because of the intimacy of the one-to-one phone call or, simply, in its provocation to think about those workers on the other side of the world and the conditions under which global capitalism operates.

CHAPTER FIVE

Affective action: Liberate Tate (2010–)

In July 2012, Tate Modern opened up a new dedicated space for exhibiting live art, performance, installation and film. This space was in the bowels of the former Bankside Power Station, in rooms referred to as 'The Tanks', a name that references the former purpose of the space as subterranean rooms in which oil was stored. In 2016 the first season of Tate Exchange was initiated; located in the new (then-named Switch House) Blavatnik Building extension, Tate Exchange is billed as: 'An annual programme that brings together international artists, over 60 partners who work within and beyond the arts, and you. A journey of discovery into the different ways that art has become active over the last 60 years and how artists have changed our understanding of what art can be and what it can do.'[1] The first season was focussed on the theme of 'exchange' and, appropriately, the current season's theme is 'production'. The symbolic resonance of opening The Tanks – the world's first 'museum galleries permanently dedicated to exhibiting live art, performance, installation and film' – and the participatory Tate Exchange in the contemporary period (while still relegating this work to the subterranean strata of the gallery) is appropriate given neo-liberalism's co-option of the performing artist, to be discussed in this chapter.[2]

As discussed in Chapter Two, Tate Modern was born within the particular economic context of neo-liberal Britain. This was a period

in which the arts were being made accessible to a wider audience (a year and a half after its opening in May 2000, free admission was announced for all national galleries in England). At the same time, one might argue that the arts were simultaneously being commodified through the establishment and on-going development of the creative industries. Blair's New Labour government inherited some of the cultural hang-ups of the preceding Conservative government initiated by Thatcher (and concluding with Major) as prime minister. Under Thatcher, corporate sponsorship of the arts increased and was openly encouraged as a public relations strategy for businesses. As Chin Tao Wu sets out in her important analysis, alongside the 'cultural capital' that being associated with the arts had to offer, the tax concessions allowed for the category of 'sponsorship' (redefined under Thatcher) were also attractive to corporations.[3] While reducing state arts funding (something readdressed under New Labour), free market, flexible capitalism thus encouraged exhibition sponsorship to the highest corporate bidder.

As Wu highlights, and Mel Evans takes up in *Artwash*, companies that belong to industries 'whose image is in need of polishing' (i.e. tobacco, petroleum and weapons) are often most attracted to arts sponsorship.[4] In 1990 the recently privatized British Petroleum (BP) began to sponsor the Tate collection. Since its opening in 2000, Tate Modern's Turbine Hall has welcomed a sponsor beginning with Unilever and, after a three-year hiatus, in 2015 Hyundai committed to an (unprecedented) eleven-year sponsorship deal. At 11.53 am on the 13 June of the same year, seventy-five black-clothed and veiled figures entered the Turbine Hall and proceeded to write on the floor with willow charcoal. The performance lasted until 12.55 pm the following day. This was not a Tate-commissioned work but an unsanctioned performance by the art-activist group Liberate Tate.

In a now well-known origin story, the group formed at a Tate commissioned workshop on art and activism in January 2010. Its first intervention – an 'art not oil' sign displayed in the member's room window overlooking the Thames – was made in response to being told by Tate not to make work about the sponsors. Conversely, the request encouraged participants to look more closely at the corporate sponsors and, in particular, BP.[5] And this returns us to Wu's important analysis that acknowledges the role that sponsorship plays in making a company appear cultured,

philanthropic and benevolent. By Tate attempting to protect the image of the sponsors, the gallery assists in maintaining the corporate sponsorship motivated by what Mel Evans has termed 'artwashing', a form of image-cleansing through the company's alignment with the arts.[6]

While the motivations of Liberate Tate's practice are important, this chapter focuses on the wider conditions and performative aspects of the group's activism. Contrary to the types of practice introduced in the previous chapter, which might be seen as adapting to changes implemented within a neo-liberal economy, this chapter looks to those artists/practitioners who do not adapt to the changes but whose practice nevertheless utilizes these tropes for political action. In fact, these performers step outside of the structuring institutions of art (if not the institution itself) to critique the institution's relationship to capitalism. As such, the case study for this chapter is the British-based art-activist group Liberate Tate. The following picks up the discussion of immaterial labour from the previous chapter, refocusing on the affective mode of labour in Michael Hardt and Antonio Negri's analyses. In understanding the alignment of performance and action in Liberate Tate's practice, Paolo Virno's call for the assimilation of intellect with action (as opposed to intellect with work) is discussed in relation to the role of the virtuoso under neo-liberalism. Focusing on Tate's London galleries, in concluding the chapter, I propose that the institutional space of the gallery could be understood as a microcosm of the multitude made up of virtuosos (Virno).[7] Within this context, Liberate Tate provide a way for thinking about how action can be assimilated with intellect to disrupt the co-optation of collective and creative traits by capitalist work.

Affective labour

The writers on immaterial labour discussed in the previous chapter (Hardt, Negri and Lazzarato) hold in common a view that the shift to immaterial labour could provide the impetus for anti-or alternative to capitalist activity. This potential lies specifically in affective labour, which Hardt and Negri define as: 'labour that produces or manipulates affects such as a feeling of ease, well-being, satisfaction, excitement, or passion'.[8] In their argument,

it is the subjective turn facilitated by affective labour under neo-liberalism that allows for anti-capitalist activity to develop. In 'Affective Labour' (1999), Hardt states: 'Given the role of affective labour as one of the strongest links in the chain of capitalist postmodernization, its potential for subversion and autonomous constitution is all the greater.'[9] As affective labour always requires the presence of others, Hardt considers this type of work to be collective by nature. Thus, the cooperative, collaborative and communicative features of immaterial labour (and specifically its affective mode) become central to Hardt and Negri's concept of the 'multitude'.[10] This concept is presented as an alternative to existing terms such as 'the people' and 'the population' that Hardt and Negri see as homogenizing plurality; alternatively, the multitude is seen as 'plural and multiple'.[11] It is composed of a set of singularities within a social subject that cannot be reduced to sameness. Thus, it is deduced that the multitude is based on the bringing together of differences and of heterogeneity.

We might pause here to consider the multiplicity of art practices under the 'social turn' both within and outside of the art institution. The effect of an ideology that fosters subjectivity while embracing plurality, collectivity and multiplicities can be problematic for studying critical politically engaged art practices. The neo-liberal embrace of heterogeneity (on the surface at least) makes it difficult to ascertain which works are simply commensurate with neo-liberal ideology, adopting the appearance of critical work, and those that are engaging in political action. The aestheticization of politics is now common; a work like Jeremy Deller's *Battle of Orgreave* (2001) is exemplary. *The Battle of Orgreave* was a one-off performance on 17 June 2001 that comprised of a re-enactment of a historic 'battle' in British history. It brought together eight hundred participants from distinct social groups: historical re-enactors (the experts), ex-coal miners, ex-police officers and members of the (largely working class) public from Orgreave, South Yorkshire. The performance recreated a violent clash between coal miners and the police force that took place on 18 June at the height of the 1984 miner's strike in Britain. More than one third of the participants were former miners and police officers who were involved in the original clash, with the recreation largely taking place at the original site.

The event was recorded and made into a film directed by Mike Figgis; Deller was involved in the editing of the film: 'I wanted to

make a political film about the miner's strike on the back of an artwork.'[12] This statement reveals the political ambition of the performance itself that, here, is situated firmly within the realm of 'art'. The work takes on the appearance of political action – it depicts an historical struggle still etched on the collective unconscious of at least one third of the participants in the performance – however, for Deller, it remained as art. It merely replicated or re-enacted political action. Despite its political aesthetic, Deller did not intend the work to be politically affective (that is, as activism); he has stated that his intention was to restage a crime scene and not to encourage a cathartic moment. He further claimed that, if anything, he wanted to make people more angry.[13] Although the anger could precipitate further action, it was not the intention of the work. In fact, we learn from Figgis' film that the ex-miners were warned that if they became aggressive, their payment would be withheld.[14]

Hardt claims that affective labour produces: 'social networks, forms of community, biopower'.[15] Biopower, in this sense, refers to: 'the production of collective subjectivities, sociality, and society itself'.[16] The political potentiality therefore lies in the communicative nature of a kind of labour that produces 'socialities' and 'collective subjectivities'.[17] Hardt proposes that there is the capacity for what he terms 'biopolitics' (after Foucault) because of the dominant position of affective labour in capitalist production.[18] In Foucault's understanding of (specifically, American) neo-liberalism, biopolitics extends the rationality of the market 'to domains which are not exclusively or not primarily economic: the family and the birthrate, for example, or delinquency and penal policy'.[19] This latent biopolitics that Hardt identifies is found in the dual nature of biopower: on the one hand it is associated with the production and reproduction of life (taken from feminist analyses) that is the foundation for capitalist accumulation. On the other hand, the production of subjectivities and affect hold potential for 'autonomous circuits of valorisation' that Hardt considers to be a possible liberation.[20]

However, we have to beware of the development of these autonomous circuits. Emma Dowling warns of how the valorization of social reproduction (which is a mode of affective labour) has become susceptible to the extraction of surplus within the neo-liberal capitalism. Dowling uses the term 'affective remuneration' to describe the phenomenon by which capitalism extracts surplus

from, for example, voluntary labour, in exchange for affect (i.e. the feelings associated with doing charity work).[21] Thus, while the work is valorized, it is still not valued. Furthermore, David Harvey criticizes Hardt and Negri's emphasis on the production of subjectivities as new to this particular mode of capitalism. He argues that capital as a social relation is a foundational proposition; in Marx's analysis, all commodities are symbols of social value.[22] The increased visibility of the commodification of subjectivity in the contemporary period, reminds us, once again, of Marx's warning that the creation of wealth will become dependent on the social brain rather than the expenditure of labour power.

Hardt and Negri began to make the argument for a latent politics in the new work models in *Empire*, in which they somewhat optimistically proposed that: 'Today productivity, wealth, and the creation of social surpluses take the form of cooperative interactivity through linguistic, communicational, and affective networks. In the expression of its own creative energies, immaterial labour thus seems to provide the potential for a kind of spontaneous and elementary communism.'[23] For Hardt and Negri the political potential of affective labour lies in the collective, network-based, communicative socialities that capitalism produces. This proposition overlooks the idea that these communicative socialities produced by capitalism have been co-opted and subsumed from an earlier moment of radical critique. Capitalism has already made benign the radical critique of the 1968 moment; as we have learned, the freedom and autonomy demanded in the artist critique was granted, on the surface at least, in the 'new spirit' of the 1990s.

In developing the idea of the multitude, it is acknowledged that cognitive labour produces a multitude of singular producers.[24] Thus, cognitive labour and singularity (or, as I understand it, the individualism, autonomy and heterogeneity fostered by neoliberalism) brings about a desire for artistic expression, which leads Negri to the idea of a potential in relation to artistic practice in the 'era of cognitive labour' in his 2008 article 'Metamorphoses'.[25] Here artistic practice is aligned with the body and the production of knowledge in the collective. He identifies three stages within (what he terms) 'biopolitical labour': first, it presents itself as (internal) *event*; secondly, it is a *multitudinous event* (within which are identified the same 'collective and cultural characteristics' as contemporary industry); and thirdly, he argues that the *multitudinous event* is

excess open onto the common.[26] This final stage aligns labour with artistic production which, Negri states: 'traverses industry and constitutes common languages. Therefore, every production is an event of communication, and the common is constructed through multitudinous events'.[27]

In this neat argument Negri clearly sees cognitive labour (which is becoming more *bios*) as producing an artistic phenomenon. He argues that the thing it produces 'transcends the independence and autonomy of its own production'.[28] However, through the preceding discussion of art's historical correspondence with the forms of capitalist production and the examples that he cites, it is clear that Negri has in mind object-producing artistic practices. Thus, the three stages largely remain focussed on the question of ontological development (which he earlier evokes in relation to the writings of Wilhelm Dilthey) in his analysis. Furthermore, the reference to ideas around the aesthetic – to the beautiful and the sublime via Kant – highlight perhaps a need for thinking about art and immaterial labour beyond the existing aesthetic paradigms separate from the Romantic.[29]

Interestingly, Negri does not cite any examples of contemporary art practice that engage the multitudinous event. We might consider Deller's recreation a multitudinous event, which brought together a diversity of people to re-enact a moment of political and actual trauma in the locale. The performers were paid (presumably from the funding by Artangel), so we could understand this as waged (affective) labour aligned with artistic production. However, if the participants were angry, the political potential of revisiting or creating new knowledge of the event was never realized beyond the performance itself. At best, it created a spectacle (human communication that has been commodified).[30] So, how do we get from the event to (what Hardt and Negri identify as) the common, what does it look like *materially* and what do we do when we get there? The intimation is that art has somehow remained on the outside, in its relative autonomy, and will bring this political potentiality to evoke the politicization of workers (who increasingly act like artists). However, this argument abstracts the nature of the work from its role as waged labour. The freedom associated with immaterial labour, as we have seen, is only apparent (and often short-lived once work becomes routine). By 2001, even Bourriaud had back-tracked on the radical potential

of art engaging in relational aesthetics (which is based on the event) when he asks in his 'Berlin Letter' (2001): 'now that the ideology of internet links and continuous contact has come to pervade the globalised economy (Nokia: "Connecting people"), how much critical radicality is left to work based on sociality and conviviality?'[31] By 2016 Tate Modern – the same year it was claimed to be the most visited modern art museum in the world – had opened dedicated spaces for event-based, performative and participatory practices.

Hardt and Negri's ideas about the potential of biopolitics (via affective labour) becomes less palpable when they develop the proposition, in *Commonwealth*, that it could form the basis of an entirely new regime change that they term altermodernity (which cuts diagonally across capitalism and socialism).[32] As Harvey points out, because Hardt and Negri draw on Spinoza and Kantian philosophical ideas the material conditions of this new altermodernity are never established in their analysis.[33] The concept of becoming is central to their ideas on subjectivity, Hardt and Negri write: 'We will have to discover the passage from revolt to revolutionary institution that the multitude can set in motion.'[34] Thus we might understand their altermodernity as the end point of part of a longer process of becoming.

There are aspects of Hardt and Negri's analysis of immaterial labour, however, that are relevant to thinking about political artistic practice and that are developed in the work of other thinkers useful to this analysis. Negri elaborates on the potential of the multitudinous event when he writes: 'Consequently, this is how the capacity to renew the regimes of knowledge and action that – in the era of cognitive labour – we call artistic is determined.'[35] This coupling of knowledge and action is central to Paolo Virno's thinking around political action in the age of neo-liberalism and forms the basis for my thinking about Liberate Tate's performative action in this chapter.

The activist and the virtuoso

Paolo Virno's argument is analogous to and yet distinct from those of Hardt and Negri. Like Hardt, Negri and Lazzarato, Virno also discerns the symbiosis of work with general intellect/social

knowledge as the aspect of neo-liberal capitalist production in which the potential to affect sociopolitical change lies.[36] Virno sees the symbiosis as a hindrance to action because, he argues, 'work has absorbed the distinct traits of political action'.[37] The absorption of the traits of political action, he continues, was made possible by: 'the intermeshing between modern forms of production and an intellect that has become public'.[38] The intellect that has become public is found in the knowledge aspect of the immaterial labour in Hardt and Negri's writings. In Hannah Arendt's writings (from which Virno takes reference) she argues that both the virtuoso and the politician have in common two elements: both need an audience and a publicly organized space for their practice.[39] Political action is thus allied with qualities associated with virtuosity. Virno writes: 'Every political action, in fact, shares with virtuosity a sense of contingency, the absence of a "finished product", the immediate and unavoidable presence of others.'[40] Thus, the virtuosic is precarious, immaterial and social.

Akin to Boltanski and Chiapello's 'artist', Virno cites the virtuoso – the performing artist – as influencing new work models under capitalism. Virtuosity was once reserved for the realm of politics; however, he argues that under post-Fordism, the three fundamental spheres of the classical division of human experience – labour, political action and intellect – have become blurred, with the virtuoso taking centre stage within post-Fordist labour.[41] In line with Hardt and Negri's multitude made up of singularities, Virno's post-Fordist multitude is the 'multitude of virtuosos'.[42] Under this model, labour turns into a virtuosic performance (incorporating the subjectivity on which Hardt and Negri write and reminding us of Nunes' waitress example cited in the previous chapter who continuously 'resets' her performance). In Chapter Four we saw how call centre workers adopt attributes of the performing artist with given roles, names and scripts while undertaking durational performances in the form of phone conversations. Furthermore, the service industry more widely becomes one of performance, with the worker's subjectivity incorporated into the expended labour-power. This is evident in the call centre worker whose role becomes that of a scripted performer.

Virno claims that post-Fordism is the 'communism of capital'.[43] This lies in the alignment of capitalist production with traits such as communication, abstraction and the self-reflection of living

subjects, which now constitute the general intellect.[44] He builds on this idea, arguing for a coalition between intellect and *action* rather than the dominant model of intellect and *work*. How we are to utilize the social knowledge that immaterial labour produces is never really addressed by Hardt and Negri. Virno's account appeals because of its contradictory nature: on the one hand, he proposes the potential for a redefinition of political praxis but, on the other, he agrees that the 'virtuosity' – the realm of politics and ethics – has been co-opted by capitalist production. If capitalist virtuosity continues the political potential is rendered redundant. So, how does one (or rather, many) utilize social knowledge for the greater good?

Performing action

The notion of the performative consistently appears in discussions of contemporary capitalism and work. Virno utilizes the concept of virtuosity (from Aristotle, Arendt and Marx's writings) to argue that new work models now embody the 'special capabilities of the performing artist'.[45] Furthermore, Virno identifies the massification of this type of labour with the onset of the culture industry.[46] In Virno's account virtuosic labour is considered to be unproductive labour that is now waged.[47] It is, first, an activity that finds its own fulfilment in itself and without producing a finished product; and, secondly, it requires the presence of others: 'the performance only makes sense if it is seen or heard'.[48] He draws on the distinction that Artistotle makes between material production and political action in which material production is activity-with-end-product, and, the latter, activity-without-end-product.[49] Historically, virtuosity had two functions, it either concealed the structural characteristics of political activity (Artistotle, Arendt) or it takes on features of waged labour that is not productive labour (Marx). However, today: 'This bifurcation decays and falls to pieces when productive labour, in its totality, appropriates the special characteristics of the performing artist.'[50] At the heart of Virno's analysis is the transformation of historically unproductive modes of labour into productive waged labour; that is, the service industries, or what Virno calls 'servile labour'.[51]

When confronted with a society now comprising of 'performers' (that has the appearance of political action), Virno readdresses the possibilities of a politically engaged alternative to the virtuoso. He calls for a coalition between intellect and action as a response to the virtuosity that has infiltrated capitalist work. Only when the individuals that make up the multitude align intellect with action, rather than work, do they become re-politicized. The formation of a group like Liberate Tate might constitute a re-politicized moment within the multitude whose practice subverts the capitalist virtuosic by recoupling intellect and action.

Liberate Tate

So let us return to the appearance of a group of black-clothed, veiled figures in the Turbine Hall on the 13 June 2015. The unsanctioned performance – known as *Time Piece* – was arguably one of Liberate Tate's most ambitious actions. The performance required Liberate Tate to remain within the Turbine Hall after the gallery was closed.

FIGURE 5.1 *Liberate Tate*, Time Piece, *2015. Photo: Martin Le Santo-Smith.*

The performance was conceived to last from high tide on 13 June (11.53 am) to high tide the following day (12.33 pm). Liberate Tate describe it as:

> A textual intervention, Time Piece is a tide of stories and narratives flowing in waves up the slope of Tate Modern's Turbine Hall. The texts are fictional and factual responses to art, activism, climate change and the oil industry. The performance explores lunar time, tidal time, ecological time, geological time and all the ways in which we are running out of time: from climate change to gallery opening hours; from the anthropocene to the beginning of the end of oil sponsorship of the arts.[52]

Beyond the performance of inscribing quotations from texts in willow charcoal rising up the Turbine Hall's sloped entrance, the intervention was meticulously planned (Figure 5.1). It was not a casual protest but an orchestrated durational action. The performers brought with them sleeping bags (in Liberate Tate's signature black), sustenance (in the form of self-heating food), toilets and a social media hub. Each performer also brought with them a book; a library of texts related to art, activism and oil was created throughout the duration from which the performers selected their quotations.

The site of the Turbine Hall was not arbitrarily selected. This was Liberate Tate's fifteenth performance and not the first to take place in the Turbine Hall. In 2010, Liberate Tate members released black balloons onto the strings of which fish and feathers were tied in reference to BP's involvement in the Gulf of Mexico oil spill (*Dead in the Water*, May 2010); in July 2011, on the invitation of Liberate Tate, Reverend Billy performed the *Exorcism of BP* in the Turbine Hall; in January 2012, Liberate Tate walked a piece of Arctic Ice from the Occupy camp at St Paul's Cathedral into the Turbine Hall (*Floe Piece*) and, in July the same year, gifted a propeller from a wind turbine to Tate leaving it on the floor of the Hall (*The Gift*) (Figure 5.2); and, in 2014, the Turbine Hall was the site of *Hidden Figures* – an unrehearsed performance involving a sixty-four square metre black cotton square (referencing the concurrent Malevich exhibition), which was used in a manner reminiscent of parachute games to highlight Tate's refusal to disclose how much money BP sponsorship provides (Figure 5.3).

AFFECTIVE ACTION

FIGURE 5.2 *Liberate Tate, The Gift, 2012. Photo: Martin Le Santo-Smith.*

The Turbine Hall's sanctioned commissions have always been tasked with creating something spectacular (in the truest sense of the term). An invitation to exhibit in the space must fill an artist with excitement and apprehension (much like the sublime, which has been engaged more than once in the Turbine Hall commissions). The commissions began with Louise Bourgeois' large-scale sculptural, yet interactive, installation of three towers – *I Do, I Undo, I Redo* (2000); from the outset the Turbine Hall commissions invited the viewer's interaction. Even the more formal works – Anish Kapoor's *Marsyas* (2002) and Rachel Whiteread's *Embankment* (2005), for example – asked the viewers to negotiate their way through the space. Olafur Eliasson's *The Weather Project* (2003) altered the visitors' perception of the space through its use of light and mirrors, creating an environment in which visitors would sit, lie down and spend time. As I write this chapter, Superflex is currently occupying the space with an invitation for visitors to swing on purpose-build swings in threes in order to defy the law of gravity and to change the world.[53]

The Turbine Hall has also been a site of more openly political commissions: Ai Weiwei's *Sunflower Seeds* (2011) referenced the global politics of the 'Made in China' phenomenon, while Doris

FIGURE 5.3 *(2 images): Liberate Tate,* Hidden Figures, 2014. Photos: Martin Le Santo-Smith.

Salcedo's *Shibboleth* (2007) opened up a subterranean chasm in the Turbine Hall's floor to make visible the overlooked and as a reminder that, despite Europe's postcolonial claims, racial hatred remains. The scar is still visible within the space today and it is over which Liberate Tate performers inscribed their own political words on 13 June 2015. When, in 2009, Tate purchased Tania Bruguera's *Tatlin Whisper #5* (2008), two policemen on horseback entered the Turbine Hall and used various methods of crowd control on the unsuspecting gallery visitors.

In short, the Turbine Hall is a space in which it seems anything can happen; the spectacle – in Virno's understanding, human communication that has become commodity – becomes common within the Turbine Hall commissions. It has been the site of sanctioned political critique, performance and participation. And this is what makes a piece like *Time Piece* affective. In some ways, the contemporary art institution magnifies a section of the (de-politicized) multitude made up of virtuosos.[54] Historically, the public that belongs to museums and galleries have been understood as belonging to a certain class, or educational background.[55] Although not delivering a direct reflection of British society, we might consider that given the decline in British manufacturing a portion of the visitors to Tate Modern are comprised of people employed in the cultural industries or in service/affective/immaterial work.[56]

The commissioned performative (or relational) works take on the appearance of intellect now combined with work – that is, they adopt the traits of immaterial labour.[57] *Call Cutta in a Box*, for example adopted the appearance of work – through using the call centre – and employed the tropes of the performing artist (through the script and the call centre worker). Although the work provoked a consideration of the global structures of labour, it was not intended as political action. Intellect is the abstract thought which has become the pillar of production.[58] Now that work is aligned with the virtuoso, it could thus be argued that sanctioned political critique (such as some of the works that Bourriaud dubs 'relational') is neutralized by the framing institutional support of the museum, replicating the virtuosic co-opted by (art) work.

The subsumption of non-object production (i.e. unproductive labour) as the dominant work mode forms the basis of Virno's thinking. He argues that all political action is virtuosic and thus

virtuosity is intrinsically political. The problem lies in separating the three spheres (work, intellect, action) that have become entwined within contemporary capitalism. Artworks that no longer produce an object, similarly, become common within contemporary art production, and this began to permeate the art institution. Hirschhorn has famously stated (paraphrasing Jean Luc Godard) that he does not make political art but does art politically.[59] Thus, it becomes a question of how do we separate politics from art work?

In 2012, Tate commissioned their first live work for the Turbine Hall series: Tino Sehgal's *These Associations* in 2012. It comprised of 'an assembly of participants whose choreographed actions use movement, sound, and conversation'.[60] In addition to the choreographed movements, the performance involved the performers approaching visitors and answering a question they hadn't been asked. The Turbine Hall was filled with unexpected encounters between the performer and members of the public. We might understand the performers and the visitors to the Tate as belonging to the (now de-politicized) multitude, comprised of virtuosos. While the encounter with a performer might be unexpected for some visitors, the intellect (the performative skills) remained aligned with artistic work.[61]

Virno sees work as adopting the traits of political action; in our analogy it becomes difficult to distinguish between artwork that adopts the appearance of politics (through its virtuosity) and those engaging in political action.[62] And this mystification is used to Liberate Tate's advantage; in its performances, the tools of both the performer and the political activist are brought together. Furthermore, the group avoids the rescindment of their politics through their unsanctioned status. The fact that the group is not invited to perform activates the politics within the public space of the gallery. The context of commissioning temporal, interactive performances such as Sehgal's (in which a stranger might approach you and start talking) or Bruguera's (where you might be kettled into a corner of the Turbine Hall by horse-backed police) allows for Liberate Tate to walk into the gallery and set up camp without hindrance from the public. The performers in *These Associations* belong to the virtuosic multitude – people paid to perform; the performers in Liberate Tate are there for a different reason. The two may seem similar (this is the alignment of the virtuosity with work);

however, Liberate Tate aligned knowledge – the general intellect of the multitude – with political action.

In *Artist at Work*, Kunst argues that the 'constant flow of relations' in the gallery is 'never threatened by incontrollable or unpredictable social dissent' due to the institutions' 'meticulously structured spaces'.[63] Liberate Tate provide an exception to the argument. The group constitutes a politicized moment within the multitude through realigning the performing artist with politics; however, the nature of capitalist work allows for its possibility within the institutional space. We could understand this practice as fundamentally dialectical: Liberate Tate's practice is reliant on the group's position as both inside and outside of the institution. The group exists because of the institution; the collective was born out of a Tate-held workshop. However, their performances are not commissioned nor sanctioned by the galleries; rather, it engages in uncommodified 'spectacles' within the gallery space. Thus the politicized practice of Liberate Tate balances on the axes of the group's relative autonomy; that is, they simultaneously operate as art and also as non-art. Members of the group come from activist, artistic, gallery and academic backgrounds; some trained in drama and others in artistic practice and theory. This combination of theatrical, artistic and intellectual skills contributes to the group's success. The group do not just adopt the qualities of the virtuoso; they *are* performing artists. It also includes Tate members, whose membership helps to fund the Tate. Again, they are autonomous from, yet attached to the Tate. This dialectical relationship (inside-outside; subject-object; performative labour-knowledge) then finds its temporal synthesis in action, which relies on the group being both inside and outside of the Tate and the art world, bringing together both subjective (information) and objective (the use of props and the material space of the gallery) aspects and also utilizing performative skills combined with intellect for the purpose of action.

The Performer's Tools: *Parts per Million* (2013)

The Turbine Hall is not the only gallery space in which Liberate Tate has performed. The group has also undertaken performances within

the older Tate Britain; this gallery has particular resonance as the site of the group's first performative action (after hanging the 'art not oil' sign in response to the workshop). It also has resonance, as it was the only Tate gallery at the beginning of its relationship with BP. While *Time Piece* relied on text, through the inscription of words on the sloped floor, *Parts per Million* (2013) relied on the voice (Figure 5.4). The action might be considered as adopting more traditional aspects of performance; it was a choreographed performance, including stage directions and a script. *Parts per Million* (Liberate Tate's tenth intervention) took place at Tate Britain on 23 November 2013, coinciding with the official reopening of the gallery's chronological rehang of the public collection now titled the 'BP Walk Through British Art.' Beginning in 1840, the year in which the impact of the industrial revolution was first felt, fifty veiled figures dressed in black entered each gallery space and counted aloud the increase in atmospheric carbon parts per million during each time period.

Intellect is central to Virno's understanding of post-Fordist labour. Returning to the virtuoso analogy, the score from which the multitude now plays is general intellect. It is also collective: 'public intellect is one and the same as cooperation, the acting in concert of

FIGURE 5.4 *Liberate Tate,* Parts Per Million (1840 gallery), *2013. Photo credit: Martin Le Santo-Smith.*

human labour, the communicative competence of individuals'.[64] The knowledge gained from work is no longer put to work for labour (in terms of object production), but directly contributes to capital. These moments of collectivity in contemporary working practices – the temporary project, the fostering of networks – are symptomatic of this transition from the dominance of manufacturing to that of intellect aligned with work. This is in contrast to the (political) public sphere created in the past when intellect and language coincided. The shift towards non-object production in social modes of artistic production (such as those discussed earlier in this analysis) could similarly be attributed to this wider economic shift, which creates work that has the appearance of politics (a public sphere). The creation of work that appears as a public sphere might also provide reason for Bourriaud's identification of a potential politics in the examples that he discussed in *Relational Aesthetics*. Similarly, we might understand Hirschhorn's monuments as constituting temporary public spheres. This confusion is utilized by Liberate Tate.

Like the virtuosic multitude, Liberate Tate engages in cooperation. The group brings together varying numbers of participants dependent on each action. *Parts per Million* required fifty people, whereas *Human Cost* only three. The score of post-Fordist (neo-liberal) society is general intellect; Liberate Tate's actions are also concerned with the production of knowledge. In *Parts per Million* there is a literal score: the booklets, referred to as 'choreography maps', which contained the route, the formation in which the performers would stand in each room and the range of numbers that they would count for each decade. But this was more than performing a script. Throughout the performance, the counting of the rising numbers in each room had a purpose: to make the public aware of the increasing environmental damage as a result of industrialization. Furthermore, this damage is inherently linked to BP whose image is being 'cleansed' through its sponsorship of the Tate. However, this is not simply stated by Liberate Tate. Without knowledge of its context, the performance remains as another 'artwork' in the gallery. Liberate Tate rely on the viewer, the Tate-visiting public's curiosity to actively seek out information. For each performance, they provide information signs telling the viewer that it is an unsanctioned performance and the reasons for the performance (Figure 5.5). The signs often adopt the visual language of Tate branding (font, style). Furthermore, for *Parts per Million* in the list

> **Birthmark**
>
> **bp**
>
> BP Walk through British Art
> 1840s gallery
>
> **TATE** LIBERATE
>
> *Created, performed, written,
> designed and curated by Liberate Tate*
>
> This performance is made possible by the dedication
> and hard work of over 500 members of the Liberate Tate
> art collective, which is part of the Art Not Oil coalition.
> All time is volunteered and all costs are funded through
> collective earnings by way of performance lectures, writing
> commissions, and art print sales. Liberate Tate exists to free
> Tate from BP, performing unsanctioned live art in Tate spaces
> to eject BP as sponsor from the gallery.
>
> The harm BP is responsible for is made possible by Tate's
> association with the company. BP is the third largest emitter
> of carbon dioxide in the world, and is responsible for
> countless environmental and social catastrophes including the
> Deepwater Horizon disaster, human rights abuses in Colombia
> and controversy over Indigenous people's land rights in
> Canada. Tate's association provides BP with the social licence it
> desperately needs to continue its harmful operations.
>
> *Photography is encouraged during this performance.*
>
> #Birthmark
> www.liberatetate.org.uk
> facebook.com/liberatetate
> @liberatetate

FIGURE 5.5 *Liberate Tate.* Birthmark *Information Booklet.*

of materials for the performance it is stated 'voices (sotto voce)'; sotto voce refers to speaking in a quiet voice, thus vocally beckoning the public to come closer to hear what is being spoken. The actions are described on the website as 'performances' rather than actions; through presenting politics through the (verbal, written and visual) language of the activity typical in the gallery, Liberate Tate avoid openly disruptive behaviour. When Bobbi and Toni (played by Mel Evans and Anna Feigenbaum) – a reference to Bobby Dudley and Tony Hayward (the outgoing and incoming BP CEOs at the time) – spilled 'oil' from beneath their grand party dresses during Tate's 2010 Annual Summer Party celebrating twenty years of BP sponsorship, they raised awareness of BP's disastrous relationship with the Tate in a comedic, performative fashion (Figure 5.6).

FIGURE 5.6 *Above: Liberate Tate,* Toni and Bobbi, *June 2010, Tate Britain. Film still. Video credit: Gavin Grindon. Below: Liberate Tate, Toni and Bobbi. Photo credit: Immo Klink, 2010.*

For Virno: 'Civil disobedience represents, perhaps, the fundamental form of political action in the multitude.'[65] Liberate Tate purposefully separates itself from the neo-liberal virtuoso when performance is used as a device for the purpose of engaging political action. The group has described what they do as 'creative disobedience'.[66] Through the act of creative intervention, information is disseminated. In the case of *Parts per Million*, the knowledge is very specific: the parts per million of carbon in the atmosphere since the Industrial Revolution in Britain. Its political motivation is also explicit: to end the oil sponsorship of the arts and, in particular, the BP sponsorship of the Tate Galleries in Britain.

Liberate Tate can thus be understood as adopting the role of the virtuoso, in the politicized understanding of the term. *Parts per Million*, like the politician in Arendt's discussion, needed an audience (Tate's visitors), a publicly organized space for its action (Tate Britain) and depended upon others for the performance (through bringing together fifty performers). Unlike other commissioned performers in Tate, these virtuosic traits were put to use for political action. The group members are not waged performers. They employ the appearance of artistic practice and performance while engaging in political action; without the political purpose, the group would not perform in the gallery. Liberate Tate's very existence is political, which aligns them with the politician (i.e. someone *doing* politics) in Arendt and, subsequently, Virno's argument.

Whatever happened to the public sphere?

It could be argued that we have already witnessed a moment in which intellect was realigned with action in a wider economic and global context. Occupy Wall Street did not emerge out of the factories but began in 2011 with a call from a creative magazine to gather at Zucotti Park in Wall Street. The demographic of the protesters was arguably, not the working class (with whom Marx envisaged revolution) but those aligned with the creative industries, academia and students.[67] Thus we might deduce that it came from the multitude of virtuosos engaged in the type of work that emerged out of the capitalist co-optation of the artist critique, post-1968. The aesthetics and mode of political struggle experienced in the global contestations of c.1968 are subsumed into the daily operation/

functioning of capital. While 2011 bore witness to the potential for political action based in the public sphere on numerous occasions – the Occupy movement and the Arab Spring, for example – global change was never brought into fruition. On a micro-scale, in the art world, however, Liberate Tate's activism was successful. In 2015, after five years of creative disruption, Tate dropped BP's sponsorship; Liberate Tate celebrated with a party in the Turbine Hall.

Writing about literature in 'The Author as Producer' (1934), Walter Benjamin presents a discussion on the relationship between intellect and revolution, which offers an interesting diversion in which to view Virno's call for the marrying of intellect and action. Referring to the 'bourgeois Left' in 1930s' Germany, Benjamin denounces the revolutionary potential of Activists (a specific branch of intellectual literary writers) because of the intellectual nature of their production. He states that their founding principle is reactionary not revolutionary. What this group of activists lack, for Benjamin, is a solidarity with the worker as a *producer*. They do not work alongside the proletariat with whom their cause is aligned. It is in this notion that perhaps one could argue that, in contemporary society, the new art-activists *are* aligned with the worker because of the way in which certain types of labour are now affective, virtuosic and based around projects or cooperation. The art-activist – Liberate Tate – now finds its basis in the work that it attempts to revolutionize.[68]

Art is not subject to the same economic systems and law of value as general labour; however, its associated form of labour (i.e. unproductive) has now been transmuted into capital. While distinct from productive labour, in the economic sense, art remains susceptible to the dominant ideologies perpetuated by the shift to an economic system becoming increasingly reliant on former modes of unproductive labour. I have, therefore, here considered contemporary artistic practice and its publics as constitutive of a multitude (also made up of virtuosos) in itself. For Virno, 'The key to political action (or rather the only possibility of extracting it from its present state of paralysis) consists in developing the publicness of Intellect outside of Work, and in opposition to it.'[69] Liberate Tate take the skills learned through virtuosic work (be it artistic practice, performance, education) and put them to work for the purpose of informing the public in the gallery space. And this is contrary to the organizational framework of the public space itself, that is, Tate.

Tate could be thus understood as an institutional structure that presents a microcosm of the society or multitude made up of virtuosos. With its classed and creative public, it might provide a more suitable example of Virno's multitude of virtuosos (encompassing a larger proportion of those who belong to the creative industries) than that of society at large. Of course, this is a problematic proposition (there is no accessible data on the Tate galleries' demographics, for example) and so I offer it as a provocation rather than a conclusive argument here. It is not implausible to think of the Tate as providing a space in which to reflect on the virtuosic multitude: The Tate is connected to the State and has a governing structure.[70] It is classed as a non-departmental public body and is sponsored by the State – that is, by the Department of Culture, Media and Sport – and has full charitable status in the UK. About 70 per cent of its income, however, is raised from non-governmental sources (including public donations, corporate sponsorship, Tate Enterprises and Tate Members). A Board of Trustees, in line with the Museums and Galleries Act, 1992, governs the institution with the director appointed by the board and approved by the prime minister. The Tate houses a public art collection and ultimately it is accountable to the public via parliament for the services it provides.

Within this institutional framework, there are those artworks (discussed in this chapter) that engage virtuosity, presenting a depoliticized public sphere that *appears* political. The recently initiated Tate Exchange has even been described as an 'open Agora' – the original public sphere.[71] However, there are those who realign their intellect with action, such as Liberate Tate. The group utilizes the language of the multitude but, rather than put it to work for the institution (the state in a wider context) they engage intellect (cooperation, knowledge) for political action. That is, to call for the decoupling of Tate galleries with BP sponsorship.

Furthermore, the battle that Liberate Tate fought was over disclosing knowledge. The group went beyond the governing structure of the Tate and into the realm of law to make public information disclosing the amount of sponsorship money that BP contributed to Tate under the Freedom of Information Act. Despite Tate being a public institution, the figure was not disclosed in public documents so Liberate Tate worked to make it public record by fighting a legal battle, resulting in a tribunal, which ruled in Liberate Tate's favour. As a result, it was revealed initially that BP

contributed on average £240,000 a year between 1990 and 2006; in 2016, after splitting with BP, Tate were asked to disclose the figures for 2007 to 2011, £350,000 a year, less than 0.5 per cent of Tate's annual income.

Conclusion

The increase in social practices in art institutions falls prey to the aestheticization of politics through creating an image of the public sphere that belongs to capital. This idea is aligned with Virno's idea that post-Fordist or neo-liberal societies are depoliticized through capitalism's co-optation of the virtuoso. The performer/artist was a role that, historically, resisted the production of a surplus value that could be turned into profit and that, in Arendt's understanding, was also aligned with political action in the guise of the politician. The performative is now adopted to simply perform, rather than act but still presents an appearance of political action, as is the case with Deller and the *Battle of Orgreave*. Arendt's alignment of the virtuoso with politics, however, is not in vain. Within or relatively autonomous to contemporary art there is a political model emerging that aligns itself with action, through the use of knowledge for action, rather than knowledge for work. This model, in some ways, is indebted to neo-liberalism. The fact that fifty people can walk into the Tate galleries and perform for an audience is, perhaps, symptomatic of the fact that we now live in, to steal Bourriaud's phrase, 'a society of extras'.[72] Performative traits are so prevalent in today's dominant working models that no one is quite sure when someone is performing or acting. This, arguably, assists those who act.

The social mobility of art-activist groups can be attributed to an increase in knowledge, information, communication and affect within general work. In the face of a society comprising of 'performers', Virno readdresses the possibilities of a politically engaged alternative to the virtuoso. To achieve this alternative, he calls for a coalition between intellect and action in the face of virtuosity. The multitude is the society made up of virtuosos; only when the individuals that make up the multitude align intellect with action, rather than work, do they become re-politicized. By looking at a specific section of society – within the art institution – a

response to Virno's call can be found in art-activist practices that marry intellect and action. Within this coupling lies the performative nature of the virtuoso. To summarize, the intellect or knowledge is gained, for Virno, through work but rather than put this knowledge to work for capital, this knowledge is now put to use for action, in this case, performative or creative action. Once such example can be found in the group Liberate Tate.

CHAPTER SIX

Digital labour and capitalist technologies: etoy's *Toywar* (1999) and *Mission Eternity* (2005–)

The preceding two chapters considered the subjective, affective, biopower forms of immaterial labour to understand how these types of work (in the West) could be thought in relation to artistic practice in both its critical and political modes. In Chapter Four, Hardt and Negri's original categories of immaterial labour (from *Empire*) were presented. When the writers reassessed immaterial labour in *Multitude*, the first type – informationalized industrial production: production that incorporates communication technologies that change the production process – was dropped. However, the role of technology in contemporary capitalist production and consumption cannot be overlooked. This book began with a chapter focussed on artists contracting manufacturing to skilled workers (in the example of Lippincott Inc.); with the advent of computer-aided-design and, more recently, three-dimensional printing, the intervention of the computer is now evident in the making process from conception to execution. It replaces intellectual skills (mathematical and problem-solving) and also manual (through manufacture). And, by extension, information becomes central to the contemporary mode of capitalist production.

The narrative of the transition from tool (an extension of the hand) through the machine (which intervenes in work) and later the brain, follows Marx's own narrative as work develops in *Capital*. Despite this development, however much the tools of work change, the fundamental capitalist premise – that is, to create profit – has nevertheless remained the same. As such, labour in its distinct guises remains central to the creation of value.

The historical introduction of the machine into the workplace was for the purpose of extracting more surplus value from the worker; the invention of personal computer (PC), the internet and other digital technologies have only allowed for further exploitative practices to develop. In his 'Considerations of a Hacker Manifesto' (2013), McKenzie Wark claims that a new ruling class has emerged – the vectorialist class – which is no longer concerned with owning the means of production (factories, for example) but rather control the logistics by which the material conditions of production are managed.[1] Amazon's Mechanical Turk, for example, offers an on-demand marketplace of 'human intelligence tasks' (HITs) where digital tasks that require human input are undertaken globally by the person who is willing to complete the task for the least amount of money, while Amazon fulfilment centre workers are affixed to digital wristbands during working hours, which monitor anything from the time taken to undertake a task to their comfort breaks. While it provides anything from labour to (digital and physical) books, groceries and online television, logistics (and information) is central to Amazon's business model. The way in which the labour is divided might be new (i.e. via electronic means); however, Mechanical Turk further offers an example of how Taylorist working practices have continued into the information society.[2]

The PC has penetrated every aspect of our daily lives. Mobile phones are miniature computers in our pockets; we are now infinitely connected to quick answers, commerce, travel tickets, calendars, images, social media, email, messages, through, first, the birth of the internet, dial-up internet, then wireless, 3G, followed by 4G … ad infinitum. In 'Is the Internet Dead?' (2017) Hito Steyerl paints an anxiety-inducing picture of what she identifies, in response to the titular question, as the omnipresence of the internet. In this short text she highlights the blurring of the lines between material reality and digital reality (the exemplar of which might be the 'internet of things') in which she states: 'Today's workplace could turn out to

be a rogue algorithm commandeering your hard drive, eyeballs and dreams.'[3]

Dubbed the 'informational society' the Western world *appears* very different to the one birthed in the Industrial Revolution.[4] However, Christian Fuchs argues that the term 'information capitalism' is incorrect; based on Forbes' list of largest companies in the world, he informs us that information, in fact, only comprises the third largest sector. Although it is not the dominant industry (it is superseded by finance and the fossil fuel sector), Fuchs argues that there is evidence to support claims that there is a trend towards 'informatization' (a rise in the importance of information in the economy).[5] This idea ties in with the new models of labour based on knowledge work, to which digital labour belongs. This ever-present access to information and constant connection to the new tools of work makes it more difficult for people to separate life from work and thus creates surplus in less obvious ways.

The connection between (invisible) work and leisure is most obfuscated, perhaps, in the role that social media now plays in people's lives. These so-called social networks that promote connecting with people, sharing and communication, generate income from your seemingly benign clicks, likes and shares.[6] Every click you make amounts to (unwaged) labour, generating income through providing data to the capitalist companies that own the social media network (Twitter, Facebook and Instagram, e.g.) Wark points out the absurdity of this phenomenon, in relation to Facebook he states: 'Not only are we to passively consume these images, we have to make them ourselves.' adding, 'The model here is to reduce the paid labour force in the production of images as close as possible to zero and pay them only in the currency of recognition.'[7] Meanwhile, this data is sold to advertisers (creating profit for Facebook) who return the results of your collected data in the form of targeted advertising, encouraging you to shop.[8] And this returns the user to e-commerce and the world of online shopping (lest we forget the material conditions of the wrist-device wearing labourers picking and packing our goods in the fulfilment centres).[9]

This chapter thus considers the ways in which information communication technologies – and its associated type of work, digital labour – are embedded within capitalist work models. I return to Marx's 'Fragment on Machines' (1857–58) – in which he envisaged that the knowledge created through machinery would become key

to capitalist working practices – through another Italian workerist thinker, Raniero Panzieri, in questioning the neutrality of machines that are put to work for capital. In considering these debates, the case study for this chapter is the Swiss digital art collective etoy. The group's early hackivist action, known as the *Toywar* (1999), put to use capitalist technologies for anti-capitalist activity engaging in what Ricardo Dominguez has termed 'electronic civil disobedience'.[10] The later example, the on-going *Mission Eternity* (2005–), provides an opportunity to explore digital labour and its complexities in relation to contemporary artistic practice and informational capitalism.

A note on digital labour

The term 'digital labour' often appears in analyses of the information society. Despite developments in artificial intelligence (AI), a completely digital/immaterial dominant mode of production without human involvement remains unthinkable. As with the information society, the term can be misleading; digital labour implies that the work is solely being undertaken digitally or by the digital (which is not implausible given the role that algorithms play in marketing, e.g., or the development of intelligent machines). Like immaterial labour, however, digital labour has a very material, human basis. The aforementioned Amazon Mechanical Turk, provides a case in point; sometimes described as 'artificial intelligence' tasks, such as tagging images, transcribing audio files or translating texts, are undertaken by human workers often in exchange for a only few US cents.[11]

This type of outsourced labour is referred to as 'crowdsourcing' that, as Ayhan Aytes points out, has become a function of neo-liberalism's 'global system of exception'.[12] That is, the global outsourcing of knowledge work or cognitive labour via the digital division of labour deterritorializes the work. Thus workers across the globe are more susceptible to exploitation with the blurring of necessary legislation in employing workers not resident in the country that houses the company for which they are working.[13] Moreover, the workers are classed as 'contractors' thus avoiding the legal commitment to minimum wage, and other workers' rights. The workers are more precaritized due to this process; the phenomenon of piecemeal work undertaken in the home can be understood in relation to 'housewifization'. That is, labour that is

recognized as 'activity' that 'bears the characteristics of housework, namely labour not protected by trade unions or labour laws, that is available at any time, for any price'.[14] The division of tasks into small parts undertaken by a crowd of workers across the globe alienates them further from the products of their labour. The tasks undertaken are those that AI is still not able to undertake; however, some of the tasks, in fact, contribute to training machine-learning algorithms that will eventually replace the human role. The process of crowdsourcing thus devalues and deskills the work.

Finally, in acknowledging a human element to digital labour, I adopt Christian Fuchs' understanding of digital labour as 'alienated digital work' comprising a broad category that 'involve[s] all activities in the production of digital media technologies and contents'.[15] In *Digital Labour and Karl Marx* (2014), Fuchs presents case studies that range from the digital 'slave work' of those mining for minerals to make computer chips; Foxconn workers; call centre workers through to software developers in India; and the high-end Silicon Valley workers. All of these examples constitute digital labour. By incorporating the diverse roles within the division of labour in digital production, the global presence of digital labour is evident. Digital labour remains alienating, focussed on extracting surplus and thus creating capital in its various guises. In this manifestation of capitalist production, only the productive forces change: knowledge and IT. These two 'forces' are both key to the (unproductive) practice of etoy.

etoy: 'Twisting values since 1994'[16]

Formed in the 1990s, etoy is a Swiss-based digital art collective with an international membership that presents itself as an internet-based art corporation or 'corporate sculpture'.[17] The group were early pioneers of internet art; etoy launched their website in March 1993 – etoy.INTERNET-TANKSYSTEM – and, coming out of the rave scene, the group naturally held a party that simultaneously took place in the material world, across two cities, and online. The collective nature of etoy is important to its functioning. Contrary to the autonomous artist, etoy state that the group: 'redefines art history by replacing the obsolete role of the genius by a network of collaborating agents: a group of exceptional artists and engineers

who exploit technology to create and explore new territories. Given these circumstances, the artist's signature and the stroke of the brush are no longer adequate indicators of authorship and authenticity'.[18] Collectively, etoy.AGENTS (the term used to denote group members/collaborators) have come from diverse disciplines, including art, architecture, medicine, social work, economics, web design, graphic design and law. Presenting itself as a corporation, the group adopts a strong visual identity both on and offline; the 'brand' colours are orange, black and white, with a logo (and specific font types that are detailed on the etoy.IDENTITY 'Basic Elements' information sheet). There are separate visual identities for etoy projects and the *Mission Eternity* project (which predominantly comprises of white and orange, as opposed to the typical black and orange of other projects). When etoy appears in public, members wear a branded 'uniform', be it an orange and black 'corporate' look, or a white boiler suit with orange *Mission Eternity* logo (for the *Mission Eternity* projects) (Figure 6.1). An orange, or white in the case of *Mission Eternity*, shipping container – a common symbol of the global economy – often accompanies its 'material' projects.

FIGURE 6.1 etoy, *etoy.SHARE-CERTIFICATE No. 56, representing the etoy.CREW (1996). etoy.SHARE-CERTIFICATE No. 056 represents the 7 etoy.AGENTS (etoy.CREW v1.0/1994–1998) performing for the ars electronica festival in linz. The etoy.AGENTS always line up with the same outfit and the same tools (formula one style). 1998, copyrights: etoy. CORPORATION.*

etoy do not create art works for the art market. It sells shares in the company – etoy.CORPORATION – which is one of the ways in which it funds its work, alongside financial support from organizations such as the Arts Council in Switzerland, the Federal Office of Culture for Switzerland and corporate sponsors such as the sewing machine manufacturer Bernina and office furniture suppliers Lista Office (LO). On the website is stated: 'The only available product in the art market is the etoy.SHARE: unique Swiss stock certificates visually document the etoy.HISTORY and represent the idea of sharing intangible assets such as knowledge, passion and code or social networks and cultural value.'[19] etoy operates as a not-for-profit company. This point is made very clear on the website, which even includes a disclaimer: 'etoy.DISCLAIMER: etoy. INVESTMENTS are not focused on financial profits. The etoy. VENTURE is all about cultural revenue, social profit and intellectual capital generated with the invested resources.'[20] Despite the corporate aesthetic, etoy's mission is non-capitalist.

In return for buying shares in etoy, shareholders receive a certificate bearing the specially created etoy hologram, which authenticates the document; the certificate is also referred to as an artwork (Figure 6.2).[21] The selling of shares in the company implicitly references the increase in working practices related to finance or fictional capital in the contemporary period. The money raised from the shares is used to fund etoy's projects, be it hacking or their on-going ambiguous *Mission Eternity* – a project concerned with people facing death, creating a digital post-mortem of themselves to live on beyond their demise, to be discussed later in the chapter.[22] The group largely avoids the pitfalls of co-optation by not producing a saleable object (with the exception of the share certificate). Of course, the production of the share certificate is susceptible to fetishization. As with documents of performances there is the possibility that these could become commodified as a collector's item and, given that art collectors own shares in etoy, it is likely that this is the case. In fact, etoy rely on collectors for the longevity of the *Mission Eternity* project. Simultaneously, the shares also act as payment for the agents working on a project. It states on the website: 'etoy. SHAREHOLDERS invest their workforce (agents, contributors and advisors) or cash (art collectors, donors and fans) into the venture that is art and reinvests all profits into the production

146 WORKING AESTHETICS

FIGURE 6.2 etoy, *etoy.HISTORY/SHARE CERTIFICATES 2010*. Copyrights: *etoy*.CORPORATION.

of more art. Depending on the market situation and projects between 10 and 25 etoy.AGENTS work for the art group in return for etoy.SHARES.'[23] This is in keeping with the peer-to-peer (P2P) community's ethos that works on the basis of something like a gift economy (i.e. mutual exchange) with, according to the P2P Foundation, a direct link to financial payment disallowed.[24]

While exhibiting as artists and undertaking ambitious digital projects, etoy replicates the numerous aspects of a corporation under neo-liberal capitalism – the adoption of the network; the centrality of the project to their practice; the selling of shares; the branding; the employment of individuals with diverse skills – so well, that even art critics appear to be fooled. In his essay 'Artistic Autonomy and the Communication Society' (2004), Brian Holmes argues that the proliferation of artists groups that perform mimetic interpretations of 'the values projected from the consulting firms and human-resources departments', emerging in recent years, demonstrate the extent to which the artist critique has been absorbed by capitalism.[25] He furthers his argument by claiming that the permeation of the artworld by transnational state capitalism is only restated in the collective work of artists' groups that subversively adopt the traits of 'neomanagement'.[26] Despite their subversive nature, Holmes concludes that the emergence of groups like etoy – 'which endlessly reiterates the forms of corporate organisation' – are sorry testimony to the capitalist absorption of the artist critique.[27] Rather than adopting a formal perspective akin to Holmes, in revisiting the theoretical analyses from Marx and Panzieri around technology and capitalism, the following analysis will explore etoy's critical relationship to capitalist technologies and digital labour. I argue that this group, in fact, challenges the absorption of the artist critique, first, through its electronic civil disobedience and, secondly, through what I perceive as its critical approach to digital memory.

The 'Fragment on Machines'

Given the prominence of new ICTs in contemporary capitalist work, I return here to some earlier theoretical considerations of the role of the machine (and its subsequent effect on labour) in the workplace. The 'Fragment on Machines' from Marx's *Grundrisse* is a central tenet of Italian workerist (autonomia) and post-workerist

(post-autonomia) thought. In this section, Marx essentially acknowledges the centrality of the machine in the labour process (within industrial production) and the capitalist system, more widely and its effect on labour.

For Marx, the labour process is constituted from the interaction of three elements: the material of labour, the means of labour and living labour. With the introduction of machinery (means of labour) there develops an 'automaton' within the workplace. The automaton is not merely the machinery but the interaction between the machinery and living labour, which Marx refers to as a 'moving power that moves itself';[28] the workers no longer control the machinery but become 'conscious linkages' within the automaton comprised from 'numerous mechanical and intellectual organs'.[29] This relationship is evident in depictions of nineteenth-century industrial labour, such as textiles production, or even the Fordist assembly lines in which human labour and the machine are entangled in a symbiotic process. Unlike the (hand) tool that required the worker to activate it and put it to work, the automaton does not rely on living labour (that is, labour power in action). Thus labour no longer dominates the production process:

> Labour appears, rather, merely as a conscious organ, scattered among the individual living workers at numerous points of the mechanical system; subsumed under the total process of the machinery itself, as itself only a link of the system, whose unity exists not in the living workers but rather in the living (active) machinery, which confronts his individual, insignificant doings as a mighty organism.[30]

In the above statement, it is implied that the value is created by the intellectual labour that is embodied in the machinery, rather than active labour power (living labour). Furthermore, Marx claims that in production reliant on the machine, the appropriation of living labour by objectified labour (machinery) is posited as the character of the production process itself.[31] In using the term organism, Marx anthropomorphizes the automaton of capitalist labour in the machine age. He furthers the analogy when he writes of the machine as consuming fuel as the worker consumes food. And this is not simply a literary device; in making this analogy, Marx shows how the labour process becomes an entanglement of machine and

worker. The conscious organ refers to the brain; that is, the presence of knowledge and informational work in the labour process. And with this notion, we are also reminded of the alienation of the worker who can no longer identify her work in the objects that she produces. The labour of the worker is homogenized into one 'mighty organism' of the labour process: 'In machinery, objectified labour confronts living labour within the labour process itself as the power which rules it; a power which, as the appropriation of living labour, is the form of capital.'[32]

Marx concludes the section with an oft-cited passage: 'The accumulation of knowledge and of skill, of the general productive forces of the social brain, is thus absorbed into capital, as opposed to labour, and hence appears as an attribute of capital, and more specifically of fixed capital, in so far as it enters into the production process as a means of production proper.'[33] In short, while bypassing labour, the accumulation of knowledge and skill (i.e. general intellect) becomes a means of production in itself. And this is from where Virno, Hardt and Negri developed their arguments regarding potentiality in immaterial labour but only if the intellect is put to work for political action. In this section, Marx refers to the machine as the virtuoso and we can see the logical steps from the social brain being crystallized in machinery to knowledge work developing as separate from the industrial machine but also transmuting into technologies for informational tasks.

Post-autonomia thinkers have interpreted Marx's 'Fragment' as holding the key to overthrowing the fetters of production (through knowledge put to use for political action); it also acts as a warning. Wark suggests that 'the vectoral class has brought the fabled general intellect into material existence and is doing its best to make it private property'.[34] This is in keeping with the previous chapter's discussion of immaterial labour, which is understood as privatizing the knowledge and affective skills of the worker. Fuchs claims the rise of transnational informational capitalism is based on the dialectic of the contradictory subjective/objective understandings of the development of work.[35] The objective approaches are techno-deterministic, while the subjective focus on agency and knowledge. The two together form the distinct poles of the dialectic. And both these – subjective and objective – aspects are found in the short passage from Marx above, which had only begun to imagine the alienating effects of the subsumption of human knowledge into

machinic production. The Mechanical Turk workers provide us with the contemporary manifestation of the absorption of the general productive forces of the social brain via exploitative knowledge work. The workers are simply nodes in an automaton, now beyond their own comprehension. Unlike the worker who labourered side-by-side with the machinery in the factory, the Mechanical Turk worker does not receive a regulated wage, nor do they know how their minute task fits into the company's overall process. This leaves the contemporary digital pieceworkers much more alienated and fragmented than their historical counterpart discussed in Chapter One.

Capitalism and the neutrality of machines

In the mid-1960s, Panzieri, an Italian Marxist militant associated with the establishment of operaismo (workerism), returned to and updated Marx's 'Fragment on Machines'.[36] He is often referred to as a contributor to the founding of Italian operaismo because of the role that his journal – *Quanderni Rossi* – had in bringing together the protagonists of the movement, including Negri and Mario Tronti. Panzieri published this essay during a time of political and economic unrest in Italy; only a few years later, Italy would witness mass student protests, erupting into violence (the 'Battle of Valle Guila' in Rome 1968, e.g), industrial disputes and the Red Brigade bombings in the 1970s. While Panzieri's essay, titled 'The Capitalist Use of Machinery: Marx Versus the Objectivists' (1964), is grounded in an earlier period of capitalism based on industrial production (the late 1960s' industrial expansion in Northern Italy), the implications of his argument can be applied to the neo-liberal phase of capitalism, which has witnesses a total penetration of the machine (informational and communication technologies) into capitalist work and life.

In 'The Capitalist Use of Machinery', Panzieri proposes that the use of technology in the factory is not neutral. That is, the technology is tied to the capitalist process and the power held by capital, rather than simply being a tool to assist work. With the move from manufacture to large-scale industry, the worker becomes more fragmented – the skill that he once owned has now become the skill of the machine. At the same time, Panzieri argues that the

capitalist power, which is harnessed through the increase of large-scale machinery, also relies upon the social organization of labour that was established within the cooperative phase. The alignment of the social organization of labour and the introduction of the machine, he argues, is specific to the capitalist mode of production. With the introduction of large-scale machines, however, the worker becomes fragmented and alienated from his work. To counter worker protests stemming from a dissatisfaction with work, the capitalist adopts techniques of 'information', which, Panzieri argues, manipulates working-class attitudes and that: 'restore that "charm" (satisfaction) of work of which the *Communist Manifesto* already spoke'.[37] In short, the introduction of machinery increases the control of the worker by making the machine the *subject* of work. Once the worker becomes alienated from his labour and the object of production, the capitalist-factory owner establishes new management techniques (which include the worker in technical decisions) that appear to restore the charm of work, while increasing the flow of capital. The worker, in this equation, is deskilled from manual skills, but the deskilling is masked by the 'charm' of informational techniques.

Neutrality and informational capitalism

The informational techniques of which Panzieri writes become the forces of production in the contemporary period with these forces now driving even the more traditional forms of material production. Further, within the neo-liberal period, the type of relationship between worker and technology in Panzieri's analysis is magnified. The difference lies in the displacement of the machine from the factory so that we are even more so tied to work, while simultaneously, promised autonomy, mobility and flexibility. The 'charm' (in high end work) is now found in the appeal of autonomy (one of the demands of the artist critique). The barrier between office work and life is broken as people increasingly work from home, on public transport or in the coffee shop. Furthermore, these technologies become the tools of our non-work activities, such as reading books, listening to music, our interactions with others (via social media) and shopping thus effectively eradicating the historical bifurcation of work/leisure.

When intellect becomes a means of production, the worker no longer needs to be present at a site of work to labour for capital; the machine adapts to the work with the mobility of informational communication technologies. Labour now penetrates the non-work space and, at the same time, convinces us that this is to our own benefit (via restoring the charm of work). In this seemingly inescapable entanglement of work/life, is it possible to overcome the capitalist nature of these technologies and the associated mystification of its control? Akin to Panzieri's understanding, David Harvey argues that, ultimately, the use of capitalist technologies is detrimental to the implementation of an 'other' to capitalism.[38] He regards the failure of past attempts at communism to be because of the continued use of capitalist technologies, which, he argues, need replacing after the initial revolutionary stages. Vladimir Lenin also questioned the neutrality of capitalist working practices. However, after the Bolshevik Revolution in 1917, he adopted aspects of Taylorist methods in Soviet Russian production. Contrary to Harvey, Lenin believed that only once the Taylorist methods were freed from working *for* capital, could they be employed to achieve their full productive potential.[39]

The classed nature of work undertaken using capitalist technologies poses a further problem. Drawing on Marx's discussion of machinery in the first book of *Capital*, Harvey claims that there is a 'problematic class character of capitalist technologies'.[40] Panzieri argues that the use of technology is oppressive as it increasingly facilitates capital's control of the worker in each stage of capitalism's development from cooperation, through manufacture and large-scale industry. In the latter stage, work appears more satisfactory to the worker than in previous periods. The control that capital exerts over him is mystified because the worker *appears* to be content.[41] Panzieri's thesis anticipates the relationship of workers to their work fostered in the neo-liberal period, which he did not witness in his lifetime. While some workers experience the charm of work, this does not eradicate class relations. As Fuchs shows in his book, digital labour is subjected to the stratification of labour from slave-labour through to high-end work. The opacity of these class relations is facilitated by the use of transnational ICT companies that attempt to hide the global displacement of its workers through performative devices that hide the workers' real location.

Panzieri further illustrates the control that capital has over the social nature of work in the cooperative phase. He makes clear that the socially productive power of labour in the capitalist labour process is a 'free gift to capital' that is obtained when workers are placed under certain conditions.[42] As such, the sociality that labouring with others encourages is not necessarily for the benefit of the worker. Consequently, the utilization of capitalist tools and machinery encourages relations in which technology is viewed as competition with the worker, rather than an aid. Marx states that technology was a powerful tool in suppressing strikes calling machines 'weapons against class revolt'.[43] Harvey builds on this idea to describe the social nature of technology. He proposes that capitalist technology can be utilized for revolution but, in order for a non-capitalist state to succeed, the technologies have to be replaced alongside the establishment of a new state. If the existing capitalist technologies were to be implemented in a newly emergent non-capitalist state, the social conditions of capitalism would be replicated rather than abolished through the continued use of technologies that are not socially neutral. Similarly, Panzieri states: 'The relationship of revolutionary action to technological "rationality" is to "comprehend" it, but not in order to acknowledge and exalt it, rather in order to subject it to a new use: to the socialist use of machines.'[44] Panzieri argues that we need to understand technology in order to use it against capital. How can we understand the socialist or, rather, the counter- or anti-capitalist use of machines within art-activist practices?

It was contended in the previous chapter that the political potential of immaterial labour is (partially) realized through the practice of art-activism. Liberate Tate's performative action acts as a response to Virno's call for the symbiosis of intellect and action, through utilizing the performative skills found in immaterial labour for political action through their creative interventions in Tate galleries. Furthering this argument, the example in this chapter – etoy – similarly align intellect with action to act against capitalism through the use of communicative informational technologies now associated with contemporary work. To return to Panzieri, the informational techniques that accompanied the introduction of large-scale industry have now evolved into a kind of reskilling of work with immaterial skills and knowledge based in socialized labour. These informational skills, in turn, are put

to use otherwise by art-activists, exemplified in etoy's famous *Toywar*.

Toywar (1999)

The *Toywar* action (Figure 6.3) occurred as a result of a corporation throwing its virtual weight around and illustrates the kind of use that capitalist technologies can be put to for anti-capitalist purposes. In 1999, five years after etoy's establishment, etoy was approached by eToys Inc. – an online toy retailer – with an offer to buy their web domain (allegedly valued at half a million dollars). etoy refused and continued to turn down further offers. eToys Inc. retaliated to etoy's refusal by taking legal action to have etoy.com (and its associated email accounts) taken down. This is when the *Toywar* began. etoy describe the 'war' as follows:

> TOYWAR.com did not follow common political strategies: TOYWAR.com successfully mobilized the net-community (among them hundreds of journalists), involved the enemy in a insane TOYNAM situation (preventing overview by fighting on too many layers with the help of 1799 soldiers) and turned eToys' aggressions against themselves (martial arts for the net) until art finally neutralized the naïve power of money. By playing a game on the web, in the court room and on the NASDAQ the etoy.CORPORATION and supporters forced eToys to step back from their aggressive intention. The reason for this success was the combination and involvement of all kinds of people (artists, lawyers, riot-kids, university profs, business people, freaks and djs).[45]

etoy effectively recruited 1799 'agents' to assist them in intermittently crashing the etoy website (in short bursts of fifteen minutes over ten days) in the days leading up to Christmas. Assisted by RTMark, they employed technology that would take a purchase to the checkout and then cancel at the last minute. As one participant describes:

> The cleverest script was probably "killertoy.html", a non-linear script that fills cookies-based shopping carts to the brim without actually making a purchase. For every new item, the server

DIGITAL LABOUR AND CAPITALIST TECHNOLOGIES

FIGURE 6.3 etoy, *TOYWAR.battlefield* in January 2000. TOYWAR. battlefield on the internet: showing some of the 2500 TOYWAR.agents in January 2000, two weeks before eToys INC. signed a settlement and dropped its lawsuit against etoy.2000, copyrights: the TOYWAR.soldiers represented by the etoy.CORPORATION.

would have to refigure the complete list all over again, a process that would take longer and longer as the cart filled, and some of the mirrors could generate a hundred thousand or more requests a day.[46]

This tactic has been termed a virtual 'sit-in'.[47] Real customers were unable to make their own purchases due to the overwhelming demand for the website, which, in turn, led to negative reviews and also affected the share price of the corporation. etoy succeeded in devaluing the eToys Inc. share price to $0 in 12 days. In 2001, eToys filed for chapter 11 bankruptcy (Figure 6.4).

etoy states that this action relied on a 'distributed brain', the website states: 'TOYWAR IS BEYOND YOUR CONCEPTION OF REALITY! THIS IS ITS BENEFIT. NO ONE CAN CONTROL

FIGURE 6.4 etoy, *The legendary TOYWAR.map (2000) TOYWAR. map 2000, showing some of the locations in the real world form where TOYWAR.agents coordinated their counter strike against eToys INC's multibillion-dollar empire. 2000, copyrights: the TOYWAR.community represented by the etoy.CORPORATION.*

IT ... 1799 RECRUITED AGENTS BUILT ITS DISTRIBUTED BRAIN WHICH IS TOO COMPLEX TO DESTROY. MONEY & POWER DO NOT EVEN TOUCH THIS SYSTEM.'[48] This brain drew upon many diverse individuals, each with a particular 'skill' originally learned to assist capital – be it journalists, artists or web programmers – that was put to use counter to capitalism. The social nature of this type of action, coupled with the virtual technological dimension – that is, the virtual 'sit-in' – produced a result that, some would argue, contributed to the bankruptcy of a very successful e-commerce corporation.

The term 'distributed brain' is redolent of the social brain from Marx's 'Fragments': the 'general productive forces of the social brain' that constitute the general intellect.[49] We might thus understand the distributed brain utilized in the *Toywar* as an example of Virno's call for the assimilation of intellect with action. Rather than assisting the flow of capital, it throws a virtual spanner in the works, a spanner forged in the general intellect fostered in digital work,

now knowledge put to use.[50] In *A Thousand Machines* (2010), through critiquing the post-autonomist argument that immaterial labour can destroy the conditions under which labour develops, Gerald Raunig writes: 'Marx at least writes in the Fragment on Machines that forces of production and social relations are the material conditions to blow the foundation of capital sky-high.'[51] If, as Fuchs suggests, the new forces of production are knowledge and IT then, combined with the social relations of the distributed brain, the *Toywar* already provided a moment in which the foundation of capitalism could be shaken, at least.

While maintaining the group's digital knowledge, in 2005 etoy began to move away from the earlier haktivist work to develop *Mission Eternity*. The Mission Strategy opens with the following: 'After the internet hype of the 1990's it is now time to radically slow down and to investigate the sustainable impact of digital media in full depth.'[52] Conceived as a long-term project, etoy's later *Mission Eternity* relies on social memory and the 'products' of digital labour (software, data, online presence and art objects) for its modus operandi.

Mission Eternity (2005–), or the 'digital cult of the dead'

Mission Eternity is an ambitious, infinite project that etoy began working on in 2005. The group describes the project as an 'information technology-driven cult of the dead'.[53] The project intends to bridge the gap between life and death via digital means. It comprises of a few volunteers – known as Mission Eternity PILOTS – whose data is stored on thousands of devices through Mission Eternity ANGELS who donate at least 50 MB of storage space to the project by downloading and running a program (ANGEL-APPLICATION) on their computers to store the data.[54] The data of each pilot is thus stored in the provided memory across a network of computers and devices. The data is collated in a particular way and takes the form of a Mission Eternity ARCANUM CAPSULE, which is intended to travel space and time forever. While living, the pilot has to follow a standardized procedure, including filling out an admission form, a series of photo shoots, voice and video recordings. As stated on the

Mission Eternity website: 'The encapsulation involves interaction with trained etoy.AGENTS to devise the POST MORTEM PLAN, which is a substantial part of the work of art.'[55] There are a number of Mission Eternity TEST PILOTS, with Timothy Leary being one of the first to pass away and have his mortal and digital remains stored as part of the project. Sometimes described as a 'social memory system', it entails a complex system that gathers and stores biomass and traces in the global memory intended to remain long beyond a person's death. etoy describe the project as 'one of the most challenging open content projects in the history of art'.[56]

In addition to the 'digital post-mortem' – the immaterial encapsulation of a person's digital presence long after they are deceased – there are physical, material elements to *Mission Eternity*. These material elements usually adopt the appearance of or simultaneously function as an artwork. The data held in the ARCANUM data capsules is presented via the SARCOPHAGUS: a white shipping container modified to include 17,000 pixel screens on the walls and the floor. The screens are able to display information from the ARCANUM CAPSULES and with which it can be interacted via mobile phones or devices. The SARCOPHAGUS acts as a public mobile installation; it was launched at the International Society of Electronic Artists (ISEA) 2006 Festival in San Jose, California, before travelling to other US and global locations. In addition to the digital information, the SARCOPHAGUS acts as a mobile sepulchre; it is equipped to hold the mortal remains of one thousand PILOTS for those who prefer to be buried at an indeterminate geographical location.

The SARCOPHAGUS (Figure 6.5) constitutes one of the Mission Eternity BRIDGES that are created to link both the digital (memory) and material spaces of the project. These outputs are the most connected to the art world as they are intended to be exhibited at art galleries in order to ascertain cultural value. The long-term plan is for etoy to outsource the conservation of these 'works' to 'protected environments and experts financed by governments, foundations and private collectors' to ensure the works longevity.[57] But it is also ensured by the public, etoy states: 'M∞ will be maintained by hundreds or thousands of independent individuals who are emotionally involved and attached to the content of the project.'[58]

There are also the mortal remains (which etoy refers to as the 'hardware') of the Mission Eternity PILOTS, a small portion

FIGURE 6.5 etoy, *MISSION ETERNITY SARCOPHAGUS, 2008.*
Photo: Luca Zanier/copyrights: etoy.CORPORATION.

of which are mixed with concrete to create the TERMINUS. A TERMINUS UNIT is described as an art object; a concrete plug-shaped repository is created, which is plugged into the infrastructure of the SARCOPHAGUS. It is the same size as a pixel (60 × 60 × 100mm) and once plugged in, creates a dead pixel on the screen. On the object is also inscribed information, which allows for the associated ARCANUM CAPSULE to be located online. The TERMINUS UNIT thus connects the physical and immaterial presence of the assigned PILOT.

The project is further materialized in the TAMATAR, which are interactive artworks that are performed in the gallery space. Again, these connect people and electronic devices to the digital afterlife of Mission Eternity PILOTS. They are described as follows:

> TAMATAR are white spherical carriers created for the resurrection of dead MISSION ETERNITY PILOTS. The reincarnation of one human being takes place in 16 Styrofoam bodies. Styrofoam is a typical packaging material: light, cheap, shock-absorbing and, thus, ideal to protect sensitive content. The inherent fragility of the material and the ephemeral nature of its

function remind us of the permanent decay of matter ... Only through its behaviour and interaction with the environment a TAMATAR reveals its value.[59]

This value is revealed through the means of performance. The work was exhibited as part of *Virtual Identities* exhibition at the Centre for Contemporary Culture Strozzina in 2011. In addition to the formal installation, the work was performed by an etoy. AGENT during which the software is ritualistically uploaded to the TAMATAR (the spheres). This act is understood as a process of resurrecting the Mission Eternity PILOT whose data is contained in the software. As the spheres are able to move and talk with the voice of the PILOT, etoy describe the result as: 'a dynamic hybrid between a constantly moving sculpture and a social software that divulges itself in a theatre play and dance choreography involving the living audience as well as the dead PILOTS and all involved etoy.AGENTS.'[60] I am reminded here of Marx's proposition in his 'Fragment' that through replacing the skill and strength of the worker, the machine becomes the virtuoso with 'a soul of its own'.[61] But here the role of the performer is equally as important to the work, demonstrating the automaton of subjective and objective work entailed in the piece. Virno writes: 'Within the contemporary labour process, constellations of concepts exist, which function as productive "machines" themselves without needing a mechanical body or a little electronic soul.'[62] In revealing the PILOT's soul, the TAMATAR bring the machinic and virtuosic together: 'The performance act translates the digital and spiritual into material. Information becomes visible, palpable and present.'[63]

While the work physically brings together human and digital materials through the incorporation of human remains into the infrastructure of the mission (in the TERMINUS UNIT and the SARCOPHAGUS), it also comprises another exclusively human element: emotional content. The emotional content is an interesting tangent; rather than the performative approach of immaterial or affective labour, *Mission Eternity* invites people who are emotionally involved with the project. Given the emphasis on memory a work that, ultimately and quite literally, takes as its subject death etoy state: 'etoy.AGENTS carefully approach the memory issue from an emotional, a technical and an artistic perspective.'[64] It is, afterall,

reliant on relatives (of those deceased and of the ANGELS) for its progression.

The project is a complex undertaking, combining conceptual, poetic even, ideas about the role of the digital in the/as a form of afterlife with technical, digital skills, alongside legal and emotional aspects. The 'automaton' of *Mission Eternity* is perhaps, the stored memory in thousands of networked computers and mobile devices of Mission Eternity ANGELS who sign up for the Mission. Without this network, the project ceases to exist. In a world of fast technological change and even faster information distribution, at the heart of the group's project is adaptation and survival; for this, art becomes the key: 'The plan to survive is to hack deep into culture.'[65]

etoy was a pioneer of internet art; its hacking projects were activist and anti-capitalist. In the six years between the *Toywar* and *Mission Eternity*, the internet grew into a behemoth, the focus of which quickly turned to the circulation of capital. Acknowledging that the internet has penetrated every aspect of life, the group state that etoy has survived level one and is prepared for level two in which 'memory space explodes while our art form faces massive problems to cope with its history, conservation, loss and mediation'.[66] As such, the project invites us to consider how does art survive a world based on networks and the subsumption of the internet to capital? How does digital artistic practice allow for this to develop and what role does the digital play?

etoy and the automaton (or, David and Goliath 2.0)

It is easy to see why, on the surface, Holmes mistakes etoy for another artwork fooled by the co-optation of the artist critique; the use of the network, the project form which brings together heterogeneous disciplines and artistic practice all signify neo-liberal work. Akin to other modes of digital labour, *Mission Eternity* is reliant on human intervention; that is, living labour. This labour includes the intellectual and physical labour of programmers, designers, fabricators, performers and more. On the surface, the mission appears to be reliant on something akin to crowdsourcing through

the 'employment' of Mission Eternity ANGELS to build its storage network. The allocation of memory is described as 'a social back up solution (100% open source and public domain)' that establishes a peer-to-peer network for the long-term storage of data.[67] We might initially perceive the ANGELS simply as digital workers whose task is to download free software onto their devices; subsequently, the software creates a virtual network. However, while crowdsourcing is reliant on the exploitation of dispersed workers, peer-to-peer production pitches itself as something distinct. Michel Bauwens (Founder and President of the P2P Foundation) states that: 'Peer to peer is the relational dynamic at work in distributed networks, with the latter having as requirements the freedom of agents to engage in cooperation.'[68] He further specifies four characteristics of peer-to-peer production:

1 Voluntary engagement.
2 A production process under the control of the participants.
3 Universal access property regimes.
4 There is no direct link between input and output (non-reciprocal character of peer production), i.e. there can be no payment directly linked to the production.[69]

While the first criterion can be found in crowdsourcing businesses such as Mechanical Turk (i.e. people sign up to undertake the work), the latter three belong to a fairer system that places the participants in control. This is the basis for etoy's corporation. Unlike the alienated Mechanical Turk worker, in the *Toywar*, for example, each 'soldier' was compensated with a share in etoy. CORPORATION, allowing them voting rights, ergo a say in how the action proceeded (soldiers were even polled to see if etoy should take the payout offered by eToys Inc.) etoy.CORPORATION is registered as a shareholder company under Swiss law.

The reliance on human intervention in *Mission Eternity* is in keeping with the general tenet of the automaton in which the system of machinery (now ICTs) consists of 'numerous mechanical and intellectual organs.'[70] But rather than being exploitative, the created network is beneficial for the participants. Marx writes: 'In machinery, knowledge appears as alien, external to him; and living labour [as] subsumed under self-activating objectified labour.'[71] In utilizing public

licenses, open-source coding and programming (and in keeping with its terms), the produced knowledge is made visible and transparent rather than being objectified, alienating and privatized (through commodification). In a sense, we might think of the information as avoiding what Wark understands as the privatization of information through bypassing the circulation of capital.

While they identify the machine in their analyses, Hardt, Negri and Virno often place non-technological action at the centre of their revolutionary ideas, focusing on the sociability fostered through general intellect. For them general intellect is created in the machinic, but further developed as a social category, cooperation. While this is a plausible logic for thinking about how the intellect is fostered in developing an alternative to capitalism (the cooperation of users in the not-for-profit P2P model, e.g.), the role of the machine (that together with living labour formed the automaton) is lost.

However, there is a focus on technology in recent political activities counter to capitalism. The organization of recent protests has been understood in relation to the role of social media, including in Fuchs' analysis of digital labour.[72] The role of technology in revolutionary or anti-capitalist protest in recent years (in 2011 Time magazine named the 'protestor' as person of the year) has been focussed on social media in the organization of and dissemination of protest; haktivists (such as those in etoy) have not only been using but also developing code/software in ICTs for counter-capitalist activity for much longer. I believe those people looking for a revolutionary technology in social media are searching in the wrong place. Yes, Twitter/Facebook is a short-term, immediate platform to engage with the masses; however, the protestors use the increasingly economically valorized, capitalist technologies for their activism. As Harvey (after Marx) warned, these technologies are not neutral. In response to alternative uses, these media are further developed to prevent the dissemination of real-time news (the introduction of non-chronological timelines on Facebook, Twitter and Instagram or the reprogramming of algorithms to only show you things you already like), for example, or become tools of surveillance. We are thus reminded here of Walter Benjamin's call for the overthrowing of the fetters of production through changing or improving the apparatus for the revolutionary cause. He states: 'technical progress is for the author as producer the foundation of his political progress. In other words, only by transcending the specialisation in the

process of intellectual production ... can one make this production politically useful; and the barriers imposed by specialization must be breached jointly by the productive forces that they were set up to divide'.[73]

Arguably, in developing its own technologies in the form of code and software (e.g., killertoy.html or the ANGEL-APPLICATION), etoy avoids the pitfalls of capitalist technology. It states that one of the criteria of 'open source' is that the 'License Must Be Technology-Neutral'.[74] Moreover, it could be argued that Fuchs is looking in the wrong place for his example of digital labour as politicized practice, as Wark states: 'The hacker class does not march down the boulevard behind red banners on May Day. But it is fully capable of organizing around net neutrality, creative commons, open publishing in science, challenging stupid and harmful patents and so on.'[75] Given the informationalization of society, should the revolution be digital? etoy have proven (in their victory over eToys) that haktivism can be affective in challenging capitalist structures.

Conclusion

The relationship between digital labour and hacktivism is complex; even more so is the relationship between the two, coupled with art. In etoy's examples, digital labour is put to use for non-capitalist activity; although the physical tool (PC) is essentially capitalist, the software is developed within a non-commercial system via P2P. As the code and programmes in *Mission Eternity* (and the *Toywar*) have been written or adapted from open source by hackers associated with etoy, it avoids ever being put to work for capital. Thus it is understood here as an example of what Panzieri called the 'socialist use of machines'.[76] The ANGELS are connected to other 'peers' in the network (P2P) – they are not workers – thus the cooperation (found in the automaton) that is fostered in working together through technological means is not a mystification of the charm of work because there is no payment involved. The economy in P2P and *Mission Eternity* is distinct; be it gift-based, or otherwise, it is not capitalist. In fact, we might question whether the more cooperative P2P model was, in fact, co-opted for economic gain. The earliest P2P networks emerged in the 1990s (Napster's arrival in 1999 is the canon here); the contemporary

understanding of 'crowdsourcing' (i.e. in relation to digital labour) did not appear until 2005. Crowdsourcing alienates its workers, as with Mechanical Turk; the tasks do not require the cooperative skills fostered in other forms of collective knowledge work. *Mission Eternity* is trans-individual, reliant on a mass of people at each stage undertaking tasks as varied as coding and programming, making, conceptualizing, implementing, performing and administering.

Is *Mission Eternity*, therefore, the ultimate hack? It exists as a process of ongoing revolution to come in which new modes of existence in a digitized world are predicated on the axes of art, technology and human emotion. It draws on knowledge learnt in the first phase of the internet and puts this knowledge to work in response to the dangers of the internet in its second (hyper-commodified) phase. Through the means of digital labour or, more accurately, digital work, *Mission Eternity* invites us to critically reflect on how data is being utilized in contemporary society; how do we exist in or as data and for how long? The ambiguous nature of the Mission (adopting both haktivist and artistic perspectives throughout infinity) makes it difficult to, first, comprehend the project as a whole and, second, draw a conclusion as to its effects. While the project's preservation is reliant on fetish encountered in the art world ('deep-hacking culture'), it also foresees and prepares for the transformation of art in the future. The project is progressive and, with each stage, relies on the symbiosis of human intervention and digital production (much like the automaton); the 'social brain' employed the *Toywar* hack is very much present and guaranteed as long as *Mission Eternity* exists. In this way, the work preserves a microcosm of cooperation in an increasingly individualized world. etoy largely avoided creating surplus value in earlier works through existing as a share holding company, based on voting rights rather than financial gain. However, how the preservation of *Mission Eternity* works in terms of profit through its reliance on collectors and the artworld is still unclear. Perhaps art's economic exceptionalism and relative autonomy will act as a preservative.

Conclusion
Making work visible

Working Aesthetics is about the relationship between art, labour and capitalism. Throughout the chapters we see the capitalist working practices become compartmentalized and individualized with artistic practice responding to these changes in diverse ways. As the modus operandi of the new work models becomes less about sustained cooperation and more about the temporary and fragmented moments of sociality, how does art respond? This analysis begins to answer this question through presenting a series of case studies that focus on the moments in which work/life and artistic practice meet. In an attempt to understand how the changing models of work under capitalism have affected artistic practice, distinct models of labour constitute the structuring logic of this analysis; we encounter project management, immaterial, affective and digital modes of work. These models are paired with diverse artistic practices that adopt a form of what is termed here social labour.

As I noted in the introduction, this book does not present an exhaustive list of practices that engage with the subject of work. And, doubtlessly, some theoretical analyses will have been missed. The intention of this volume is to draw attention to certain practices in which there appears to be an alignment with capitalist work (be in practically or ideologically), presenting an opportunity for further discussion about the relationship between art, labour and

capitalism in the contemporary period. In this conclusion, I wish to reflect on some of the key overarching ideas evident throughout the book: social labour in art, the collapse of work into life and finally, the visibility of work.

Social labour in art

The earlier phases of capitalism employed a mass of workers who laboured together to produce saleable goods. The working models of Taylorism and Fordism relied on a workforce that was cooperative but not necessarily flexible in its working methods. Each worker was a cog in a well-oiled machine (i.e. the automaton) and if one faltered, it affected the other workers. At the same time, the collective nature of work was threatened by the introduction of incentive systems that relied on the individual working towards his own targets to gain financial reward. With the introduction of piecemeal tasks, the work was increasingly alienating (both from the worker's own labour, the entire process of manufacturing and the objects that they produced); at the same time these workers, through labouring side by side, had the potential to become a powerful force when unionized.

It is within this context that the fabrication firms devoted to art production emerged in the United States. Their practice displaced the alienation of through employing craft skills and embracing a more familial approach. The studio model employed cooperative labour to make the large-scale public works of art. Nonetheless, the working practices of the employed craftsmen are in some ways aligned with those in mainstream production with the division of labour into specific tasks for specific workers employed in the production of some of the large-scale artworks. In the example of Lippincott Inc., we could argue that the deskilling is passed on to the artist as the person contracting the skilled labour of others, but who arguably replaces these skills with managerial ones.

The early neo-liberal phase witnessed a different form of alienation: it strove to ideologically denigrate this politicized collectivity in work and society (pointedly under Thatcher's prime ministerial terms in the UK). People were encouraged to become 'self made' or entrepreneurial. It is within this period that the Mike Smith Studio emerged. We see Smith as the entrepreneurial individual who

built a network of fabricators and knowledge in order to establish his art business in tandem with the 'new spirit of capitalism' evident in the 1990s.[1] Interestingly, for Smith, it is the knowledge work that he values. In this spirit the individual was birthed, evidenced in Thatcher's proclamation that 'There is no such thing as society. There are individual men and women and there are families.'[2] Socialized modes of labour were thus discouraged; the privatization and closure of historically community-building industries such as coal mining is just one example. Subsequently, the relics of these industries became the new sites of culture within 'creative Britain'.

As manufacturing began to be outsourced globally, the service industries began to manifest in the UK and elsewhere. The new neo-liberal worker was encouraged to be flexible while possessing the ability to adapt to diverse working environments but still with temporary (short- or mid-term) pockets of working collectively via the project form. Hirschhorn's monuments presented an opportunity for the artistic manifestation of these changes to be explored. In this analysis, Hirschhorn is likened to the project manager, who engages a finite sociability in bringing together diverse groups of people to work on his temporary monuments. The project form is the basis of the monuments and, through reading Boltanski and Chiapello, we identify in Hirschhorn the 'great man' in the projective city; this is a figure resultant from the co-optation of the Romantic conception of artist, a model with which Hirschhorn partially identifies in maintaining the role of autonomous artist. This identification raises questions about whether the co-opted skills are actually those of the contemporary artist or whether artists engaged in social works – such as Hirschhorn – have adapted to the new conditions of capitalism.

Capitalism was founded on cooperation – social labour – but through its later stages there is a shift towards temporary, precarious, contracted work or, undertaking alienating work: headset-wearing individuals sat in rows of workstations, alienated from their co-workers through the employment of technologies of control. The example of *Call Cutta in a Box* presents a more literal translation of these work models in replicating the labour of the call centre worker. Rimini Protokoll plays with the lived experience of the audience in inviting them to engage in a conversation with a displaced call centre worker. The actor-worker becomes a human being, a temporary friend. At the same time they mirror the performance of their immaterial worker counterparts. However, the borrowing

of the script from the tradition of theatre and performance in call centre working practice again throws into question who is replicating whose labour?

Liberate Tate takes the performative qualities of affective labour and turn them against capitalism. The group responds to the resulting effects of the economic changes in the UK in the 1980s that reduced state funding of the arts and encouraged competitive corporate sponsorship. Arguably, the changed attitude towards the arts in New Labour's Britain that encouraged an assimilation of working class aesthetics (i.e. old sites of industry) and the arts also had an influence on its performances. The overwhelming space of the Turbine Hall (that once housed the turbines that generated power) becomes the site of the spectacle in which anything is possible, even spectacular unsanctioned performances. The group's performances are based on the collective practice of working together. *Time Piece*, in particular, required seventy-five participants to maintain all the moving parts of an ambitious durational action. Similarly, *Parts per Million* relied on the collective voice of fifty performers to aurally emphasize the growing amount of carbon dioxide in the atmosphere.

While it does not necessarily require people to physically work together in the same location, the social brain – collective knowledge – becomes important in the final chapter, particularly to those working on countercultural practices such as etoy. The temporary nature of these moments of socialized labour is evident in all the examples of artistic practice discussed in this volume reflecting the transient nature of the project form so central to the post-1990s 'new spirit'. *Mission Eternity* is the only example that attempts to subvert the temporal nature of the project by proposing a work that is infinite (and which is entirely reliant on cooperation/the social brain for its longevity). In the face of the increasing emphasis on the individual in work, the new social practices could be understood as resistant to this individualizing turn, placing emphasis on sociality rather than on the individual artist working to produce an object.

Work into life into art

As the boundary between work and life becomes blurred in contemporary work, contemporary art practice begins to follow

a similar logic. The proximity of art and work is evident in the practices discussed throughout this analysis. If art is connected to contemporary life (that is, non-work) then it is also intangibly connected to work. The divisions between art and life/work are becoming blurred as artists go on strike, act as project managers, employ call centres and set up corporations as part of their practice. The coalescence of work and life and, subsequently, art and life/work reminds us of the call of the historical avant-garde that Peter Bürger delineated in his well-known analysis as the return of art into life praxis.[3] Through its practice, the historical avant-garde of the early twentieth century intended to revolutionize life. However, Bürger argues that, ultimately, the historical avant-garde was unsuccessful in its revolutionary endeavour. He states that 'Art as an institution neutralises the political content of an individual work.'[4] As the avant-garde art lost its shock value, through continuing historical avant-gardist tropes, the neo-avant-garde cemented its fate by institutionalizing avant-gardist art.[5]

I had intended to suggest that, in collapsing art into life, some of the examples discussed in this book present new modes of avant-garde art making. On reflection, however, I began to question how useful it is to return to the existing category of the avant-garde to talk about the contemporary when the 'new spirit' is, in part, based on the capitalist reabsorption of the artist critique (originating with the modernist avant-garde). Like the use of capitalist machinery in post-capitalist/socialist societies, the idea of the avant-garde is not neutral. It is tied to a history of modernist artistic practices, often accompanied by stories of 'great men' artists, with their female counterparts on the periphery. Once subsumed into capitalism, the aesthetic that accompanies 'art into life praxis' becomes commonplace in the institution (hence Bourriaud's relational aesthetics that encouraged convivial encounters) while critical practices are accused of paying testament to this absorption (as with Holmes on etoy). Moreover, there exist enough critical accounts of the avant-garde in relation to the contemporary to allow for its avoidance as the framing logic here.[6] Bürger claims that the institution stopped the avant-garde from really penetrating life; this is not the case in some of the examples discussed in this volume.[7]

Making work visible

What this book is ultimately about is making visible the relationship between work and art within the contemporary period. Presented here are complex and distinct relationships; some are business models employing labour in a more straightforward way, the labour of which is often hidden from the art viewer. Sometimes the relationship is more nuanced: a practice inflected with the ideologies stemming from the absorption of the artist critique post-1968 (Hirschhorn); a group that relies on art's new-found proximity to affective labour to enable its creative actions (Liberate Tate) or a typical consumer phone call subverted into a personal exchange, provoking the viewer to the global conditions of capitalism (*Call Cutta in a Box*).

Each chapter and case study in this volume has drawn attention to labour in artistic practice in its heterogeneous forms. Sometimes work is clearly understood as labour – as in Chapters One and Two – while the other examples require more work to understand how artistic practice responds to the changing nature of capitalist work in this period (Hirschhorn, Liberate Tate and etoy). Thus we can understand the *practice* of working aesthetics as making work visible. This task becomes more urgent as contemporary labour no longer resembles what was traditionally conceived of as 'work'.

This dichotomy of visibility/invisibility is prevalent throughout the volume. The labour that is made visible in the examples is often not the skilled work or the artistic labour of the artist but that of the non-artist. And this is the labour that within the history of modernist art, at least, was rendered invisible. It seems to me that this remains a classed relationship. By its very nature, employed labour under the capitalist system constitutes a class structure. When life and work become blurred so too does the visibility of class. Class becomes divided across international borders with the hidden labour of workers now globally displaced. The class structure has not disappeared but now manifests on different terms.

We might recognize the labour of the skilled manual workers in the fabrication firms as a type of work that is traditionally aligned with the working class. Both Lippincott Inc. (now Lippincott's LLC) and the Mike Smith Studio employ labourers to manufacture art. The former employed a core team of skilled workers (presumed

waged labourers) in its original manifestation. The latter also employs a team and contracts out work to other businesses. But there is a different type of invisibility at play in these examples. The two books on the companies' practices – published by either a family member or worker at the company, respectively – are an attempt to make visible the often-invisible labour of art making in post-war sculpture.[8] As part of their working practice, the firms participate in a system that obfuscates the labour of the employed workers after the object is produced. As such, the historical hierarchical distinction between artist and craftworker is again evident once the work enters the art market. Galleries and dealers are often hesitant to acknowledge the labour of others in a saleable art object.[9]

While engaging in an understanding of the development of these firms in relation to the wider context of a shifting economic system (that is, from late capitalism through neo-liberalism) it is also my intention to make visible the labour of non-artists in these chapters to show how art has been consistently reliant on paid labour since the post-war period. Contemporary art belongs to this legacy; the Mike Smith Studio has produced some of the most iconic public British art of the twenty-first century (Whiteread's *Monument* (2001), for example) and yet the studio is little known outside of the art world.[10]

In the examples of Hirschhorn's monuments and *Call Cutta in a Box*, there is a perceived difference between artist and worker, or viewer-participant and actor-worker.[11] The examples are predicated on these existing assumptions. Hirschhorn purposefully seeks sites in which the art audience is not the only viewer; in the examples of the *Bataille Monument* and *Gramsci Monument* as part of his non-exclusionary policy, he sought out working class housing estates with inhabitants from diverse ethnic backgrounds in which to site his temporary projects. Presence becomes central to Hirschhorn's practice as he learned that being 'invisible' temporarily for a portion of the week led to the early closure of his *Deleuze Monument* in Avignon. As such he develops the idea of 'presence/production' in his subsequent practices. Furthermore, Hirschhorn names those who labour alongside him on the projects. On the *Gramsci Monument* website there is posted lists of names of the participants who worked on the project.[12] Similarly, the non-art workers are visible through a large range of documentary photographs. These are not hidden workers.

Call Cutta in a Box relies on the viewer-participant's assumptions about the person on the other end of the phone. The revelation that the actor-worker employs paid (socially reproductive) labour in the home is a device intended to invite critical reflection on these assumptions about globally displaced labour. *Call Cutta in a Box* makes visible the often-invisible worker on the other end of a phone call both literally – through the video chat – and also, I would argue, consciously through the provocation to reflect on the lived experience of workers across the globe. The actor-worker again is named when they provide the viewer-participant with a 'business card' detailing their name and contact details at the start of each performance. etoy's practice plays with the idea of invisible/ visible through utilizing anonymous workers while simultaneously presenting the group as an identifiable corporate entity in gallery contexts and through the group's web presence. The digital labour employed in both the etoy examples discussed is reliant on an invisible digital workforce but unlike its capitalist counterparts, this workforce is, arguably, unalienated.

The economic structure of the art institution is made visible through Liberate Tate's creative interventions. The group relies on the ambiguity of their unsanctioned performance made intentionally visible once performed within the institutional space. Both etoy and Liberate Tate hide in plain sight as, in the former, anonymous workers storing data or running programmes that fill virtual shopping trolleys full of toys or, in the latter, as just another performance in the gallery space. The unexpected space of the gallery (as the site of the multitude of virtuosos) facilitates Liberate Tate's unsanctioned performances.

Throughout *Working Aesthetics* the connections between social practices in contemporary art and work are made visible. I end this book not with a definitive conclusion but a call for more work to be undertaken in order to further our understanding of art's complex relationship to work and capitalism and to make visible those labouring for art. As capitalist work infiltrates everyday life, we might look to the final two examples – Liberate Tate and etoy – to see how the working practices of capitalism can be used to critique it. Liberate Tate aligned the affective qualities so welcomed in the immaterial labour of the call centre (that of the virtuoso) with politics in the pursuit of highlighting the dubious sponsorship of the public gallery space. etoy looks for alternatives

to capitalist practices: the use of peer-to-peer networks and open-source software bypasses any profit-driven legacy for its *Mission Eternity*, while the work provokes interesting questions about our own digital legacies in a world in which data is increasingly valued. What becomes clear throughout this volume is that, in tandem with the increasing proximity of work and art under capitalism, there is a working aesthetics developing in contemporary art practice.

Afterword
Where do we go from here? A note on post-work

In 2016, artist Maria Eichhorn responded to the Chisenhale Gallery's invitation to hold her first solo exhibition by closing the gallery and asking the staff to withdraw their labour for the five-week duration of the exhibition. The exhibition was conceived to replace labour with the implementation of leisure and 'free' time.[1] In the final stages of completing this manuscript, the *Guardian* published a 'long read' on post-work.[2] While I was thinking about the relationship between work/life and whether the two are any longer indistinguishable, it occurred to me that post-work offered an alternative to the subsumption of work into life. I also wondered if some people are already living in a post-work condition (but not the one imagined), one in which work and life are indistinguishable, so there is no distinct 'work'.

While the focus of *Working Aesthetics* is labour, this analysis would not be complete without a note on post-work. I began this book with a quotation from Kathi Weeks; in the same book she imagines a post-work politics in which she concludes that in order to 'get a life', we must 'contest the terms of the work society and struggle to build something new'.[3] The importance of post-work thinking to artistic practice is already stirring. The emergence of volumes devoted to the idea of strike such as *Strike Art, I Can't*

Work Like This and the 'On Strike' section in *Work*, or the refusal of work (as in Shukaitis' chapter on 'Learning not to Labour') is testament to the importance of withdrawal to neo-liberal working life.[4] Furthermore, it firmly places the subject of work within art's grasp, something that this contribution aimed to make clear. The increased appearance of work as a subject for contemporary art means, for me, that this boundary has now been traversed. We have seen, after all, that the artist's demands were co-opted by capitalism post-1968; artists are now adapting to their own subsumption into work. As labour is central to the production of value under capitalism, post-work imagines a different system in which the role of art will be once more transformed.

NOTES

Prologue

1 Athenaeum, 9 May 1874, quoted in Kathryn J. Summerwill, 'The Dinner Hour, Wigan', *Eyre Crow* website, https://eyrecrowe.com/pictures/1870s/the-dinner-hour-wigan/ (accessed 8 August 2017).

Introduction

1 Kathi Weeks, *The Problem with Work: Feminism, Marxism, Antiwork Politics, and Postwork Imaginaries* (Durham and London: Duke University Press, 2011), 2.
2 Henrich Wölfflin *Principles of Art History: The Problem of the Development of Style in Later Art* (New York: Dover Publications, 1950); Clive Bell, *Art* (London: Arrow Books, 1914/1961) and Clement Greenberg, *Art and Culture: Critical Essays* (Boston, MA: Beacon Press, 1961).
3 The Work Foundation, *Staying Ahead: the Economic Performance of the UK's Creative Industries* (June 2007), 141.
4 John Berger, *Ways of Seeing* (London: Penguin, 1972).
5 Raymond Williams, *Keywords* (London: Fontana Press, 1988), 334.
6 Ibid.
7 Ibid., 176–178.
8 Leon Trotsky, 'From Literature and Revolution' (1925), in *Art in Theory 1900–2000*, ed. Charles Harrison and Paul Wood (Malden and Oxford: Blackwell, 2003), 445.
9 Theodor Adorno, *Aesthetic Theory* (London: Continuum, 1996), 6.
10 Beech notes that Marxist writers are among the most prominent theorists of art's autonomy. Dave Beech, *Art and Value: Art's Economic Exceptionalism in Classical, Neoclassical and Marxist Economics* (London: Haymarket, 2016), 28.

11 Karl Marx, 'Theories of Surplus Value' in *Karl Marx Selected Writings*, ed. David McLellan, 2nd edn (Oxford: Oxford University Press, 2007), 432.
12 The interpretation of socially reproductive labour as unproductive labour is challenged in the work of Silvia Federici (and other feminist materialist thinkers in the 1970s), and who founded the 'wages for housework' campaign.
13 Marx, 'Theories of Surplus Value'.
14 Karl Marx, *Capital*, vol. 1, trans. Ben Fowkes (London: Penguin, 1990), 1044.
15 Arnold Hauser, 'The Sociological Approach: The Concept of Ideology in the History of Art', in *The Philosophy of Art History* (New York: Alfred A. Knopf, 1959), 36.
16 I must also acknowledge Fred Orton's teaching here, as his undergraduate lecture on *The German Ideology* has long resonated in both my thinking about and my own teaching of the history of art.
17 Karl Marx and Frederick Engels, *The German Ideology* (1845–46), ed. C. J. Arthur, students' edition (London: Lawrence & Wishart, 1978), 108.
18 Hauser, 'The Sociological Approach', 28.
19 Karl Marx, 'Preface to a Critique of Political Economy' (1859) extract, in *Karl Marx Selected Writings*, ed. David McLellan, 2nd edn (Oxford: Oxford University Press, 2007), 425.
20 Leon Trotsky, 'From Literature and Revolution' (1925), in *Art in Theory 1900–2000*, ed. Charles Harrison and Paul Wood (Malden and Oxford: Blackwell, 2003), 445.
21 This point is noted in Jorge Larrain, 'Base and Superstructure', in *A Dictionary of Marxist Thought*, ed. Tom Bottomore, 2nd edn (Oxford and Malden, MA: Blackwell, 2001), 46.
22 It should be noted that ideologies can take more time to develop and/or be sustained within periods beyond those in which the correspondent economic relations first emerged. After the introduction of the Fordist assembly line in 1914, for example, the Fordist ideology did not manifest in America until the mid-twentieth century.
23 *Work*, ed. Friederike Sigler (London: Whitechapel Books, 2017). *I Can't Work Like This: A Reader on Recent Boycotts and Contemporary Art*, ed. Joanna Warsza (Berlin and New York: Sternberg Press, 2017).
24 *Work, Work: A Reader on Art and Labour*, ed. Jonatan Habib Engqvist et al. (Berlin and New York: Sternberg Press, 2012).
25 Temporary Services, 'About Art Work', http://www.artandwork.us/about/ (accessed 27 January 2018).

26 There are some interesting perspectives coming from performance – Shannon Jackson's *Social Work: Performing Art, Supporting Publics* and Bojana Kunst's *Artist at Work*, for example, which are referred to in the main argument.
27 Roberts, *Intangibilities of Form: Skill and Deskilling in Art After the Readymade* (London: Verso, 2007), 5. I return to Roberts in Chapter One in relation to his denouncing the use of Harry Braverman's deskilling thesis in relation to artistic labour.
28 Roberts, *Intangibilities of Form*, 126. The section on 'non-artist collaborators' similarly dismisses 'hired labour' and 'subject to executive decision' in favour of the more directly collaborative work in the historical example of the Soviet Productivists. 160–161.
29 Gregory Sholette, *Dark Matter: Art and Politics in the Age of Enterprise Culture* (London and New York: Pluto, 2011), 1.
30 Stevphen Shukaitis, *The Composition of Movements to Come: Aesthetics and Cultural Labour after the Avant-Garde* (London and New York: Rowman & Littlefield, 2016).
31 Angela Dimitrakaki, *Gender, artWork and the Global Imperative: A Materialist Feminist Critique* (Manchester: Manchester University Press, 2013).
32 Angela Dimitrakaki and Kirsten Lloyd, '"The Last Instance" – The Apparent Economy, Social Struggles and Art in Global Capitalism', in *Economy* ed. Dimitrakaki and Lloyd (Liverpool: Liverpool University Press, 2015), 24.
33 Dimitrakaki and Lloyd, 'The Last Instance', 7.

Chapter One

1 Exhibitions include *Artist & Fabricator*, Fine Arts Center Gallery, 1975; *14 Sculptors: The Industrial Edge*, Walker Art Centre, Minneapolis, 1969 and *Monumenta*, Newport, Rhode Island in 1974.
2 Nicolas Bourriaud, *Relational Aesthetics* (Paris: Les Pressés du Reel, 2002).
3 Michelle Kuo, *Artforum*, 'Art of Production' issue, October 2007; Julia Bryan-Wilson, *Art Workers: Radical Practice in the Vietnam War* (Berkeley, Los Angeles, London: University of California, 2009), 83–125.
4 Glenn Adamson and Julia Bryan-Wilson, *Art in the Making: Artists and their Materials from the Studio to Crowdsourcing* (London: Thames and Hudson, 2016).

5 Harry Braverman, *Labour and Monopoly Capitalism: The Degradation of Work in the Twentieth Century* (New York, London: Monthly Review Press, 1974).
6 Lucy Lippard and John Chandler, 'The Dematerialization of Art' (1968), in *Conceptual Art: A Critical Reader*, ed. A. Alberro and B. Stimson (Cambridge: MIT, 2000), 46–50.
7 Lippard edited and published 'Questions to Stella and Judd', *Art News* 65, no.5 (September 1966), she also wrote the essay 'Eros Presumptive' published in *The Hudson Review* (Spring 1967), an essay on the eroticism in minimalist language.
8 Michael Fried, 'Art and Objecthood', *Artforum* (Summer 1967) pp. 12–23. Clement Greenberg, 'Recentness of Sculpture' in *American Sculpture of the Sixties (catalogue)* (Los Angeles: Los Angeles County Museum of Art, 1967).
9 Clement Greenberg, 'Modernist Painting' (1961) in *Art in Theory 1900–2000: An Anthology of Changing Ideas*, ed. Charles Harrison and Paul Wood (Malden, MA, and Oxford: Blackwell Publishing, 2003), 773–779.
10 Michael Fried, *Three American Painters: Kenneth Noland, Jules Olitski, Frank Stella* (New York: Fogg Art Museum, 1965) and 'Art and Objecthood' (1967), in *Minimal Art: A Critical Anthology*, ed. Gregory Battock (Berkeley, Los Angeles, London: University of California, 1995), 116–147.
11 Benjamin H. D. Buchloh, 'Hans Haacke: Memory and Instrumental Reason' in *Neo-Avantgarde and the Culture Industry: Essays on European and American Art from 1955 to 1975* (London and Cambridge, MA: MIT Press, 2003), 210.
12 Ibid., 211.
13 Ian Burn (1981) cited in ibid., 210.
14 Roberts, *Intangibilities of Form.*
15 Roberts is unclear as to the form that the reskilled art takes. He does not believe that art after the decline of craft-based skill became entirely heteronomous, despite the argument that conceptual art replaced these skills. The hand was still useful in making conceptual works, even if it was only directed by the artist (rather than attached to him). Roberts makes the argument that skill re-emerges as the craft of reproducibility of copying without copying (as Roberts suggests the Readymades are). Ibid., 97–99.
16 Rosalind E. Krauss, 'Sculpture in the Expanded Field' in *The Originality of the Avant-Garde and Other Modernist Myths* (Cambridge: MIT Press, 1986), 276–290.
17 Peter Galison and Caroline A. Jones provide an interesting discussion of Robert Smithson's *Spiral Jetty* in relation to changing models

of industrial architecture and a collective working practice in 'Factory, Laboratory, Studio: Dispersing Sites of Production' in *The Architecture of Science*, ed. Peter Galison and Emily Thomas (Cambridge, MA: MIT Press, 1999), 497–540.
18 Krauss, 'Sculpture in the Expanded Field'.
19 Buchloh, 'Hans Haacke: Memory and Instrumental Reason', 227.
20 Max Weber, *The Protestant Ethic and The Spirit of Capitalism* (New York: Charles Scribner's, 1976), 181.
21 Cited in Bryan-Wilson, *Art Workers*, 44.
22 John Lobell (architecture writer and Milgo consultant) in *Arts Magazine* (June 1971). Quoted in Michelle Kuo, 'Industrial Revolution', *Artforum* (October 2007), 306–315 and 396.
23 Hugh M. Davis, 'Interview with Robert Murray', in *Artist & Fabricator*, exhibition catalogue, Fine Arts Center Gallery (University of Massachusetts/Amherst, 1975), 54.
24 Davis, 'Interview with Donald Lippincott', 35.
25 Charles Ritchie and Ruth E. Fine, *Gemini G.E.L.: A Catalogue Raisonné, 1966–1996*, http://ww.nga.gov/gemini/essay2.htm (accessed 17 March 2010).
26 See: Lori Moody, 'Some Assembly Required', Los Angeles Life supplement, *Daily News*, 26 July 1995.
27 David Pagel, 'The Art Factory', *Calendar*, 31 August 2003, E33.
28 Leslie Maitland, 'Factory Brings Sculptors' Massive Dreams to Fruition', *The New York Times*, 24 November 1976, 35 and 55.
29 Davis, 'Interview with Donald Lippincott', in *Artist & Fabricator*, 35–44.
30 Of course, there are exceptions to this, as was the case with Clement Meadmore.
31 Davis, 'Interview with Roxanne Everett', *Artist & Fabricator*, 45.
32 Ibid., 10.
33 Braverman, *Labour and Monopoly Capitalism*, 126.
34 Adam Smith, 'Of the Division of Labour' in *The Wealth of Nations: Books I-III*, ed. Andrew Skinner (London: Penguin, 1982), 110.
35 Braverman, *Labour and Monopoly Capitalism*, 90.
36 Marx, *Capital*, 716.
37 Greenberg, 'Modernist Painting'.
38 Braverman, *Labour and Monopoly Capitalism*, 90.
39 Ibid., 100.
40 Ibid., 112.
41 Ibid., 118.
42 David Harvey, *The Condition of Postmodernity* (Cambridge, MA and Oxford: Blackwell, 1990), 125.

43 Terry Smith, *Making the Modern: Industry, Art and Design in America* (Chicago: University of Chicago, 1993), 23.
44 Ibid., 23–24.
45 Antonio Gramsci (1929–35) in *Selections from the Prison Notebooks of Antonio Gramsci*, ed. Quentin Hoare and Geoffrey Nowell-Smith (London: Lawrence and Wishart, 1971), 302.
46 Smith, *Making the Modern*, 50.
47 Harvey, *The Condition of Postmodernity*, 129 and 135.
48 Bryan-Wilson, *Art Workers*, 102.
49 Roberts, *Intangibilities of Form*.
50 Ibid., 84–87.
51 Beech, *Art & Value*, 256–266.
52 Bryan-Wilson, *Art Workers*, 93.
53 Michelle Kuo describes the minimalist who worked with Treitel Gratz as engaging in 'the dialogical dance of high end industrial design'. Kuo, 'Industrial Revolution', *Artforum* (October 2007): 309. Treitel Gratz is now Gratz Industries. The term dialogical also conjures Grant Kester's dialogic art, which he uses to refer to contemporary social art practices. See: Kester, *Conversation Pieces: Community and Communication in Modern Art* (Berkeley, Los Angeles and London: University of California Press, 2013).
54 Davis, 'Interview with Donald Lippincott', in *Artist and Fabricator*, 40.
55 Ibid.
56 Ibid.
57 Lesley Maitland, 'Factory Brings Sculptors' Massive Dreams to Fruition', *The New York Times*, 24 November 1976, 55.
58 Maitland, 'Factory Brings Sculptors' Massive Dreams to Fruition', 55.
59 Ruth E. Fine, *Gemini G.E.L. Art and Collaboration* (New York: Abbeville Press, 1984), 27–28.
60 Everett in *Artist & Fabricator*, 47.
61 I am entirely reliant upon sources from the period and the documentary photographs for my understanding of Lippincott's working process. I am incredibly thankful that Roxanne Everett was such an avid documentary photographer. The images reproduced in *Large Scale* from Lippincott's collection have been invaluable.
62 Jonathan Lippincott, *Large Scale: Fabricating Sculpture in the 1960s and 1970s* (New York: Princeton Architectural Press, 2010), 135.
63 Ibid., 138.
64 Ibid., 141.
65 Bryan-Wilson, *Art Workers*, 82–125.
66 Ibid., 85.

67 I note the ethnicity of the worker as the white, cigar-smoking Morris operating the fork-lift truck while an African American worker removes the dolly from beneath the forks' load, which returns race to the question of labour. Although we might read the image as depicting the artist-worker, there is an unfortunate hierarchy implied in the image between machine operator and porter.
68 *Artist & Fabricator*, 19.
69 In utilizing the term 'formalist', I refer to those critics and art historians who took their lead from Romantic philosophers such as Immanuel Kant, art historians such as Heinrich Wölfflin and the critic Clement Greenberg who prioritize the *form* of an artwork.
70 Suzanne Lacy, 'Introduction' in *Mapping the Terrain: New Genre Public Art* (Seattle: Bay Press, 1995), 19–30.
71 Braverman, *Labour and Monopoly Capitalism*, 411. 'Even more, they [unproductive labourers] *fall outside* of the distinction between productive and unproductive labour, because they are *outside the capitalist mode of production*.' Braverman's emphasis.
72 Lippincott, *Large Scale*, 22.
73 Email correspondence with Jonathan Lippincott, 4 May 2016.

Chapter Two

1 'History', http://www.lippincottsculpture.com/history.html (accessed 22 November 2016).
2 Ed Suman, 'The Producers' in *Artforum*, 'The Art of Production' issue (October 2007), 356.
3 In 2010, the British foundry Morris Singer also went into administration; the firm is still operating today.
4 'History', http://www.lippincottsculpture.com/history.html (accessed 22 November 2016).
5 Mike Smith, 'Construct Your Ambition: Making Grand Ideas Become Realities', in *The Artist's Yearbook 2006*, ed. Ossian Ward (London: Thames and Hudson, 2005), 188.
6 Anya Gallaccio interviewed by William Furlong, in *Making Art Work*, ed. Patsy Craig (London: Trolley, 2003), 474–478.
7 Smith himself is very aware of this aesthetic. Smith in *Making Art Work*, 27.
8 David Batchelor quoted in Patrick Barkham, 'Can You Do Me a Quick Cow's Head?', *The Guardian*, 5 March 2008.
9 The 'philistine' is a term used by Roberts to describe the work of the YBAs. Beech and Roberts, eds, *The Philistine Controversy* (London and New York: Verso, 2002).

10 *Technique Anglaise: Current Trends in British Art*, ed. Andrew Renton and Liam Gillick (London: Thames and Hudson, 1991), 17–19.
11 Koons cites his view of art as an interface between the European figurative tradition and American minimalism, so it makes sense that some of the emergent artists were drawn to his work whilst students. Koons cited by Eckhard Schneider, 'Surface and Reflection' in *Jeff Koons* (Kunsthaus Bregenz, 2001), 17.
12 These figures fluctuate as Smith takes on more staff for certain projects and fewer staff members are employed for others.
13 See 'Artist Project Time Line', in *Making Art Work*, 4–10.
14 *Making Art Work*, ed. Patsy Craig.
15 Interestingly, Smith's father was an engineer.
16 Wade Saunders, 'Making Art, Making Artists', *Art in America*, 81 (January 1993): 89.
17 These publications include: Mike Smith, 'Construct Your Ambition: Making Grand Ideas Become Realities'; Zoe Manzi, 'Vision Unlimited', *Tate*, 8 (November/December 2003): 22–26; 'The Producers', *Artforum* (October 2007), 352–359 and 402; and *Making Art Work*.
18 Julian Stallabrass, *High Art Lite: The Rise and Fall of the Young British Artists*, expanded edition (London and New York: Verso, 2006).
19 Saatchi and Saatchi was employed for Thatcher's election campaign in 1979, producing the well-known 'Labour isn't Working' poster depicting queues of unemployed workers.
20 Robert Hewison, *Cultural Capital: The Rise and Fall of Creative Britain* (London: Verso, 2014).
21 Maurice Saatchi – Charles's brother and the other Saatchi in 'Saatchi and Saatchi' – was among the informal group formed in 1995 that birthed 'Creative Britain'.
22 Hewison, *Cultural Capital*, 46.
23 Luc Boltanski and Eve Chiapello, *The New Spirit of Capitalism* (London and New York: Verso, 2005).
24 At the time of writing *The New Spirit of Capitalism*, Luc Boltanski was a professor of social sciences at École des hautes études en sciences sociales, Paris and Eve Chiapello was an associate professor at the HEC School of Management, Paris. This dual background of sociology and management studies forms the basis of their analysis.
25 Boltanski and Chiapello, *The New Spirit of Capitalism*, xx.
26 Marx, 'Preface to a Critique of Political Economy', 425.
27 Boltanski and Chiapello, *The New Spirit of Capitalism*, xx.

28 Reference to this analysis is now common in critical analyses of contemporary art. Authors who have referenced Boltanski and Chiapello include Brian Holmes, Maria Lind, Gregory Sholette and Angela Dimitrakaki. Brian Holmes, 'The Flexible Personality: For a New Cultural Critique', www.noemalab.org/sections/ideas/ideas_articles/pdf/holmes_flexible_p.pdf. (2004) (accessed 14 May 2008); Maria Lind 'The Collaborative Turn' in *Taking the Matter into Common Hands*, ed. Johanna Billing et al. (London: Black Dog, 2007),15–31; Gregory Sholette, *Dark Matter* and Dimitrakaki, *Gender, artWork and the Global Imperative*.
29 Boltanski and Chiapello, *The New Spirit of Capitalism*, 8.
30 Kevin Doogan, *New Capitalism? The Transformation of Work* (Cambridge and Malden, MA: Polity, 2009), 31.
31 The model of 'social critique' that Boltanski and Chiapello work with comes from César Graña's *Bohemian versus Bourgeois. French Society and the French Man of Letters in the Nineteenth Century* (1964).
32 Boltanski and Chiapello, *The New Spirit of Capitalism*, 37.
33 I refer throughout to 'artist critique', rather than the sometimes-cited 'artistic critique', following Chiapello's preference delineated in her article 'Evolution and Co-optation'. Chiapello states:
 Whereas many artists expressed this [artist] critique forcefully, they were not alone in doing so, which is why I prefer to speak of 'artist critique' rather than 'artistic critique' – especially since the latter is an ambiguous term liable to mean that artists are the subject of either the critique or its target. (Chiapello, 'Evolution and Co-optation: The "Artist Critique" of Management and Capitalism', *Third Text*, 18, no. 6 (2004): 586, emphasis in original)
34 Boltanski and Chiapello, *The New Spirit of Capitalism*, 37.
35 Alex Callinicos, *The Resources of Critique* (Cambridge and Malden, MA: Polity, 2006), 67.
36 Boltanski and Chiapello, *The New Spirit of Capitalism*, 33.
37 Holmes, 'The Flexible Personality: For a New Cultural Critique'.
38 Ibid.
39 Ibid.
40 Jen Harvie, *Fair Play: Art, Performance and Neoliberalism* (Basingstoke: Palgrave Macmillan, 2013), 95.
41 Richard Sennett, *The Craftsman* (London: Penguin, 2008).
42 Sennett, *The Craftsman*.
43 Harvie, *Fair Play*, 48.
44 The artists in whom Harvie identifies these qualities are strange bedfellows, such as popular artists Jeremy Deller and Grayson Perry, but this is not my argument here.

45 Landy's *Breakdown* (2001) involved the artist categorizing and then destroying all of his possessions in an assembly-line format in an old C&A building in London.
46 Harvie, *Fair Play*, 99.
47 Ibid., 105–107.
48 Similarly, Harvie sees the employment of assistants in Ackroyd and Butler's temporary Flytower work as collaborative and further instills its egalitarian virtues through its designation as public. Although technically collaborative (in the sense that more than one person worked on the piece), there is still work to do in understanding contracted labour in artistic practice, when often the collaborators are unnamed assistants or unacknowledged entirely.
49 Harvie later refers to the artworks commissioned by Artangel as 'pop-up'. Harvie, *Fair Play*, 121.
50 Commissioning agencies, such as Artangel and Situations, focused on public or site-specific contemporary art are another new business model found in Britain in the 1990s. These agencies fund and facilitate/organize art projects that don't always take place in the gallery space.
51 Earlier in her chapter on 'The Artrepeneur', and in relation to the YBAs, Harvie denounces models of networked collaboration as 'informal, temporary and insecure'. Harvie, *Fair Play*, 88.
52 Sennett, cited in Harvie, *Fair Play*, 98.
53 Mike Smith and Patsy Craig, 'The Art of Collaboration' talk at the AA School of Architecture, 12 October 2004 (published online 5 June 2015), https://youtu.be/M4IEHSXBTOQ.
54 Mike Smith and Patsy Craig, 'The Art of Collaboration'. The Turbine Hall commissions are a case in point for the site-specific works made for particular locations cited by Smith.
55 Doogan, *New Capitalism?*
56 Ibid., 33.
57 Chiapello, 'Evolution and Co-optation'.
58 David Harvey, *The Condition of Postmodernity* (Malden and Oxford: Blackwell, 1990).
59 Ibid.
60 Ibid., 142.
61 Ibid., 156.
62 Ibid., 157.
63 Hewison, *Cultural Capital*, 42.
64 Harvey, *The Condition of Postmodernity*, 152.
65 Ibid., 159.
66 Suman, 'The Producers', 356.

67 Alex Callinicos equates the cities to 'political communities', an interpretation which is useful here. Callinicos, *The Resources of Critique*, 64.
68 Luc Boltanski and Laurent Thévenot, *De la justification: les économies de la grandeur* (Paris: Gallimard, 1991).
69 The gendered labelling of the 'great man' is, of course, problematic.
70 Boltanski and Chiapello, *The New Spirit of Capitalism*, 23.
71 The city models are not without critique. See: Callinicos, *The Resources of Critique*, 51–72.
72 Boltanski and Chiapello, *The New Spirit of Capitalism* 24.
73 Doogan, *New Capitalism?* 5.
74 Boltanski and Chiapello, *The New Spirit of Capitalism*, 103.
75 Ibid., 103–107.
76 Ibid., 104.
77 Smith and Craig, 'The Art of Collaboration'.
78 Patsy Craig in *Making Art Work*, 19.
79 About this new model of worker, Barry King writes: 'It is less about being a type of worker and more a matter of being a style of person. The new "ideal" worker becomes a modular self; one who fits into the team and is yet at the same time (hopefully) is unique and irreplaceable.' Barry King, 'Modularity and the Aesthetics of Self-Commodification', in *As Radical as Reality Itself*, ed. Matthew Beaumont et al. (Bern: Peter Lang, 2007), 342.
80 Smith in *Making Art Work*, 28.
81 Manzi, 'Vision Unlimited, 25.
82 Smith and Craig, 'The Art of Collaboration'.
83 Boltanski and Chiapello, *The New Spirit of Capitalism*, 114–115. Italics in original.
84 Noble and Webster speak of eventually going to Smith for help on one element of a piece which they had made themselves, because they got a large commission and could afford to use the studio. They had avoided it for three years as when they had previously visited Smith for advice they had seen a whiteboard with the name of almost every British artist chalked upon it, which Noble claims still haunts him to this day. Webster comments that: 'it felt like joining a club. And it's like you know you always want to see yourself as an individual and you have to remind yourself of that and when we saw the list of names and we thought that everyone had given into this man who could make your dreams come true'. Noble and Webster in *Making Art Work*, 359.
85 Noble and Webster in *Making Art Work*, 359.
86 Chiapello, 'Evolution and Co-optation', 585. Rob Austin and Lee Devin's *Artful Making: What Managers Need to Know About How*

Artists Work (New Jersey: Financial Times Prentice Hall, 2003) evidences this transition into management discourse.
87 Boltanski and Chiapello, *The New Spirit of Capitalism*, 77.
88 Ibid., 115.
89 Ibid.
90 Notably, Peter Carlson had a similar background, he moved from Electrical Engineering to study Fine Art.
91 Mike Smith, 'The Producers', 402.

Chapter Three

1 These practices will be discussed in the following chapters.
2 The number of political artistic groupings established in New York alone during the late 1960s and early 1970s (and adopting the artist mode of critique) – such as the Art Workers Coalition (AWC), Colab and Women Artists in Revolution (WAR) – is significant.
3 Smith, 'The Producers', 402.
4 Thomas Hirschhorn, 'Monuments' (2006), in *Critical Laboratory: The Writings of Thomas Hirschhorn*, ed. Lisa Lee and Hal Foster (Cambridge, MA: MIT, 2013), 46.
5 Ibid., 45.
6 There are artists who list people as their materials, including Rikrit Tiravanija who lists 'lots of people' in his installations.
7 Hirschhorn, 'Letter to the Residents of the Friedrich Wohler Housing Complex (Regarding the *Bataille Monument*)', in *Critical Laboratory*, 226.
8 Hirschhorn, 'Monuments', 45.
9 Thomas Hirschhorn, Royal College of Art, London, 11 March 2014.
10 Hirschhorn has undertaken other non-monument projects that fall under the 'presence/production' category including the *Bijlmer Spinoza-Festival* (2009) and the *Théâtre Précaire* (2010).
11 Thomas Hirschhorn, 'Conversation: Presupposition of the Equality of Intelligences and Love of the Infiniture of Thought: An Electronic Conversation between Thomas Hirschhorn and Jacques Rancière' (2009/10), in *Critical Laboratory*, 371. Lacy, *Mapping the Terrain*.
12 'I had never thought the *Bataille Monument* could be discussed and criticized as a social art project. I think it is totally proper that social issues are raised through an art project.' Hirschhorn, 'Letter to Iris (Reflections on the *Bataille Monument*)', in *Critical Laboratory*, 238.
13 Thomas Hirschhorn, 'Bataille Monument' in *Contemporary Art: From Studio to Situation*, ed. Claire Doherty (London: Black Dog, 2004), 135.

14 Hirschhorn, 'Letter to the Residents of the Friedrich Wohler Housing Complex (Regarding the *Bataille Monument*)', 225.
15 Hirschhorn was not the first artist to site his work away from the main *Documenta* arena. In 1982, Joseph Beuys exited the main site of *Documenta 7* to create his work *7000 Oaks*. Beuys undertook a social work of a different kind, with the planting of 7000 trees – and accompanying basalt columns – as its aim. Beuys anticipated that each tree would be a 'monument'.
16 Hirschhorn, 'Letter to Iris (Reflections on the *Bataille Monument*)', 237.
17 Cited in Hirschhorn 'Letter to Iris (Reflections on the *Bataille Monument*)', 236.
18 Ibid., 236.
19 Hirschhorn, 'Bataille Monument', 140.
20 Ibid., 143.
21 Hirschhorn, 'Monuments', 45.
22 Benjamin H. D. Buchloh, 'An interview with Thomas Hirschhorn', *October*, 113 (Summer 2005): 85–86.
23 Luisa Vale, 'Object Lesson: Thomas Hirschhorn's Gramsci Monument: Negotiating Monumentality with Instability and Everyday Life' in *Building & Landscapes*, 22, no. 2 (Fall): 20.
24 It is commendable that, during his 2014 talk, Hirschhorn named almost every person with whom he worked on the *Gramsci Monument*.
25 Boltanski and Chiapello, *The New Spirit of Capitalism*, 39.
26 Ibid., 38. This, of course, returns us to the discussion of unproductive labour.
27 Charles Baudelaire, 'The Painter of Modern Life' (1863) in *The Painter of Modern Life and Other Essays* (London: Phaidon, 1995), 1–41.
28 Walter Benjamin, 'Paris, the Capital of the 19th Century' in *The Work of Art in the Age of its Technological Reproducibility and Other Writings on Media*, ed. Jennings, Doherty and Levin (Cambridge, MA, and London: Belknap, 2008), 96–115.
29 César Graña, *Bohemian Versus Bourgeois. French Society and the French Man of Letters in the Nineteenth Century* (New York: Basic Books, 1964).
30 Richard Lloyd, *Neo-Bohemia: Art and Commerce in the Postindustrial City* (New York and Oxon: Routledge, 2006).
31 Austin and Devin, *Artful Making: What Managers Need to Know About How Artists Work*.
32 The Work Foundation, 'Staying Ahead'.
33 Ibid., 20.

34 Ibid., 141.
35 Maurizio Lazzarato, 'The Misfortunes of the "Artistic Critique" and of Cultural Employment', http://eipcp.net/transversal/0207/lazzarato/en. (2007) (accessed 18 January 2010).
36 The Work Foundation, 'Staying Ahead', 141.
37 Ibid.
38 In her essay 'The Clouded Mirror', Christine Battersby presents an overview of the gendered term 'genius' in art. She plots the genesis of the term from its original associations with mimesis – creating a 'masterpiece' – through to the Romantic notion of genius, attributed to artists in the Renaissance. The Romantic notion of genius was considered to be a talented male with good judgement and knowledge. His work was also associated with originality, which was gaining value at the time. Originality, however, in this sense, was still closely connected to mimesis. In the modern sense, originality comes to be aligned with the artist rather than his mimetic abilities. The artist-genius myth is further concretized through a concern with not only the life of an artist but also his (or her) psychology, which is then considered in relation to an artist's oeuvre to build a 'story' for the artist – or an artistic subject – as is the case with Vincent van Gogh. Christine Battersby, 'The Clouded Mirror' (1989), in *Art and its Histories: A Reader*, ed. Steve Edwards (New Haven and London: Yale University Press, 1999), 129–133. See also: Griselda Pollock, 'Artists Mythologies and Media Genius, Madness and Art History', *Screen*, 21, no. 3 (1981): 57–96.
39 Boltanski and Chiapello, 104. Emphasis in original.
40 A full description of the project can be found in Hirschhorn, 'Bataille Monument'.
41 According to documentation provided on the Gramsci Monument website, 'black' residents make up 41.2 per cent, while 'Hispanic' residents constitute 56.2 per cent of the total population in Forest Houses. 'Forest Residents: Percentage Distribution', http://awp.diaart.org/gramsci-monument/page53.html (accessed 9 September 2017).
42 Thomas Hirschhorn, 'Unshared Authorship' (2012), http://awp.diaart.org/gramsci-monument/page47.html (accessed 16 August 2017).
43 The Other is a term used in philosophy (Derrida, Hegel) and psychoanalysis (Lacan) to denote difference. It also has negative associations, as with orientalism in which the term was used to denote racial difference (and a perceived hierarchy).
44 Despite Hirschhorn's assertion of equality throughout his writings, due to its historical use, the term Other may also signal hierarchical difference.

45 Hirschhorn, 'Unshared Authorship'.
46 Carlos Basualdo, 'Bataille Monument, Documenta 11, 2002', in *Thomas Hirschhorn*, ed. Benjamin H. D. Buchloh (London: Phaidon, 2004), 96–108.
47 Benjamin H. D. Buchloh, 'An Interview with Thomas Hirschhorn', *October*, 113 (Summer 2005), 86.
48 Hirschhorn, Royal College of Art, London, 11 March 2014.
49 Hirschhorn, 'Bataille Monument'.
50 Hirschhorn, 'Conversation: Presupposition of the Equality of Intelligences and Love of the Infiniture of Thought', 378.
51 Orlando Mcallister, *Gramsci Monument Pt1*, https://www.youtube.com/watch?v=bYNRyu_TMi8&t=354s (accessed July 2017)
52 Hirschhorn, 'Bataille Monument', 135.
53 Claire Bishop, 'Antagonism and Relational Aesthetics', *October*, 110 (Fall 2004): 51–79.
54 Buchloh, 'An Interview with Thomas Hirschhorn', 86.
55 Ibid., 87.
56 Thomas Hirschhorn, 'Conversation: Presupposition of the Equality of Intelligences and Love of the Infiniture of Thought'.
57 Hirschhorn, 'Unshared Authorship'. Bojana Kunst, *Artist At Work: Proximity of Art and Capitalism* (Hants: Zero, 2014), 68.
58 Hirschhorn held a three-day opening event at *Bataille Monument* to correspond to *Documenta 11*'s opening activities.
59 However, this interpretation could be a little too utopic; participants may have remained in their social groups while eating, as one may experience in a cafe or restaurant.
60 Kunst, *Artist at Work*, 59.
61 Ibid., 67.
62 Ibid., 68.
63 Boltanski and Chiapello, 112, original emphasis.
64 Ibid., 111–112.
65 The Work Foundation, 142.
66 Ibid., 142.
67 Boltanski and Chiapello, 112.
68 Buchloh, 'An Interview with Thomas Hirschhorn', 87–88.
69 Ibid., 87.
70 Basualdo, 'Bataille Monument, Documenta 11, 2002', 96.
71 Buchloh 'An Interview with Thomas Hirschhorn', 95. Emphasis in original.
72 Hirschhorn states:
 Visitors often asked me how the project was received by the residents of the housing complex. I am certainly the last person who could answer that question! It seems obvious that an answer

would involve a value judgment. That would mean that if the project was received well it was a success and if not, then it was a failure. The Bataille Monument project was not a matter of acceptance or rejection. ("Bataille Monument", 145)
73 Ibid., 136.
74 Hirschhorn claims, with the *Bataille Monument*, the money issue is unresolved for him. He understands that, 'as soon as payment is involved, inevitably the working hours and achievement of the co-workers are observed'. He states that 'This led to many unproductive, non-beautiful situations.' Hirschhorn, 'Bataille Monument', 145–146.
75 Boltanski and Chiapello, 110.

Chapter Four

1 The intention is not to narrow down a definition here but to understand the shift to a social practice within the wider conditions of capitalism.
2 Maurizio Lazzarato, 'Immaterial Labour' (1996), in *Radical Thought in Italy: A Potential Politics*, ed. Paolo Virno and Michael Hardt (Minneapolis: Minnesota, 2006), 133.
3 Lazzarato, 'Immaterial Labour', 137.
4 Maria Lind presents a good overview of the different terminologies adopted in writing about the new social art practices. See: Lind, 'The Collaborative Turn', in *Taking the Matter into Common Hands*, ed. Johanna Billing et al. (London: Black Dog, 2007), 15–31.
5 Lacy, *Mapping the Terrain*.
6 Claire Bishop, 'Antagonism and Relational Aesthetics', *October*, no. 110 (Fall 2004): 51–79.
7 These include: *Collective Creativity*, exhibition catalogue, Kunsthalle Fridericianum, Kassel (1 May–17 July 2005); *Living as Form: Socially Engaged Art from 1991–2011*, ed. Nato Thompson (New York and London: Creative Time Books, 2011), Tom Finklepearl, *What We Made: Conversations on Art and Social Cooperation* (Durham and London: Duke University Press, 2013) and *Out of Time, Out of Place: Public Art (Now)* ed. Claire Doherty (London: Art/Books, 2015).
8 The proliferation of labels (for these artistic practices) also helps to demonstrate the heterogeneity of artists who adopt a social mode for their practice and, more widely, the diversity of contemporary art practice after postmodernism.

9 Grant H. Kester, *Conversation Pieces: Community and Communication in Modern Art* (Berkeley and Los Angeles: University of California Press, 2013).
10 The three members of Rimini Protokoll studied Applied Theatre Science in the department that Lehmann co-founded in the 1980s at the University of Giessen.
11 About Stefan Kaegi, http://www.rimini-protokoll.de/website/en/about-sk (accessed 1 November 2017).
12 Hans-Thies Lehmann, *Postdramatic Theatre* (Oxon and New York: Routledge, 2006), 52–57.
13 Barbara van Lindt, 'Call it Call Cutta in a Box', interview in the programme book (2008), www.rimini-protokoll.de/website/en/text/call-it-call-cutta-in-a-box (accessed 1 November 2017).
14 Shannon Jackson, *Social Works: Performing Art, Supporting Publics* (Oxon and New York: Routledge, 2011).
15 *Call Cutta in a Box CapeTown* (version 18 February 2009), provided by Stefan Haug.
16 Lazzarato, Maurizzio. 'Immaterial Labour', 133–147. Michael Hardt and Antonio Negri, *Empire* (Cambridge and London: Harvard University Press, 2000).
17 Ibid., 290.
18 Ibid.
19 Ibid., 293.
20 Michael Hardt and Antonio Negri, *Multitude* (London: Penguin, 2005).
21 Nick Dyer-Witheford, 'Cyber-Negri: General Intellect and Immaterial Labour', in *The Philosophy of Antonio Negri: Resistance in Practice*, vol. 1, ed. Timothy S. Murphy and Abdul-Karim Mustapha (London: Pluto, 2005), 148.
22 Dyer-Witheford, 'Cyber-Negri: General Intellect and Immaterial Labour', 148–149.
23 Caffentzis (1998) cited in Dyer-Witheford, 'Cyber-Negri: General Intellect and Immaterial Labour', 149.
24 The example in this chapter takes as its subject a working model that could be understood as the 'high end' of work, in Caffentzis' terms, in the sense that the "workers" employed are based in a call centre and are 'students or young middle-class urbanites' (Rimini Protokoll interview). This is not to overlook the contemporary artists making visible the material base of immaterial labour. Artists such as Edward Burtynsky, Ursula Biemann, Alan Sekula and Sofia Siden make work that exposes material and human conditions of 'immaterial' work taking place across global borders. There are also more contentious works, such as those of Santiago Sierra,

discussed in Bishop's 'Antagonism and Relational Aesthetics' that expose further the exploitative nature of global capitalism.
25 Christian Fuchs, *Digital Labour and Karl Marx* (New York and Oxon: Routledge, 2014).
26 Ibid., 238.
27 David Camfield, 'The Multitude and the Kangaroo: A Critique of Hardt and Negri's Theory of Immaterial Labour', *Historical Materialism*, 15 (2007); 32. Camfield does, however, point out that the positing of a stylized worker within specific periods – that is, craft worker, mass worker and the socialized worker – is in keeping with Autonomist mode of thinking (38).
28 Rodrigo Nunes (2007), 'Forward How? Forward Where?: (Post-) Operaismo Beyond the Immaterial Labour Thesis', *Ephemera* 7, no. 1: 178–202.
29 This might also remind us of the artistic critique, which criticized capitalism for its inauthentic goods. Now capitalism provides the consumer with an apparent 'authentic' experience through incorporating the 'worker's soul' into its new models.
30 Simon Houpt, 'Oh! Calcutta it's not … but please, don't hang up', 26 January 2009, *Globe and Mail*, http://www.rimini-protokoll.de/website/en/text/oh-calcutta-it-s-not-but-please-don-t-hang-up (accessed 1 November 2017).
31 Chiapello 'Evolution and Co-optation', 586.
32 Jackson, *Social Works*, 166.
33 Ibid., 164.
34 Nunes, 'Forward How? Forward Where?', 189.
35 Various scripts provided by Stefan Haug.
36 Lazzarato, 'Immaterial Labour', 133–147.
37 Ibid., 134.
38 Ibid., 136.
39 Karl Marx, 'Fragment on Machines' (1857–61), in *Grundrisse* (London: Penguin, 1993), 690–712.
40 Dyer-Witheford discusses Marx's passage in relation to *Futur Antérieur* in 'Cyber-Negri: General Intellect and Immaterial Labour', 141–142.
41 Silvia Federici, 'On Affective Labour' (2011), in *Work*, ed. Friederike Sigler, 186–188.
42 Guy Standing, 'Global Feminization through Flexible Labor', *World Development*, 17, no. 7 (July 1989): 1077–1095.
43 Weeks, *The Problem with Work*, 142.
44 Ibid., 141.
45 *Call Cutta in a Box* video, http://www.rimini-protokoll.de/website/en/project/call-cutta-in-a-box (accessed 1 March 2016).

46 Continuing this line of thought, the Berwick Street Collective's *Nightcleaners* also provides a good example; noteworthy is the collective's Brechtian-influenced approach to documentary, which draws similarities with the postdramatic theatre of Rimini Protokoll.
47 Claire Bishop, *Artificial Hells: Participatory Art and the Politics of Spectatorship* (London: Verso, 2012), 219.
48 Jackson, *Social Works*, 170.
49 Miriam Dreysse and Florian Malzacher, *Experts of the Everyday. The Theatre of Rimini Protokoll* (Berlin: Alexander Verlag, 2008), 8.
50 Bourriaud, *Relational Aesthetics*, 220.
51 Karen Jürs-Munby, 'Introduction', in Lehmann, *Postdramatic Theatre*, 6.
52 Ibid., 4. This is also the point at which Claire Bishop departs from *Relational Aesthetics* in her look at more antagonistic (social) artistic practices. Bishop, *Artificial Hells*.
53 Bourriaud, *Relational Aesthetics*, 44.
54 Ibid., 45.
55 Ibid., 47.
56 Ibid., 48. Bourriaud's emphasis.
57 Angela Mitropoulos, *Contract and Contagion: From Biopolitics to Oikonomia* (London: Minor Compositions, 2012), 173.

 Emma Dowling also takes up the idea of valuing versus the capitalist valorization of work relation to socially reproductive labour. Emma Dowling, 'Valorised but Not Valued? Affective Remuneration, Social Reproduction and Feminist Politics beyond the Recovery', *British Politics*, 11, no. 4 (December 2016): 452–468.
58 Obviously, this statement is problematic. This is not to say that the affective labour is somehow freed from capitalism; however, the workers are no longer confronted by their own alienated labour as with manufacturing, for example.
59 Bourriaud, *Relational Aesthetics*, 19.
60 Cited in Jackson, *Social Works*, 169.
61 Bourriaud, *Relational Aesthetics*, 9.
62 Ibid.
63 I am referring here to the quotation regarding owning a 'relationship to a relationship' (25). The way in which these artists make money (and the amount made) is clearly distinct from artists who produce easily saleable objects. However, artists cited in *Relational Aesthetics* do attract large commissions. In 2006 and 2009, respectively, Carsten Höller and Dominique Gonzalez-Foerster both created commissioned pieces for Tate Modern's Unilever-sponsored Turbine Hall. A number of these artists have exhibited at international biennials and other major art exhibitions (Höller, for example, represented Sweden

at the 2005 Venice Biennale and also exhibited at Documenta X; Gillick created the German Pavilion for the 2009 Venice Biennale; and Tiravanija co-curated the Utopia Station for the Venice Biennale in 2003). The distinction between the way in which money is made with traditional and relational works is that the former is often bought and sold privately, through auctions and dealers; whereas the relational works are more commonly commissioned (often with 'public' money) for short-term projects, such as exhibitions and biennials (exemplified in the Turbine Hall commissions). The former is arguably, more profitable than the latter in the long-term.

64 This becomes even more poignant when we think of Rirkrit Tiravanjia cooking for his audience, thus replicating the labour of an actual service worker.
65 Stewart Martin, 'Critique of Relational Aesthetics', *Third Text*, 21, no. 4 (July 2007): 378.
66 Ibid.
67 I write 'initially' as by 2001, looking back on the essays that were consolidated in *Relational Aesthetics*, Bourriaud already had begun to question the new practices in relation to the changing world: 'now that the ideology of the internet links and continuous contact has come to pervade the globalized economy (Nokia: 'Connecting people'), how much critical radicality is left to work based on sociality and conviviality?' Bourriaud, 'Berlin Letter about Relational Aesthetics' in Doherty, *Contemporary Art: from Studio to Situation*, 44.
68 Hardt and Negri, *Empire*, 293.
69 Marx, *Grundrisse*, 694.
70 Dyer-Witheford, 'Cyber-Negri: General Intellect and Immaterial Labour', 141–142.
71 Hardt and Negri, *Empire*, 291.
72 Jackson, *Social Works*, 173.
73 *Call Cutta in a Box* video.
74 Ibid. 168.

Chapter Five

1 Tate Website, http://www.tate.org.uk/visit/tate-modern/tate-exchange (accessed 17 December 2017).
2 Tate Website, http://www.tate.org.uk/visit/tate-modern/tanks (accessed 17 December 2017).
3 Chin Tao Wu, 'Embracing the Enterprise Culture: Art Institutions since the 1980s', *New Left Review*, 1, no. 230 (July–August 1998): 28–57.

4 Ibid., 34. Mel Evans, *Artwash: Big Oil and the Arts* (London: Pluto, 2015).
5 As the second largest industry (after finance and before information), the reference to the fossil fuel industry reminds us of the prevalence of the material base (as opposed to immaterial) of the contemporary capitalist economy.
6 Evans, *Artwash*.
7 Paolo Virno, 'Virtuosity and Revolution', in *Radical Thought in Italy: A Potential Politics*, ed. Michael Hardt and Paolo Virno (Minneapolis: University of Minnesota, 1996), 189–210.
8 Hardt and Negri, *Multitude*, 108.
9 Michael Hardt, 'Affective Labor', *Boundary 2*, 26, no. 2 (1999): 90.
10 Hart and Negri bring these ideas together in *Commonwealth* (2009) (often seen as the final volume of the *Empire, Multitude* trilogy). Hardt and Negri, *Commonwealth* (Harvard: Harvard University Press, 2009).
11 Hardt and Negri, *Multitude*, 99.
12 Deller in Doherty, *From Studio to Situation*, 95.
13 Deller, talk at Manchester School of Art, 26 February 2014.
14 Mike Figgis (dir.), *The Battle of Orgreave*, Artangel/Channel 4 (2001).
15 Hardt, 'Affective Labor', 96.
16 Ibid. 98.
17 Hardt, 'Affective Labor', 96. The identification of the potential to affect political change is redolent of the Italian Workerist and Autonomia traditions of which Negri was a fundamental part. For the Workerists, the potential for a revolutionizing of work lay with the 'mass worker' (for example, the Fordist de-skilled, homogenized worker) until around 1977, when Negri re-evaluated his ideas about the mass worker. Within the Autonomia movement, the 'socialized worker' became pertinent for change.
18 Michel Foucault defines biopolitics as: 'the attempt, starting from the eighteenth century, to rationalise the problems posed to governmental practice by phenomena characteristic of a set of living beings forming a population: health, hygiene, birthrate, life expectancy, race'. He further claims that the above problems are inseparable from liberalism which, Foucault argues, presents a critical reflection on governmental practice.
 Michel Foucault, *The Birth of Biopolitics: Lectures at the Collège de France, 1978–79*, ed. Michel Senellart (Hampshire and New York: Palgrave Macmillan, 2008), 317.
19 Foucault, *The Birth of Biopolitics: Lectures at the Collège de France, 1978–79*, 323.

20 Hardt, 'Affective Labor', 100.
21 Emma Dowling, 'Valorised but Not Valued? Affective Renumeration, Social Reproduction and the Feminist Politics beyond Recovery', *British Politics* 11, no. 4 (December 2016): 452–468.
22 David Harvey, Michael Hardt, Antonio Negri, 'Commonwealth: An Exchange', *Artforum* (November 2009): 211–215, 256–262.
23 Hardt and Negri, Empire, 294. Of course, the use of the term 'communism' here is problematic, due to its historical misappropriation and indeterminacy.
24 In Hardt and Negri's words: 'Singularity refers externally to a multiplicity of others; is internally divided or multiple; and constitutes a multiplicity over time – that is, a process of becoming.' Harvey, Hardt and Negri, 'Commonwealth: An Exchange', 212.
25 Antonio Negri, 'Metamorphoses', trans. by Alberto Toscano, *Radical Philosophy*, 149 (June/July 2008): 21–25. The paper was originally given at the 'Art and Immaterial Labour' symposium, held at Tate Britain, 19 January 2008.
26 Negri, 'Metamorphoses', 24.
27 Ibid.
28 Ibid., 24.
29 Hardt and Negri's third book *Commonwealth* develops the idea of an alternative to modernity and postmodernity: altermodernity. The terminology is problematic. Why not move away from modernist-centric perspective based in eighteenth-century thought altogether?
30 Virno, 'Virtuosity and Revolution', 60.
31 Nicolas Bourriaud, 'Berlin Letter about Relational Aesthetics' in *Contemporary Art: From Studio to Situation*, ed. Claire Doherty (London: Black Dog, 2004), 44.
32 Interestingly, eight months prior to its publication, Nicolas Bourriaud used the term 'Altermodern' for the title of the fourth Tate Triennial, which he curated.
33 Harvey, Hardt and Negri, 'Commonwealth: An Exchange'.
34 Hardt and Negri, 'The Becoming-Prince of the Multitude', *Artforum* (October 2009): 179.
35 Negri, 'Metamorphoses', 24.
36 Virno, 'Virtuosity and Revolution'.
37 Ibid., 189.
38 Ibid.
39 I expand on this notion in relation to art in the public square/street in 'Art, politics and the public square: From decoration to declaration!', Art & the Public Sphere, 6:1+2 (2017): 19–31.
40 Paolo Virno, *A Grammar of the Multitude* (Los Angeles and New York: Semiotext(e), 2004). 53.

41 Ibid.
42 Ibid., 59.
43 Ibid., 110.
44 General intellect is a term used by Marx in the *Grundrisse*. It refers to the knowledge central within social production. It is objectified knowledge that is put to work by capital.
45 Virno, *A Grammar of the Multitude*, 52.
46 Ibid., 56.
47 Ibid., 54.
48 Ibid., 52.
49 Ibid., 53–54.
50 Ibid., 54.
51 Ibid.
52 Liberate Tate, *Time Piece*, http://www.liberatetate.org.uk/performances/time-piece/.
53 The three elements of Superflex's installation – apathy, production and movement – are represented by a swinging pendulum, a production line and, finally, the swings. Superflex also pitch movement as coming out of production; at the end of the hall is an assembly line where the swing seats are assembled, stamped and stored before they are sent out into the world. The orange structure onto which the swings are hung, originates from the factory station. The intention is for the structure to extend beyond Tate Modern and out into the world.
54 Kunst argues that the production of sociality in art assists the depoliticization of the public space as a site for antagonistic thinking or the redistribution of the sensible (Rancière). Kunst, *Artist at Work*, 52.
55 Pierre Bourdieu and Alain Darbel's *The Love of Art* (1990) remains a canon of museum and gallery studies in showing how the gallery space is classed and unequal. Bourdieu and Darbel, *The Love of Art: European Art Museums and their Public* (Cambridge and Malden, MA: Polity Press, 1997).
56 After ten years of free museum access, according to the National Museum Directors' Council, Britain's galleries and museums saw an increase in BAME visitors and those from lower socio-economic groups. '10th anniversary of free admission to national museums', https://www.nationalmuseums.org.uk/what-we-do/encouraging_investment/free-admission/#ftnref4 (accessed 26 December 2017).
57 It is unsurprising that artists referenced in *Relational Aesthetics* are listed among those commissioned for the Turbine Hall: Dominique Gonzalez-Foerster; Tino Sehgal; Carsten Höller and Philippe Parreno.
58 Virno, *A Grammar of the Multitude*, 63.

59 Hirschhorn, 'Doing Art Politically: What Does This Mean?' in *Critical Laboratory*, 72–77.
60 'Unilever Series: Tino Sehgal', http://www.tate.org.uk/whats-on/tate-modern/exhibitionseries/unilever-series/unilever-series-tino-sehgal-2012 (accessed 17 December 2017).
61 It is not my intention here to identify the intention in a work like *These Associations*.
62 Virno, 'Virtuosity and Revolution: The Political Theory of Exodus', 189.
63 Kunst, *Artist at Work*, 58.
64 Virno, *A Grammar of the Multitude*, 65.
65 Ibid., 69.
66 Liberate Tate, 'Where it All Began', http://www.liberatetate.org.uk/about/ (accessed 28 December 2017).
67 Drawing on research, Fuchs suggests that the relative majority of Occupy activists are 'precarious and proletarianized knowledge workers'. Fuchs, *Digital Labour and Karl Marx*, 322.
68 Benjamin, 'The Author as Producer' (1934), in *The Work of Art in the Age of its Technological Reproducibility and Other Writings on Media*, ed. Michael W. Jennings et al. (Cambridge, MA, and London: Belknap/Harvard, 2008), 79–95.
69 Virno, 'Virtuosity and Revolution: The Political Theory of Exodus', 196.
70 'Governance', Tate website, http://www.tate.org.uk/about-us/governance (accessed 28 December 2017).
71 Andrea Goulet, 'Tate Exchange, an open Agora about Contemporary Art', *We Are Museums*, 22 September 2016, http://www.wearemuseums.com/tate-exchange-an-open-agora-about-contemporary-art/ (accessed 28 March 2017).
72 Bourriaud, *Relational Aesthetics*, 26.

Chapter Six

1 McKenzie Wark, 'Considerations on a Hacker Manifesto', in *Digital Labour: The Internet as Playground and Factory*, ed. Trebor Scholz (Oxon and New York: Routledge, 2013), 67.
2 Christian Fuchs discusses the Taylorization of call centre work in *Digital Labour and Karl Marx*, 233–242.
3 Hito Steyerl, 'Is the Internet Dead?', in *Duty Free Art: Art in the Age of Planetary Civil War* (London and New York: Verso, 2017), 149.
4 I note Western world here to acknowledge the factory system that still exists in other parts of the world, largely in the global South, manufacturing the informational communication technologies that enable digital work.

5 Fuchs, *Digital Labour and Karl Marx*, 147–148.
6 It is only in recent years that the harmful effects of social media and constant connectivity on mental health and well-being are being publicly discussed.
7 McKenzie Wark, 'Considerations on a Hacker Manifesto', 71.
8 However, in recent years there have been attempts to establish alternative social media networks not based on capitalist models (Ocupii and Diaspora, for example).
9 Jeremy Deller exhibited one of these tracking devices – a Motorola WT400 – in his *All That is Solid Melts into Air* exhibition at Manchester Art Gallery (2013–14).
10 'Mayan Technologies and the Theory of Electronic Civil Disobedience', Ricardo Dominguez interviewed by Benjamin Shepard and Stephen Duncombe, in *Art and Social Change: A Reader*, ed. Will Bradley and Charles Esche (London: Tate, 2007), 319–331.
11 Ayhan Aytes notes that this work is often undertaken by workers in the global South as a source of income, as US workers are unable to earn a living off the low fees offered for each task. 'Return of the Crowds: Mechanical Turk and Neoliberal States of Exception' in *Digital Labour*, 79–97.
12 Ibid., 91.
13 Workers without a US bank account can only receive payment via Amazon gift vouchers to be redeemed on the website.
14 Mies, Bennholdt-Thomsen and Werlhof cited in Fuchs, *Digital Labour and Karl Marx*, 239.
15 Ibid., 351.
16 I will be using the uncapitalized format of 'etoy' that the group adopts throughout.
17 etoy, http://www.etoy.com (accessed 9 January 2018).
18 etoy, 'Hologram', http://www.etoy.com/fundamentals/hologram/ www.etoy.com (accessed 9 January 2018).
19 etoy, 'Fundamentals', www.etoy.com/fundamentals/ (accessed 9 January 2018).
20 etoy website, www.etoy.com (accessed 9 January 2018).
21 Etoy, 'Hologram' (accessed 24 August 2007).
22 See: http://missioneternity.org.
23 etoy, 'Fundamentals'.
24 Michel Bauwens, 'Why Crowdsourcing Isn't Peer Production', 8 March 2007, P2P Foundation, https://blog.p2pfoundation.net/why-crowdsourcing-is-peer-production/2007/03/08 (accessed 17 January 2018).
25 Brian Holmes, 'Artistic Autonomy and the Communication Society', *Third Text*, 18, no. 6 (2004): 551.
26 Ibid.

27 Ibid.
28 Karl Marx (1857–61) *Grundrisse* (London: Penguin, 1993), 691.
29 Ibid., 692.
30 Ibid., 693.
31 Ibid.
32 Ibid.
33 Ibid., 694.
34 Wark, 'Considerations on a Hacker Manifesto', 74.
35 Fuchs, *Digital Labour and Karl Marx*, 141.
36 Raniero Panzieri, *The Capitalist Use of Machinery: Marx versus the Objectivists*, 1964, Libcom.org, http://libcom.org/library/capalist-use-machinery-raniero-panzieri (accessed 1 May 2012).
37 Ibid. These techniques of information, according to Panzieri, are techniques of integration, human relations, communications, and so forth.
38 David Harvey, *A Companion to Marx's Capital* (London: Verso, 2010), 219.
39 Vladimir Ilyich Lenin, 'The Taylor System – Man's Enslavement by the Machine', in *Lenin Collected Works*, trans. Bernard Isaacs, Joe Fineberg, and Julius Katzer, vol. 20 (Moscow: Progress, 1972), 152–154.
40 Harvey, *A Companion to Marx's Capital*.
41 There is some evidence for the existence of this 'charm': A famous 1989 experiment undertaken by University of Chicago psychologists, Judith LeFevre and Mihaly Csikszentmihalyi in which seventy-eight workers (manual, clerical and managerial) were given pagers and paged at different times with questionnaires about what they were doing and how they felt: 'The experiment found that people reported "many more positive feelings at work than in leisure". At work, they were regularly in a state the psychologists called "flow" – "enjoying the moment" by using their knowledge and abilities to the full, while also "learning new skills and increasing self-esteem".' Andy Beckett, 'Post-work the radical idea of a world without jobs', *The Guardian*, 19 January 2018, https://www.theguardian.com/news/2018/jan/19/post-work-the-radical-idea-of-a-world-without-jobs (accessed 19 January 2018).
42 Panzieri, *The Capitalist Use of Machinery*.
43 Marx, *Capital*, 563.
44 Panzieri, *The Capitalist Use of Machinery*.
45 etoy, 'Toywar 1999', http://www.etoy.com/projects/toywar/ (accessed 19 January 2018).
46 Reinhold Grether, 'How the Etoy Campaign Was Won' (2000), http://www.etoy.com//files/press-archive/2000/2000_02_26_telepolis_how_the_etoy_campaign_was_won2.pdf (accessed 19 January 2018) Mirrors are replica websites.

NOTES

47 Ibid.
48 etoy, 'Toywar'.
49 Marx, *Grundrisse*, 694.
50 etoy are not alone. There have been similar results to actions that physically mobilize people through using communications technologies. Reclaim the Streets organized a 'Carnival Against Capitalism' in June 1999; more recently, members of the Occupy movement are tweeting about occupations and actions against capitalism. The Zapatista's plight in Chiapas, Mexico was also assisted through the employment of the internet for the dissemination of information.
51 Gerald Raunig, *A Thousand Machines* (Los Angeles: Semiotext(e), 2010), 26.
52 etoy, 'Mission Strategy', http://missioneternity.org/mission-strategy/ (accessed 9 January 2018).
53 etoy, 'Mission Eternity', http://missioneternity.org/cult-of-the-dead/ (accessed 9 January 2018).
54 They are named 'ANGELS' because they are guardians of the data (accessed 9 January 2018).
55 etoy, 'Mission Eternity Arcanum Capsule', http://missioneternity.org/arcanum-capsule/ (accessed 15 January 2018).
56 etoy, 'Mission Eternity Introduction video' http://missioneternity.org/summary/ (accessed 9 January 2018).
57 etoy, 'Bridges', http://missioneternity.org/bridges/ (accessed 9 January 2018).
58 etoy, 'Data Storage', http://angelapp.missioneternity.org/data-storage/ (accessed 9 January 2018).
59 etoy 'Tamatar' http://missioneternity.org/bridges/tamatar/ (accessed 9 January 2018).
60 Ibid.
61 Marx, *Grundrisse*, 693.
62 Virno cited in Gerald Raunig, *Art and Revolution: Transversal Activism in the Long Twentieth Century* (Los Angeles: Semiotext(e), 2007), 149.
63 etoy, 'Tamatar'.
64 etoy, 'Mission Strategy'.
65 etoy, 'Data Storage'.
66 etoy, 'Mission Strategy'.
67 etoy, 'Become a Mission Eternity Angel', http://missioneternity.org/angels/ (accessed 15 January 2018).
68 Bauwens, 'Why Crowdsourcing isn't Peer Production'.
69 Ibid.
70 Marx, *Grundrisse*, 692.
71 Ibid., 695.

72 Fuchs presents an empirical analysis of the Occupy Wall Street (OWS) movement in *Digital Labour and Karl Marx*, while Paolo Gerbaudo has analysed the role the social media takes in protest movements in his *Tweets and the Streets: Social Media and Contemporary Activism* (London and New York: Pluto, 2012). In his analysis, Gerbaudo talks about the 'choreography of assembly' (12) – a term used by Hardt and Negri – in acknowledging the relationship between material space and immaterial networks in these protests.
73 Benjamin, 'The Author as Producer', 87.
74 Open Source Initiative, *The Open Source Definition (Annotated)*, version 1.9, https://opensource.org/osd-annotated (accessed 18 January 2018).
75 Wark, 'Considerations on a Hacker Manifesto', 71.
76 Panzieri, *The Capitalist Use of Machinery*.

Conclusion

1 Boltanski and Chiapello, *The New Spirit of Capitalism*.
2 Margaret Thatcher quoted in an interview with Douglas Keay in *Woman's Own*, September 1987.
3 Despite the similarities between Benjamin's notion of the penetration of life by the apparatus and Bürger's return of art into life praxis (i.e. the penetration of life by art), Bürger is critical of Benjamin's argument in 'The Work of Art' essay. Bürger views Benjamin's proposition that technological development had an effect on society to be part of social history and not exclusively influential on art. See Peter Bürger, *Theory of the Avant-Garde* (1984) (Minneapolis: Minnesota, 2004), 28–34.
4 Bürger, *Theory of the Avant-Garde*, 90.
5 Ibid., 58. These tropes include shock, chance (as in the work of the Surrealists), fragmentation (including montage) and politics.
6 Marc James Léger's edited collection – *The Idea of the Avant Garde and What it Means Today* (2014) – brings together diverse interpretations of the avant-garde for the contemporary from a number of thinkers. In introducing the volume, Léger acknowledges the conflation of avant-garde with biopolitics and creative work under neo-liberalism; the intention of the volume is to avoid this interpretation in rethinking the avant-garde. *The Idea of the Avant Garde and What it Means Today*, ed. Marc James Léger (Manchester and New York: Manchester University Press, 2014).

7 I am, of course, referring to Liberate Tate here, who used the cloak of the institutional framework for their 'real life' interventions.
8 Lippincott, *Large Scale* and Craig, *Making Art Work*.
9 Wade Saunders' 1993 interviews with artists' assistants evidence the market's role in suppressing knowledge of non-artist labourers for the art market. Wade Saunders, 'Making Art, Making Artists', *Art in America*, 81 (January 1993), 70–95.
10 When I refer to the art world here, I mean the art world 'insiders' – that is, those people engaged in making art and constructing exhibitions, rather than those visiting galleries.
11 In both these examples, the audience (beyond the local community in Hirschhorn's monuments) is often that of the art tourist. Hirschhorn's *Bataille Monument* was exhibited as part of *Documenta*, an international art fair, while *Call Cutta in a Box* has been performed at festivals and biennials.
12 See 'Construction: Team' and 'Dismantling: Team' sections on the Gramsci Monument website: http://awp.diaart.org/gramsci-monument/page58.html and http://awp.diaart.org/gramsci-monument/page65.html (accessed 19 May 2018).

Afterword

1 'Maria Eichhorn, 5 weeks, 25 days, 175 Hours', Chisenhale Gallery Archive http://www.chisenhale.org.uk/archive/exhibitions/index.php?id=178 (accessed 19 January 2018).
2 Andy Beckett, 'Post-work the Radical Idea of a World without Jobs', *The Guardian*, 19 January 2018. https://www.theguardian.com/news/2018/jan/19/post-work-the-radical-idea-of-a-world-without-jobs (accessed 19 January 2018).
3 Weeks, *The Problem with Work*, 233.
4 Yates McKee, *Strike Art* (London: Verso, 2016); Shukaitis, *The Composition of Movements to Come*; *I Can't Work Like This*, ed. Joanna Warsza; *Work*, ed. Friederike Sigler.

SELECT BIBLIOGRAPHY

Adamson, Glenn and Julia Bryan-Wilson. *Art in the Making: Artists and Their Materials from the Studio to Crowdsourcing*. London: Thames and Hudson, 2016.
Adorno, Theodor. *Aesthetic Theory*. Minnesota: Continuum, 1996.
Artist & Fabricator, exhibition catalogue, Fine Arts Center Gallery, Amherst: University of Massachusetts, 1975.
Aytes, Ayhan. 'Return of the Crowds: Mechanical Turk and Neoliberal States of Exception'. In *Digital Labour: The Internet as Playground and Factory*, ed. Trebor Scholz, 79–97. Oxon and New York: Routledge, 2013.
Barkham, Patrick. 'Can You Do Me a Quick Cow's Head?'. *The Guardian*, 5 March 2008.
Basualdo, Carlos. 'Bataille Monument, Documenta 11, 2002'. In *Thomas Hirschhorn*, ed. Benjamin H. D. Buchloh, 96–108. London: Phaidon, 2004.
Baudelaire, Charles. 'The Painter of Modern Life' (1863). In *The Painter of Modern Life and Other Essays*, ed. Jonathan Mayne, 1–41. London: Phaidon, 1995.
Bauwens, Michel. 'Why Crowdsourcing Isn't Peer Production'. 8 March 2007. P2P Foundation, https://blog.p2pfoundation.net/why-crowdsourcing-is-peer-production/2007/03/08 (accessed 17 January 2018).
Beckett, Andy. 'Post-work the Radical Idea of a World without Jobs'. *The Guardian*, 19 January 2018. https://www.theguardian.com/news/2018/jan/19/post-work-the-radical-idea-of-a-world-without-jobs (accessed 19 January 2018).
Beech, Dave and John Roberts, eds. *The Philistine Controversy*. London and New York: Verso, 2002.
Beech, Dave. *Art and Value: Art's Economic Exceptionalism in Classical, Neoclassical and Marxist Economics*. London: Haymarket, 2016.

Benjamin, Walter. 'Paris, the Capital of the Nineteenth Century'. In *The Work of Art in the Age of its Technological Reproducibility and Other Writings on Media*, ed. Jennings, Doherty and Levin, 96–115. Cambridge, MA, and London: Belknap, 2008.

Benjamin, Walter. 'The Work of Art in the Age of Its Technological Reproducibility' (1936). In *The Work of Art in the Age of its Technological Reproducibility and Other Writings on Media*, ed. Jennings, Doherty and Levin, 19–55. Cambridge, MA and London: Belknap, 2008.

Billing, Johanna et al., eds. *Taking the Matter into Common Hands*. London: Black Dog, 2007.

Bishop, Claire. 'Antagonism and Relational Aesthetics'. *October*, 110 (Fall 2004): 51–79.

Bishop, Claire. *Artificial Hells: Participatory Art and the Politics of Spectatorship*. London: Verso, 2012.

Boltanski, Luc and Eve Chiapello. *The New Spirit of Capitalism*. London and New York: Verso, 2005.

Bottomore, Tom. *A Dictionary of Marxist Thought*, 2nd edn. Oxford, Malden, MA: Blackwell, 2001.

Bourriaud, Nicolas. 'Berlin Letter about Relational Aesthetics'. In *Contemporary Art: From Studio to Situation*, ed. Claire Doherty. London: Black Dog, 2004.

Bourriaud, Nicolas. *Postproduction*. New York: Lukas & Sternberg, 2002.

Bourriaud, Nicolas. *Relational Aesthetics*, trans. Simon Pleasance and Fronza Woods. Dijon: Les presses du réel, 2002.

Braverman, Harry. *Labour and Monopoly Capitalism: The Degradation of Work in the Twentieth Century*. New York and London: Monthly Review Press, 1974.

Bryan-Wilson, Julia. *Art Workers: Radical Practice in the Vietnam War*. Berkeley, Los Angeles, London: University of California, 2009.

Buchloh, Benjamin H. D. 'An Interview with Thomas Hirschhorn'. *October*, 113 (Summer 2005): 85–86.

Buchloh, Benjamin H. D. 'Hans Haacke: Memory and Instrumental Reason'. In *Neo-Avantgarde and the Culture Industry: Essays on European and American Art from 1955 to 1975*, 203–41. Cambridge, MA, and London: MIT Press, 2003.

Camfield, David. 'The Multitude and the Kangaroo: A Critique of Hardt and Negri's Theory of Immaterial Labour'. *Historical Materialism* 15 (2007): 21–52.

Chiapello, Eve. 'Evolution and Co-optation: The "Artist Critique" of Management and Capitalism'. *Third Text*, 18, no. 6 (2004): 585–94.

Collective Creativity, exhibition catalogue, Kunsthalle Fridericianum, Kassel (1 May–17 July 2005)

Craig, Patsy, ed. *Making Art Work*. London: Trolley, 2003.
David Pagel, 'The Art Factory', *Calendar*, 31 August 2003, E33.
Dimitrakaki, Angela and Kirsten Lloyd, eds. *Economy*. Liverpool: Liverpool University Press, 2015.
Doherty, Claire, ed. *Out of Time, Out of Place: Public Art (now)*. London: Art/Books, 2015.
Dominguez, Ricardo, interviewed by Benjamin Shepard and Stephen Duncombe. 'Mayan Technologies and the Theory of Electronic Civil Disobedience'. In *Art and Social Change: A Reader*, ed. Will Bradley and Charles Esche, 319–31. London: Tate, 2007.
Doogan, Kevin. *New Capitalism? The Transformation of Work*. Cambridge and Malden, MA: Polity, 2009.
Dowling, Emma. 'Valorised but Not Valued? Affective Remuneration, Social Reproduction and Feminist Politics beyond the Recovery'. *British Politics* 11, no. 4 (December 2016): 452–68.
Dreysse, Miriam and Florian Malzacher, eds. *Experts of the Everyday. The Theatre of Rimini Protokoll*. Berlin: Alexander Verlag: 2008.
Dyer-Witheford, Nick. 'Cyber-Negri: General Intellect and Immaterial Labour'. In *The Philosophy of Antonio Negri: Resistance in Practice*. Vol.1. ed. Timothy S. Murphy and Abdul-Karim Mustapha, 136–62. London: Pluto, 2005.
Engqvist, Jonatan Habib et al., eds. *Work, Work Work: A Reader on Art and Labour*. Berlin and New York: Sternberg Press, 2012.
etoy, Mission Eternity. www.missioneternity.org.
etoy. www.etoy.com
Evans, Mel. *Artwash: Big Oil and the Arts*. London: Pluto, 2015.
Federici, Silvia. 'On Affective Labour' (2011). In *Work*, ed. Friederike Sigler, 186–88. Cambridge, MA: MIT Press, 2017.
Fine, Ruth E. *Gemini G.E.L. Art and Collaboration*. New York: Abbeville Press, 1984.
Finklepearl, Tom. *What We Made: Conversations on Art and Social Cooperation*. Durham and London: Duke University Press, 2013.
Foucault, Michel. *The Birth of Biopolitics: Lectures at the Collège de France, 1978–79*. ed. Michel Senellart. Hampshire and New York: Palgrave Macmillan, 2008.
Fried, Michael. *Three American Painters: Kenneth Noland, Jules Olitski, Frank Stella*. New York: Fogg Art Museum, 1965.
Fried, Michael, *Art and Objecthood: Essays and Reviews*, Chicago: University of Chicago Press, 1998.
Fuchs, Christian. *Digital Labour and Karl Marx*. New York and Oxon: Routledge, 2014.
Galison, Peter and Caroline A. Jones. 'Factory, Laboratory, Studio: Dispersing Sites of Production'. In *The Architecture of Science*, ed.

Peter Galison and Emily Thomas, 497–540. Cambridge, MA: MIT Press, 1999.

Gerbaudo, Paolo. *Tweets and the Streets: Social Media and Contemporary Activism*. London and New York: Pluto, 2012.

Gramsci, Antonio. *Selections from the Prison Notebooks of Antonio Gramsci*, ed. Quentin Hoare and Geoffrey Nowell-Smith. London, Lawrence and Wishart, 1971.

Graña, César. *Bohemian Versus Bourgeois. French Society and the French Man of Letters in the Nineteenth Century*. New York: Basic Books, 1964.

Greenberg, Clement. 'Modernist Painting' (1961). In *Art in Theory 1900–2000: An Anthology of Changing Ideas*, ed. Charles Harrison and Paul Wood, 773–79. Malden, MA and Oxford: Blackwell Publishing, 2003.

Greenberg, Clement. 'Recentness of Sculpture'. In *American Sculpture of the Sixties* (catalogue). Los Angeles County Museum of Art, 1967.

Hardt, Michael and Antonio Negri. 'The Becoming-Prince of the Multitude'. *Artforum* (October 2009): 173–79.

Hardt, Michael and Antonio Negri. *Empire*. Cambridge, MA, and London: Harvard University Press, 2000.

Hardt, Michael. 'Affective Labor'. *Boundary* 2, 26, no. 2 (1999).

Harvey, David, Michael Hardt, Antonio Negri. 'Commonwealth: An Exchange'. *Artforum* (November 2009): 211–15, 256–62.

Harvey, David. *A Companion to Marx's Capital*. London: Verso, 2010.

Harvey, David. *The Condition of Postmodernity*. Cambridge, MA and Oxford: UK, Blackwell 1990.

Harvie, Jen. *Fair Play: Art, Performance and Neoliberalism*. Basingstoke: Palgrave Macmillan, 2013.

Hauser, Arnold. 'The Sociological Approach: The Concept of Ideology in the History of Art'. In *The Philosophy of Art History*, 19–40. New York: Alfred A. Knopf, 1959.

Hewison, Robert. *Cultural Capital: The Rise and Fall of Creative Britain*. London and New York: Verso, 2014.

Hirschhorn, Thomas. 'Bataille Monument'. In *Contemporary Art: From Studio to Situation*, ed. Claire Doherty, 133–47. London: Black Dog, 2004.

Hirschhorn, Thomas. 'Unshared Authorship' (2012). http://awp.diaart.org/gramsci-monument/page47.html (accessed 16 August 2017).

Holmes, Brian. 'Artistic Autonomy and the Communication Society'. *Third Text* 18, no. 6 (2004): 547–55.

Holmes, Brian. 'The Flexible Personality: For a New Cultural Critique'. www.noemalab.org/sections/ideas/ideas_articles/pdf/holmes_flexible_p.pdf. (2004) (accessed 14 May 2008).

Jackson, Shannon. *Social Works: Performing Art, Supporting Publics*. Oxon and New York: Routledge, 2011.
Kester, Grant H. *Conversation Pieces: Community and Communication in Modern Art*. Berkeley and Los Angeles: University of California Press, 2013.
King, Barry. 'Modularity and the Aesthetics of Self-Commodification'. In *As Radical as Reality Itself*, ed. Matthew Beaumont et al. 319–45. Bern: Peter Lang, 2007.
Krauss, Rosalind E. 'Sculpture in the Expanded Field'. In *The Originality of the Avant-Garde and Other Modernist Myths*, 276–90. Cambridge, MA: MIT Press, 1986.
Kunst, Bojana. *Artist At Work: Proximity of Art and Capitalism*. Hants: Zero, 2014.
Kuo, Michelle, 'The Art of Production' issue, *Artforum* (October 2007).
Lacy, Suzanne. *Mapping the Terrain: New Genre Public Art*. Seattle: Bay Press, 1995.
Lazzarato, Maurizio. 'The Misfortunes of the "Artistic Critique" and of Cultural Employment'. http://eipcp.net/transversal/0207/lazzarato/en. (2007) (accessed 18 January 2010).
Lazzarato, Maurizzio. 'Immaterial Labour' (1996). In *Radical Thought in Italy: A Potential Politics*, ed. Paolo Virno and Michael Hardt, 133–47. Minneapolis: Minnesota, 2006.
Lee, Lisa and Hal Foster, eds. *Critical Laboratory: The Writings of Thomas Hirschhorn*. Massachusetts: October/MIT, 2013.
Léger, Marc James, ed. *The Idea of the Avant Garde and What it Means Today*, Manchester and New York: Manchester University Press, 2014.
Lehmann, Hans-Thies. *Postdramatic Theatre*. Oxon and New York: Routledge, 2006.
Lenin, Vladimir. 'The Taylor System – Man's Enslavement by the Machine'. In *Lenin Collected Works*, 152–54. Moscow: Progress, 1972.
Lippard, Lucy and John Chandler. 'The Dematerialization of Art' (1968). In *Conceptual Art: A Critical Reader*, ed. Alexander Alberro and Blake Stimson, 46–50. Cambridge: MIT, 2000.
Lippincott, Jonathan. *Large Scale: Fabricating Sculpture in the 1960s and 1970s*. New York, Princeton Architectural Press, 2010.
Lloyd, Richard. *Neo-Bohemia: Art and Commerce in the Postindustrial City*. New York and Oxon: Routledge, 2006.
Maitland, Leslie. 'Factory Brings Sculptors' Massive Dreams to Fruition'. *The New York Times*. 24 November 1976: 35 and 55.
Manzi, Zoe. 'Vision Unlimited'. Tate 8 (November/December 2003): 22–26.

Martin, Stewart. 'Critique of Relational Aesthetics'. *Third Text* 21, no. 4 (July 2007): 369–86.
Marx, Karl. *Capital*, vol.1, trans. Ben Fowkes. London: Penguin, 1990.
Marx, Karl. *Grundrisse* (1857–61). London: Penguin, 1993.
Marx, Karl and Frederick Engels. *The German Ideology* (1845–46), ed. C. J. Arthur, students' edition. London: Lawrence & Wishart, 1978.
Marx, Karl. 'Preface to a Critique of Political Economy' (1859) extract. In *Karl Marx Selected Writings*, 2nd edn, ed. David McLellan, 424–28. Oxford: Oxford University Press, 2007.
Marx, Karl. 'Theories of Surplus Value'. In *Karl Marx Selected Writings* ed. David McLellan, 2nd edn, 429–51. Oxford: Oxford University Press, 2007.
Mitropoulos, Angela. *Contract and Contagion: From Biopolitics to Oikonomia*. London: Minor Compositions, 2012.
Moody, Lori. 'Some Assembly Required', L.A. Life supplement, *Daily News*, 26 July 1995.
Negri, Antonio. 'Metamorphoses', trans. Alberto Toscano. *Radical Philosophy* 149 (June/July 2008): 21–25.
Panzieri, Raniero. *The Capitalist Use of Machinery: Marx versus the Objectivists*, 1964. http://libcom.org/library/capalist-use-machinery-raniero-panzieri (accessed 1 May 2012).
Renton, Andrew and Liam Gillick. *Technique Anglaise: Current Trends in British Art*. London: Thames and Hudson, 1991.
Ritchie, Charles and Ruth E. Fine. *Gemini G.E.L.: A Catalogue Raisonné, 1966–1996*, http://ww.nga.gov/gemini/essay2.htm (accessed 17 March 2010).
Roberts, John. *Intangibilities of Form: Skill and Deskilling in Art After the Readymade*. London: Verso, 2007.
Sholette, Gregory. *Dark Matter: Art and Politics in the Age of Enterprise Culture*. London and New York: Pluto, 2011.
Sigler, Friederike, ed. *Work*. London: Whitechapel Books, 2.
Smith, Adam, *The Wealth of Nations: Books I–III*, ed. Andrew Skinner. London: Penguin, 1982.
Smith, Mike. 'Construct Your Ambition: Making Grand Ideas Become Realities'. In *The Artist's Yearbook 2006*, ed. Ossian Ward, 188. London: Thames and Hudson, 2005.
Smith, Terry. *Making the Modern: Industry, Art and Design in America*. Chicago: University of Chicago, 1993.
Steyerl, Hito. *Duty Free Art: Art in the Age of Planetary Civil War*. London and New York: Verso, 2017.
Shukaitis, Stevphen. *The Composition of Movements to Come: Aesthetics and Cultural Labour after the Avant-Garde*. London and New York: Rowman & Littlefield, 2016.

The Work Foundation. *Staying Ahead: the Economic Performance of the UK's Creative Industries*. June 2007.

Thompson, Nato, ed. *Living as Form: Socially Engaged Art from 1991–2011*. New York and London: Creative Time Books, 2011.

Trotsky, Leon. 'From Literature and Revolution' (1925). In *Art in Theory 1900–2000*, ed. Charles Harrison and Paul Wood, 442–47. Malden and Oxford: Blackwell, 2003.

Vale, Luisa. 'Object Lesson: Thomas Hirschhorn's Gramsci Monument: Negotiating Monumentality with Instability and Everyday Life' in *Building & Landscapes* 22, no. 2 (Fall): 18–35.

Van Lindt, Barbara. 'Call it Call Cutta in a Box', interview in the programme book (2008). www.rimini-protokoll.de/website/en/text/call-it-call-cutta-in-a-box.

Wark, McKenzie. 'Considerations on a Hacker Manifesto'. In, *Digital Labour: The Internet as Playground and Factory*, ed. Trebor Scholz, 69–75. Oxon and New York: Routledge, 2013.

Warsza, Joanna, ed. *I Can't Work Like This: A Reader on Recent Boycotts and Contemporary Art*. Berlin and New York: Sternberg Press, 2017.

Weber, Max. *The Protestant Ethic and The Spirit of Capitalism*. New York: Charles Scribner's Sons, 1976.

Weeks, Kathi. *The Problem with Work: Feminism, Marxism, Antiwork Politics, and Postwork Imaginaries*. Durham and London: Duke University Press, 2011.

Williams, Raymond. *Keywords*. London: Fontana Press, 1988.

Wu, Chin Tao. 'Embracing the Enterprise Culture: Art Institutions Since the 1980s'. *New Left Review* 1, no. 230 (July–August 1998): 28–57.

INDEX

affective labour 15, 97, 102, 106, 111, 172, 197 n.58
 Hardt and Negri 115–20
 performative qualities of 170
AI, *See* Artificial intelligence
alienated labour 28, 33, 197 n.58
Arendt, Hannah 121, 137
art fabrication
 firms 32
 and labour process 31–3
artificial intelligence (AI) 142, 143
artist as project manager 78–80
'artist critique' 15, 51, 55, 63, 64, 84, 118, 147, 171, 187 n.33
 adoption 58, 172
 and artist model 75–8
 co-optation of 52, 60, 86, 89, 99, 111, 134, 161
 traits of 82
artistic labour 4, 5
art's relative autonomy 4–7
Aytes, Ayhan 142, 203 n.11

Basualdo, Carlos 81
The Bataille Monument (Hirschhorn) 15, 65–71, 73, 78–83, 87, 173, 190 n.12
Battle of Orgreave (Deller) 54, 116, 137
Baudelaire, Charles 76
Bauwens, Michel 162
Beech, Dave 4, 32
Benjamin, Walter 76, 163
 'The Author as Producer' 135

Berger, John 3, 171
Bishop, Claire 18, 81, 90, 104, 105
Blair, Tony 47, 114
Boltanski, Luc and Eve Chiapello 51, 55, 58–61, 75–8, 80, 84–6, 88, 101, 121
 The New Spirit of Capitalism 15, 49, 50, 64, 186 n.24
Bourriaud, Nicolas 90, 106–9, 111, 119–20, 137
 Relational Aesthetics, 18, 81, 105, 131, 197 n.63, 198 n.67
Braverman, Harry 37
 Labour and Monopoly Capital: The Degradation of Work in the Twentieth Century 18, 26–9
Bruguera, Tania 104
 Tatlin Whisper #5, 127
Bryan-Wilson, Julia 22, 31, 35, 36, 38
 Art Workers: Radical Practice in the Vietnam War Era 18
Buchloh, Benjamin H. D. 21, 36, 71
 'Hans Haacke: Memory and Instrumental Reason,' 20

Caffentzis, George 97, 98, 195 n.24
call centre work 97, 98, 101, 102, 110
Call Cutta in a Box (Rimini Protokoll) 92–6, 127, 173, 174

INDEX

contemporary artistic practice, immateriality and relationality in 104–8
'dialogical aesthetics' 91
feminization of work and unproductive labour 102–4
immaterial labour 89–91, 97–100
performance 15, 100–1
subjectivity and immaterial labour 100–1
technology and immaterial labour 108–10
Callinicos, Alex, *The Resources of Critique* 51
Camfield, David 98
Capital (Marx) 6, 140, 152
capitalism 118, 169
and neutrality of machines 150–1
'new spirit' of 49–50
capitalist labour 109, 148, 153
capitalist system 1, 5, 52, 64, 103, 104, 148, 172
capitalist technologies 16, 153, 163, 164
for anti-capitalist activity 142
and digital labour 147
uses 152, 154
'The Capitalist Use of Machinery' (Panzieri) 150
Carlson & Co. 23, 42, 44
Carlson, Peter 24
Chiapello, Eve and Luc Boltanski 51, 55, 58–61, 75–8, 80, 84–6, 88, 101
The New Spirit of Capitalism 15, 49, 50, 64
cognitive labour 118–20, 142
collaboration 18, 31, 54
non-exclusionary 86
commodity fetishism 28, 106
Communist Manifesto 151

contemporary artistic practice, immateriality and relationality in 104–8
contracted labour 6, 14, 15, 49
in art 18, 32
in artistic practice 188 n.48
sculptor's employment of 22
cooperation 162, 169
Liberate Tate 131
Craig, Patsy 45, 46, 59
Making Art Work 46
crowdsourcing 142, 143, 161, 162, 165

'Dark matter' 11–13
DCMS, *See* Department of Culture, Media and Sport
Deleuze Monument (Hirschhorn) 65, 67, 82, 173
Deller, Jeremy 117, 119
Battle of Orgreave 54, 116, 137
'The Dematerialization of Art' 19–22, 35
Department of Culture, Media and Sport (DCMS) 77, 85, 88
deskilling 11, 19–21, 36
art 31
artist 18, 168
craftworker 29
manual work 41
thesis 14, 32
work 22, 26, 35
worker 37, 151
workplace 27
'dialogical aesthetics' 91
'digital cult of the dead' 157–61
digital labour 14, 16, 141–3, 152, 165
capitalist technologies and 147
employment of 174
Fuchs' analysis of 163
and hacktivism 164
modes of 161
'products' of 157

INDEX

'digital post-mortem' 145, 158
Dimitrakaki, Angela 13
 Economy, 13
 Gender, artWork and the Global Imperative 12
'distributed brain' 155-7
Documenta 11, 68, 70, 71, 79, 80, 83
Dominguez, Ricardo 5, 142
Doogan, Kevin, *New Capitalism? The Transformation of Work* 55
Dowling, Emma 117, 197 n.57
Dreysse, Miriam and Florian Malzacher, *Experts of the Everyday. The Theatre of Rimini Protokoll* 105
Dyer-Witheford, Nick 97, 109

'economic exceptionalism' 32, 165
Eichhorn, Maria 177
Eliasson, Olafur, *The Weather Project* 49, 125
Engels, Frederick, and Karl Marx, *The German Ideology* 7-8
Enterprise Allowance Scheme 57
Equal Pay Act 103
etoy 143-7, 174-5, 205 n.50
 and automaton 161-4
Evans, Mel 114, 115, 132
Everett, Roxanne 22, 24, 33, 184 n.61

fabricators 22-4
Federici, Silvia, 'On Affective Labour' 102
feminization of work and unproductive labour 102-4
Fordism 30, 31, 37, 41, 97, 168
Fordist ideology 29-31, 37
Fordist production methods 26, 30, 56
Fourth Plinth Commissions 48, 49
Fried, Michael 19

'Art and Objecthood' 20, 25
Fuchs, Christian 98, 141, 149, 152, 157, 206 n.72
 Digital Labour and Karl Marx 143

Gemini G.E.L. 23, 24, 33
Gramsci, Antonio 88
 'Americanism and Fordism' 31
 Prison Notebooks 30
 The Gramsci Monument (Hirschhorn) 15, 65-7, 72-5, 78-81, 85, 173, 192 n.41
Greenberg, Clement 20, 21, 28, 185 n.69
 'Modernist Painting' 19

Hardt, Michael 98, 100, 102, 109, 115, 117, 120, 121, 149, 163
 'Affective Labour' 116, 199 n.17
 Empire 97, 108, 118
 Multitude 97
Harrison, Margaret, Kay Hunt and Mary Kelly 104
 Women and Work: A Document on the Division of Labour in Industry 1973-5 103
Harvey, David 15, 31, 56-7, 118, 152, 153, 163
 The Condition of Postmodernity 30, 55-6
Harvie, Jen 54, 187 n.44, 188 n.48
 Fair Play: Art, Performance and Neoliberalism, 53
heterogeneity 194 n.8
 neo-liberal embrace of 116
Hewison, Robert, *Cultural Capital The Rise and Fall of Creative Britain*, 47
Hirschhorn, Thomas 15, 38, 64, 128, 131, 169, 173, 191 n.15, 192 n.44, 193 n.72, 194 n.74
 artist as project manager 78-80

artist critique and artist model 75–8
autonomy and unshared authorship 80–4
The Bataille Monument 67–71
Chalet Lost History 65
The Gramsci Monument 72–5
'great man' 84–6
monuments 65–7
Too Too – Much Much 65
Ur Collage series 65
Hirst, Damien 44, 48, 61
HITs *See* 'human intelligence tasks'
Holmes, Brian 51–2, 147, 161
'housewifization' 142
'human intelligence tasks' (HITs) 140

immaterial labour 89, 91, 97–100, 119, 139, 142, 149
Call Cutta in a Box (*see* Rimini Protokoll)
performance, subjectivity and 100–1
social nature of 90
technology and 108–10
informational capitalism 151–4
'informational society' 141
intellectual labour 148

Jackson, Shannon 99–100, 110, 111
'actor-labourers' 94
Social Works: Performing Art, Supporting Publics 94

Kaegi, Stefan 92
Kant, Immanuel 185 n.69
Kester, Grant, *Conversation Pieces* 91
Koons, Jeff 24, 44, 45, 186 n.11
Krauss, Rosalind 36

'Sculpture in the Expanded Field' 21
Kunst, Bojana 83, 201 n.54
Artist at Work 129
Kuo, Michelle 184 n.53

labour process 30, 148
American 35
art fabrication and 31–3
capitalist 153
contemporary 160
dehumanization of 29
'mighty organism' of 149
Lacy, Suzanne, *Mapping the Terrain: New Genre Public Art* 90
Lazzarato, Maurizio 77, 89, 100, 101
Lehmann, Hans-Thies 106
Postdramatic Theatre 92, 105
Lenin, Vladimir 152
Liberate Tate (2010–) 16, 174
activist and virtuoso 120–2
affective labour 115–20
Parts per Million 129–34
performing action 122–3
public sphere 134–7
Lippard, Lucy 19, 35
Lippincott, Donald 24, 26, 33, 45, 57
Lippincott Inc. 23, 24–6, 32, 34, 36, 38, 39, 41, 42
Lippincott, Jonathan
Large Scale: Fabricating Sculpture in the 1960s and 1970s 18
legacy 38–9
Lloyd, Kirsten 13
Economy 13

Maitland, Leslie 24, 33
Martin, Stewart, 'Critique of Relational Aesthetics' 107

Marx, Karl 9, 10, 109, 153, 162
 artistic labour 4
 Capital 6, 140, 152
 "forces of production," 13
 'Fragment on Machines' 108, 141, 149, 150, 156, 160
 The German Ideology 7–8
 Grundrisse 147
 labour process 148
 unproductive labourer 52
Mike Smith Studio 43–6, 61, 172, 173
 'Art of Production' 42
 capitalist co-optation 50–5
 Fordism 41
 Fourth Plinth Commissions 48, 49
 New Labour government 47
 and the 'new spirit' 56–61
 'new spirit' of capitalism 49–50
 'new spirit' of neo-liberalism 55–6
Mission Eternity 142, 144, 145, 157–62, 164, 165, 170, 175
Mission Eternity PILOTS 157–9
Monument (Whiteread) 44, 49, 59
Morris, Robert 18, 21, 22, 32, 35, 38, 185 n.67
'Notes on Sculpture' 25

Negri, Antonio 98, 100, 102, 109, 115, 118–21, 149, 163
 Empire 97, 108, 118
 Multitude 97
neo-liberal capitalism 43, 54, 55, 117, 147
neo-liberal embrace of heterogeneity 116
neo-liberalism 43, 52–4, 58, 109
 Mike Smith Studio (1989–) (*see* Mike Smith Studio (1989–))
 'new spirit' of 55–6
neo-liberal management theory 63

neutrality
 and informational capitalism 151–4
 of machines, capitalism and 150–1
new genre public art 67
New Labour government 47
The New Spirit of Capitalism (Boltanski and Chiapello) 15, 49, 50, 64
'non-exclusive' policy 80
Nunes, Rodrigo 98, 100

Oldenburg, Claes 38, 43
 Profile Airflow 23
 Standing Mitt with Ball 33–5, 37

Panzieri, Raniero 142, 147, 151–3
 'The Capitalist Use of Machinery' 150
Parts per Million (Liberate Tate), 129–34, 170
peer-to-peer (P2P)
 community 147
 network 162
 platforms 16
performance 99, 108, 132
 art 17
 Call Cutta in a Box (Rimini Protokoll) 15, 100–1
 co-optation of 16
 of the Creative Industries 77
 delegated 104
 documents of 145
 Liberate Tate 124, 128
 political ambition of 117
 in postdramatic theatre 92
 traditional aspects of 130
 unsanctioned 123, 131, 170, 174
Postdramatic Theatre (Lehmann) 92, 105

productive labour 31, 32, 37, 38, 52, 102, 103, 122, 135
 art and 13
 categorization of unproductive and 4–7
Protokoll, Rimini 169
 Call Cutta in a Box 15, 92–6, 98–105

Raunig, Gerald 157
Relational Aesthetics (Bourriaud) 18, 81, 90, 105, 108, 131, 197 n.63, 198 n.67, 201 n.57
'reproductive labour' 5, 12, 102–4
Robert Morris: Recent Works 1970 35
Roberts, John 10–12, 31–2, 182 n.15, 185 n.9
 Intangibilities of Form 21

Saatchi, Charles 46–8
Salcedo, Doris, *Shibboleth* 49, 125–7
Saunders, Wade 207 n.9
Sehgal, Tino, *These Associations* 128
Sennett, Richard 53, 54
'servile labour' 122
Shibboleth (Salcedo) 49, 125–7
Sholette, Gregory 11
 Dark Matter: Art and Politics in the Age of Enterprise Culture 11–13
Shukaitis, Stevphen, *The Composition of Movements to Come: Aesthetics and Cultural Labour after the Avant-Garde* 12
Sierra, Santiago 104, 196 n.24
Smith, Adam, *The Wealth of Nations* 27
Smith, Mike 43, 62, 64, 84, 168–9, *See also* Mike Smith Studio

Smith, Terry, *Making the Modern: Industry, Art and Design in America* 30
'social critique' 51, 187 n.31
social labour 107, 167, 169
 in art 16, 168–70
socially engaged art 63, 67, 90, 92
'social memory system' 158
social networks 117, 141, 145
Spinoza Monument (Hirschhorn) 65
'spirit of capitalism' 50, 51, 58
Stallabrass, Julian 46
Standing Mitt with Ball (Oldenburg) 33–5, 37, 43
Steyerl, Hito 83
 'Is the Internet Dead? 140
Suman, Ed 42
Sunflower Seeds (Weiwei) 49, 125

Tate Modern 48
 Turbine Hall 48, 49, 114, 123–128, 135, 170, 188, 197, 198
Taylor, Frederick Winslow 27, 29, 30
Taylorism 27, 28, 168
Taylorist methods 28, 29, 33, 152
Thatcher, Margaret 46, 56, 61, 114, 169
These Associations (Sehgal) 128
Time Piece (Liberate Tate) 123, 124, 127, 130, 170
Tiravanija, Rikrit 82, 83, 106–8
Too Too – Much Much (2010) (Hirschhorn) 65
Toywar (1999) 16, 142, 154–7

unproductive labour 13
 categorization of productive and 4–7
 feminization of work and 102–4
Ur Collage series (Hirschhorn) 65

Virno, Paolo 115, 120–2, 127, 128, 134–8, 149, 153, 156, 160, 163

waged labour 5, 103, 119, 122
Wark, McKenzie 149, 164
 'Considerations of a Hacker Manifesto' 140
The Weather Project (Eliasson) 49, 125
Weeks, Kathi, *The Problem with Work* 1, 102–3, 177
Weiwei, Ai, *Sunflower Seeds* 49, 125

Whiteread, Rachel
 Embankment 125
 Monument 44, 49, 59
Williams, Raymond 3
Women and Work: A Document on the Division of Labour in Industry 1973–5 (Harrison, Hunt and Kelly) 103
Wu, Chin-Tao 114

Young British Artists (YBAs) movement 44, 45, 48, 59